Critical Essays on Postimpressionism

Critical Essays on Postimpressionism

Carol Donnell-Kotrozo

Philadelphia
The Art Alliance Press
London and Toronto: Associated University Presses

Associated University Presses, Inc.
4 Cornwall Drive
East Brunswick, N.J. 08816

Associated University Presses Ltd
25 Sicilian Avenue
London WC1A 2QH, England

Associated University Presses
2133 Royal Windsor Drive
Unit 1
Mississauga, Ontario
Canada L5J 1K5

Library of Congress Cataloging in Publication Data

Donnell-Kotrozo, Carol, 1945–
 Critical essays on postimpressionism.

 Bibliography: p.
 Includes index.
 1. Post-impressionism (Art)—France. 2. Painting,
Modern—19th century—France. I. Title.
ND547.5.P6D66 1983 759.05′6 81-65879
ISBN 0-87982-041-1

Printed in the United States of America

To Jana and Linda

Contents

List of Illustrations

Monochrome illustrations appear as a group starting on page 138.

Gauguin:

Van Gogh:

La Berceuse, 1889
Cypresses, 1889–90
Road with Cypress, 1889–90
Color Plates:
The Night Café, 1888
The Starry Night, 1889

Cézanne:

Une Moderne Olympia, 1872–73
Victor Chocquet Assis (Victor Chocquet Seated), ca. 1877
The Sea at L'Estaque, 1883–85
Gardanne, 1885
Village of Gardanne, 1885–86
Mont Sainte-Victoire, 1885–87
Mont Sainte-Victoire, ca. 1886–88
Still Life with Basket, ca. 1890
The Card Players, 1890–92
The Card Players, 1890–92
The Gulf of Marseilles, Seen from L'Estaque, ca. 1891
The Basket of Apples, ca. 1895
Mont Sainte-Victoire as Seen from Bibemus Quarry, ca. 1898–1900
The Sailor (Vallier), ca. 1905
Color Plates:
L'Estaque: vue du golfe de Marseilles, 1882–85
Mont Saint-Victoire, 1904–1905

Bernard:

Bridge at Asnières, 1887

Denis:

April, 1892

Sérusier: •

Landscape: Bois d'Amour (The Talisman), 1888

*Critical Essays
on Postimpressionism*

1
Introduction

A Disciplinary Debate

Can one possibly say something really new about the postimpression-
ists—Gauguin, Van Gogh, and Cézanne? These venerable revolutionar-
ies of the antirepresentational modern style have an unquestioned place
in the artistic innovators' hall of fame. A problem with luminaries of this
stature, however, is the tendency to make assumptions despite the am-
biguous nature of empirical evidence, whether it derives from the works
of art themselves or from documents of the time, including artists' state-
ments of motivation and intention.

There is an insidious tendency to infer meanings and to ascribe histor-
ical purposes to great artists in order to clarify, if not to create, a coher-
ent theory of stylistic change in art. Gauguin, Van Gogh, and
Cézanne—as fathers of modern art—seem to be invulnerable to histor-
ical abuse. And yet, if the truth be known, these rather problematic
artists have been walking a tightrope between the realists and naturalists
of the nineteenth century on one side, and the subjective expressionists
of the twentieth century on the other.

The lack of a firm foothold for this group of artists ought to be of
concern to chronologists. Art historians have equivocated for decades as
to the proper placement of this problematic late-nineteenth-century
movement. To avoid a fatal fall into the clutches of outmoded
nineteenth-century representational styles, they have preferred the more
forward-looking interpretation of postimpressionism as proto-
expressionists (implying the conscious rejection of reality and repre-
sentation to convey personal aims although it need not be of an explicit
emotive nature). Thus, the prevailing view of these artists is in keeping
with the generally held concept of evolutionary progress in style, a
progress that seems mysteriously to propel its way through history, yet
with a clarity and a logic befitting an order-seeking discipline.

The search for order has its grave limitations, for it has resulted in a

13

standard historical view of Gauguin, Van Gogh, and Cézanne that is fraught with unforeseen difficulties. Many of these stem from errors of omission. The discipline of art history seems to be remiss, actually rather negligent, in not acknowledging the advancements of philosophic and aesthetic theory in the twentieth century. This is especially perplexing considering the radical shifts in the traditional perspectives of art history that could occur. The following group of essays explores the relationship between theoretical philosophy and art history as an empirical discipline concerning a more tenable interpretation of these three largely misunderstood early modern masters. Although their importance in history will not be altered or diminished, my contention is that only a revised vision of their actual nature and purpose as representational painters will give their legacy explicit meaning and value.

What renders this group of essays innovational is the juxtaposition of general theory and specific practical criticism, unusual because of the inherent distrust of theorizing common to art history after World War I. In the United States, this antiphilosophical mood parallels the logical empiricists' repudiation of metaphysics and denotes an attempt to restrict art-historical inquiry to objective considerations of concrete evidence.

Perhaps the theoretical poverty of much art history reflects the assumption that such speculation is irrelevant to the creation of a factual world of perfect order sought by art historians. It is ironic that in its search for a refinement of methods for defining and dealing with historical facts, art historians have generally ignored the efforts of theoreticians (both within and without the field) to investigate and clarify the usage of language involved in the description and categorization of works of art. In the case of the postimpressionists, definitions of terms such as *representation* and *expression* have become confused and muddled in a manner reflective of the dualistic position of the midnineteenth-century philosophy of positivism in which objectivity, an attachment to external reality (associated with representation) and subjectivity (associated with expression) are irreconcilable.

The inconsistency and imprecision with which these terms are utilized in an art-historical context is particularly indicative of the art historian's indifference to aesthetics and its basic methodology. The way in which the unempirical a priori system-building of aesthetics is alien to the aims of art history is evidenced by the remarks of H. W. Janson, who, in a paper entitled "The Art Historian's Comments," contrasts the historical methodology of his discipline with the generalized theoretical approach of aesthetics. He concludes that the "values of art historians may be molded by contemporary artistic production but not, so far as I am aware, by aesthetics."[1] These words seem to reconfirm an earlier antagonism between art history and philosophy. In 1968 Meyer Scha-

piro challenged the views of Martin Heidegger on a Van Gogh painting, *Old Shoes*, questioning the existential philosopher's interpretation of the symbolism involved.[2] The degree of hostility directed toward the outsider intruding upon the restricted domain of art history perhaps is as revealing as Janson's remarks of the larger problem at hand.

A look at the history of the term *representation*, and associated concepts such as *realism*, *impressionism*, and *naturalism* as they are applied to postimpressionism, will expose some of the erroneous assumptions and groundless dualism perpetuated by mainstream art-historical criticism that has been guilty of a too-parochial concern for methods pursued in isolation of the more theoretical approaches of aesthetics. The essays have import beyond the narrower issues of a linguistic dispute, however. The example of the postimpressionists is meant to serve as a paradigm case of the exigency of adopting a conceptual solution to an art-historical dilemma and should ideally provoke a more fruitful interaction between the two diverging disciplines. Art historians can be heard to complain that aesthetic theories, though logically defensible, have not been tested against the works of art themselves as a measure of their theoretical validity. Contrary to such skepticism, the issues of aesthetics will be shown to be of genuine mutual concern.

A note of caution must be interjected at the start of such an enterprise. The validity of a theoretical argument rests ultimately upon the primary evidence of the works of art in question and merits application only insofar as it expresses in logical form the truth of the nondiscursive language of images. Even the various attempts to reconcile representation and expression in contemporary aesthetics, with their subtle shades of linguistic analysis and their facile turn of a philosophical phrase, pale before the eloquence of postimpressionist painting, whose power to evoke reality is so compelling that one wonders how the dichotomy could have been engendered in the first place. The theoretical explication, in a sense, becomes verbal restitution for the past deficiencies of the critical sensibility.

A New Landscape

In *Science, Perception and Reality* the noted contemporary philosopher Wilfrid Sellars employs an effective image for the parameters of knowledge.[3] Reflecting on the relationship of philosophy to other specialized disciplines, he envisions each as a segment of an intellectual landscape with philosophy as the instrument for the maintenance of the whole. Specialists know their way around in their own neighborhoods, but they do not perceive that neighborhood in the clarifying light of the landscape as a whole.

In this group of essays, I have attempted to wrest art history from the

confines of its self-imposed ghetto wherein interdisciplinary trespassing from neighboring boroughs is largely discouraged or is relegated to a minor infraction. Stylistic analysis, chronology, and iconography are still the staples of art-historical discourse, remnants of the great European hermeneutical traditions of the nineteenth and early twentieth centuries. But as much as these traditions have infused the fledgling discipline with a strict methodology of its own, and as much as they have organized a vast welter of objects and artifacts into an impressive evolutionary order of forms and motifs, they have also detached the discipline from the larger landscape. Art history has become an autonomous search for meaning that probes intrinsically into its own subject area; and the result is a rather hermetic system of knowledge, depending upon the historical period in question. Occasionally a visionary explorer will excavate the terrain more fully. Arnold Hauser, for example, in his *Social History of Art*, restores the importance of context to a body of information that is dangerously close to isolation and abstraction. Art historians look to historians for guidance in reconstructing a political, social, and cultural matrix, and to philosophers for conceptual frameworks, but the relationship of events and ideas to the elucidation of meaning in the art object is often incidental and of peripheral importance.

My desire to provoke a newfound dialogue between art history and philosophy, particularly aesthetics, is in no way meant to discount the intrinsic worth of art works nor the relevance of stylistic and iconographic analyses as interpretive tools. Like concentric expanding circles, they are the core of the discipline, leading naturally and logically to everwider dimensions. They do not preclude the larger vision but have largely been practiced as self-sufficient critical and explicatory techniques. Disciplinarians are understandably reticent to step outside the boundaries of their respective fields of inquiry. They have been too satisfied with a piecemeal perspective, reflective of the general fragmentation of knowledge perpetuated by our educational system at the highest levels.

The illumination of meaning in a work of art or in the greater corpus of an artist (as a movement or style) depends upon what the investigator wishes to know. As. E. H. Gombrich maintains:

> Because works of art so perfectly reflect their age, we should also add that like mirrors they will reflect different facts about the age according to the way we turn them, or the standpoint we adopt, not to mention the tiresome tendency of mirrors to throw back our own image. . . . The history of art is one strand in the seamless garment of life which cannot be isolated from the strands of economic, social, religious, or institutional history without leaving any number of loose threads. Where he makes these cuts and how he constructs his narrative will depend for the art historian . . . both on what he wants to know and on what he thinks he can find out.[4]

A full exposition is not necessary or desirable. For example, a discussion of the psychoanalytic ramifications of Cézanne's personal symbolism (expertly done by Theodore Reff or Meyer Schapiro) does not require forays into patronage, class structure, or political values of late-nineteenth-century French society. Psychoanalysis can stand independently of other approaches, although certainly as one interpretive construct, it eventually forms part of a coherent composite whole. Sellars's analogy of the contemplation of a large and complex painting which is not seen as a unity without prior exploration of its parts is particularly apt.

While research in art history, as in other humanistic disciplines, revolves around the predilections of the researcher as scholar for a chosen and carefully circumscribed methodological framework into which he/she can order the bits and pieces of raw evidence as the initial datum of discovery, it results in a myopic vision whose eventual expansion depends upon the interaction *between* methodologies. Perhaps conflicting pictures emerge, and an attempted fusion or synthesis bursts apart into a messy plurality of diverging projections. Biographical and psychological readings of Gauguin's paintings do not always tally with a formalist (stylistic) critical bias. This diversity reinforces the encouraging fact that art works as cultural objects retain their multidimensional, crowded meanings and resist narrow categorization. Fortunately, they resist paraphrase and reductive interpretation as well. The richness of content is inviolable and is as unfathomable as the baffling mysteries of the creative process itself. We can only chip away a fragment at a time from the whole convoluted configuration.

The intellectual landscape, then, is replete with variegated flora and fauna. Scholarship is based on the premise that it can explicate and isolate one kind from another, embedding art into its own phylogenic system. Interdisciplinary enterprises as models for novel integration of previously separate inquiries must be tentative, however, in this respect. A false synthesis clouds rather than clarifies the picture. The focus shifts but remains blurred and confused. As a justification for the present study, I maintain the need for a careful and delimited interdisciplinary analysis of a given problem: the relationship of art to reality in the case of postimpressionism. Adequate correlative studies have been undertaken. We have a wide-ranging body of information and speculative scholarship about Van Gogh, Cézanne, and Gauguin in terms of generative causality including biographical situation, literary and artistic sources, patronage and exhibition history, stylistic chronology, and aesthetic value. What emerges as untouched, in the history of art on the macroscopic level as in the history of this particular art movement on the microscopic, is the perspective of philosophy, the kind of reasoned, logical, and critical reflection that is characteristic of contemporary aesthetics and art

theory, for example, and the kind of broader metaphysical system-building that is fundamental to the synoptic vision of a major modern thinker such as Alfred North Whitehead whose theories seem to parallel and express in verbal form some of the unconscious and conscious assumptions of postimpressionism.

As a complement to traditional vantage points on postimpressionism, dually probing the works from within as well as extrinsically and contextually from without, this series of independent but interrelated essays examines conceptual issues previously left undeveloped. In adopting a theoretical mode of inquiry in contrast to the customary methodologies of art history, these essays intend to provide new insight and to provoke novel scholarly directions. They do not propose to reduce all problems of postimpressionism to the semantic disjunction of representation and expression, but see this specious polarity as forming the underground root of much contemporary critical and historical misinterpretation with branches extending well beyond the range of the initial implantation. Any critical methodology is by necessity somewhat incomplete and restricted in scope for the purposes of clarity and consistency. But it is my contention that this particular study encircles many of the older and still plausible viewpoints on postimpressionism. Confluence is the goal, not opposition. Methodologies should ultimately join forces for stronger illumination rather than embattling one another for artificial preeminence.

Notes

1. H. W. Janson, "The Art Historian's Comments," *Contemporary Philosophic Thought*, ed. Howard Kiefer and Milton Munitz (Albany: State University of New York Press, 1976), vol. 3, pp. 295–311.

2. See Meyer Schapiro, "The Still Life as Personal Object—A Note on Heidegger and van Gogh," in M. L. Simmel, ed., *The Reach of Mind: Essays in Memory of Kurt Goldstein* (New York: Springer, 1968), p. 206–208.

3. Wilfrid Sellars, *Science, Perception and Reality* (London: Routledge & Kegan Paul, 1968).

4. E. H. Gombrich, *Art History and the Social Sciences* (Oxford: Clarendon Press, 1975), p. 9.

2
Representation and Expressionism:
The Critical Polarities

The history of French art in the latter half of the nineteenth century is popularly viewed as a series of revolutions and counterrevolutions. The realism of Courbet, which was a socially oriented naturalism, signaled the beginning of the rebellion against the dominance of romanticism in art with all of its overindulgence in subjective emotionalism, in personal translations of major humanist themes, and in nostalgic historicism. Naturalism accepted the view that one's knowledge of the world was limited to those aspects of reality which the observer experienced empirically. In the most literal way the naturalist upheld the view that "seeing is believing." Art came to adopt the scientific method as the artist concentrated on reproducing the world as if neutrally observed, relinquishing subjective and emotional connotations.

According to modern psychology, however, mechanical or physiological visual sensations and true perception as the conditioned interpretation of sense data are two distinct phenomena. The artists who immediately succeeded Courbet, from Manet to the impressionists and neo-impressionists, progressively modified the naturalistic doctrine, changing the emphasis in painting from the photographic imitation of reality which was an expression of mechanistic materialism to an analysis of the retinal perception of visual impressions in its multiple variations, particularly in terms of the light effects found in nature. Relying upon the raw data of visual experience, the impressionistic painter sought the pure optic experience of reality, that is, he attempted to capture with accuracy and immediacy the perceptual surface of the world as seen instantaneously. Thus, the representation of nature changed but was still equated with a standard of objective accuracy, a norm of true perception.

The postimpressionists form a cohesive unit, despite stylistic and motivational distinctions, as a boundary-breaking art movement. This

19

logical grouping stems from the artists' common rejection of impressionism and naturalism. Although the artists of the postimpressionist movement were grappling with the relation between the natural and the practical worlds and felt there to be an intimate connection between art and nature, it was not in terms of the strict model-copy relationship of scientific naturalism. This conception of neutral or objective vision is a testimony to the influence of the positivistic philosophy of the mid-nineteenth century and is inherently dualistic, perpetuating the old Cartesian dichotomy of mind and matter. Although it is likely that artists and theorists alike misconstrued some aspects of the new philosophy, their assumptions have been held by art historians to the present day.

Baudelaire, in his "Salon of 1859," contrasts two kinds of truth sought by two divergent kinds of art: "The immense class of artists . . . can be divided into two quite distinct camps: one type, who calls himself 'réaliste' . . . and whom we, in order to characterize better his error, shall call 'positiviste,' says: 'I want to represent things as they are.' And the other type, 'l'imaginatif,' says: 'I want to illuminate things with my spirit and project their reflection upon other spirits.'"[1] Certainly this is an oversimplification of the theory of positivism in which Baudelaire distinguishes the truth of a mechanical realism (associated with the photograph) from that of a human, subjective encounter with nature. However, this divorce of the "absolute truth" of external reality and the fantasies of the imagination is found in other later critics of the period such as Eugène Fromentin, Roger Marx, Armand Silvestre, and Théodore Duret. (A sampling of twentieth-century art historians—John Rewald, Linda Nochlin, and H. R. Rookmaaker, among others—reveals similar attitudes.)

Impressionism carried the seeds of disintegration within its own theories as many painters within the movement came to see that the depiction on canvas was more than the simple recording of pure "innocent" visual sensations. Despite the popular view that the passage from impressionism to symbolism and postimpressionism was a radical and traumatic event, it was consistent with contemporary developments in physiological psychology which was already beginning to break down the positivistic distinction between subject and object through an emphasis upon the experiences of the observer and by the assertion that the so-called facts of reality were not absolute. Art, like normal visual perception, came to be seen as a process of organizing sensory elements into some degree of meaningful formal patterning.

This new awareness of perception as patterning and of the formal elements of art as an integral part of the artist's representation of his visual impressions of reality is the hallmark of the postimpressionist revolution. The term *postimpressionism* was actually coined by Roger Fry

to describe the shift from the representational art of impressionism (based upon an imitation of some aspect of natural appearances) to a new tradition based upon a more subjective analysis of reality and upon intentional acts of expression.[2] Although these artists do not constitute a cohesive school or movement, as isolated personalities, they did share the rejection of impressionism after having experimented with it at some time during their careers. Fry declared the movement "the greatest revolution in art that had taken place since Graeco-Roman impressionism became converted into Byzantine formalism," a remark reflective of his hypermetropic attitude toward subject matter in painting (which he felt must invariably compromise formal considerations).[3]

The term *postimpressionism* is accurate insofar as it is chronologically descriptive and has the additional benefit of being emotively neutral. Fry's alternative term for these artists who came chronologically after impressionism, *expressionism*, has proved to be more controversial in that it suggests a value-laden interpretation that is in accord with the dualistic position of the mid-century positivists in which objectivity and subjectivity are irreconcilable. Postimpressionism becomes the subjective antithesis of the naturalist's or impressionist's objectivity. (Clive Bell, identified with the same aesthetic creed as Fry, loathed the impressionists' "scientific pretentions" as being the ultimate degradation of imitative art.)[4] Because the naturalists and impressionists represented the standard of photographic accuracy in painting at this time, it came to be believed that the postimpressionists could offer only a distorted representation of reality by comparison.

Partly, then, as a result of the positivistic theories of late-nineteenth-century critics and theorists, and partly because of Bell and Fry's emphatic formalism which eschewed all interest in representation, the postimpressionists were credited with a radical emancipation of the artist from the entire tradition of representational art which previously sought to capture if not rival nature in paint.

Critics in general tend to describe the rebellion of these artists from impressionism in the following manner: Cézanne is said to have rejected the superficiality of the impressionist style, particularly its lack of permanence and structure. He is credited with anticipating the invention of cubism in that he used nature as a pretext for geometricized formal design. Gauguin's revolt is seen in terms of an aesthetic preoccupation with the laws of color and harmony in painting that transcend the limitations of literal description. Finally, Van Gogh is said to have literally burst the bonds of impressionism in his search for a personal and emotional experience of a religious or spiritual nature. These artists appear so radical and revolutionary in comparison to the academic art of their time that it is often held they invented a new tradition of painting that, following the lead of Roger Fry, is commonly called *expressionism*, a

loosely descriptive term for antirepresentational art, or congruent in meaning to a subjectification of reality.

The purpose of this group of essays is to refute the above-mentioned assumptions, which are prevalent in the criticism of Gauguin, Van Gogh, and Cézanne. The following new interpretations of postimpressionism are suggested as an alternative: first, that these artists are not expressionists, symbolists, or direct forerunners of any modern art movement such as cubism, fauvism, or expressionism, as is commonly maintained by twentieth-century artists and critics seeking to confirm their theories of evolutionary development in art; and second, that these incorrect interpretations are the result of the fact that postimpressionism followed a period of scientific naturalism which has erroneously been taken as the norm for the representation of objective perception. The three postimpressionists in question are really representational in the same sense in which art was representational before naturalism upset traditional modes by introducing the new concept cf a literal and true imitation of nature.

Systematic attempts to reconcile or explain the old dichotomy of representation versus expression appear in various guises in twentieth-century aesthetics. Before examining some of the representative theories, it is relevant to undertake a brief excursion into some further semantic problems involved in a discussion of postimpressionism.

The Fallacy of Naturalism

An old and problematic preoccupation of aesthetics has been the relationship of art to life. At one time, representation had been defined by the imitation theory, according to which art is understood as the "faithful, literal duplication of the objects and events of ordinary experience."[5] The art object was associated with the cognitive and descriptive elements of the visible world and its value was derived primarily from the degree of verisimilitude it displayed in relation to the object imitated. The nineteenth-century concept of naturalism is derivative of the older imitation theory.

The term has met with several objections concerning its narrow application and its limitations as a norm of descriptive accuracy in art.[6] There is a great deal of confusion and misinterpretation of the concept, not only in regard to philosophic naturalism, but in regard to its relationship to similar terms suffering also from widespread misuse (such as realism and representation). Realism refers more properly to visual forms derived from the direct experience of the actual and the commonplace in everyday life as exemplified by the art of Courbet, Millet, or Daumier. Although it has a historical reference to a later phase of nineteenth-century realism emphasizing man as a reflection of his social milieu,

naturalism in its broader sense usually refers to an uncritical or seem-
ingly unemotional manner in which the forms of reality are rendered, as
though to convey mere factual information (as in the military paintings
of Detaille, the fastidious detail of Meissonier, the trompe l'oeil illusion-
ism of Peale or Harnet, or the more contemporary photographic images
of close-focus realists such as Richard Estes or Chuck Close). The ac-
ceptance of naturalism as a norm for representational accuracy in art
forces one to draw the distinction between art which is descriptive of
reality and an art which expresses personal feelings or attitudes toward
nature.

When critics and artists began to react to the positivistic interpretation
of nature in the late nineteenth century that they felt reduced the crea-
tive possibilities of art to a slavish imitation, the term *naturalism* took on
derogatory associations implying the inhibition of artistic freedom. It
was felt that the new currents in art, such as postimpressionism and
symbolism, valued more the "inner" nature of reality rather than its
surface appearances apprehended passively through the senses. Thus,
those who rejected naturalism nevertheless failed to understand that an
artist need not be naturalistic in order to represent reality according to
valid (albeit not merely "objective") perceptions. Rather, they upheld
the dualistic proposition that the language of objective reality is natu-
ralistic, that truth is scientific and value free, and that there is an un-
bridgeable ontological dichotomy between the subjective and objective,
between values and facts.

Such assumptions and such a narrow conception of naturalism as a
standard of representation in art gave rise to an aesthetic theory that
failed entirely to take into account the basic aims of postimpressionism
whose fundamental formal and representational interests became ob-
scured by the prevailing dualistic distinction between representation and
expression. Nevertheless, terms such as *expressionism, symbolism*, and
synthetism arose as alternative theories to justify the postimpressionists'
aversion to a positivistic reality and to account for what was viewed as a
"flight into what is subjective and detached from the outer world."[7]

The concept of synthetism is closely associated with the name of
Emile Bernard, who sought to simplify form and color for the sake of
more forceful expression in painting. In line with the ideas of the literary
symbolists of the day, Bernard declared: "Anything that overloads a
spectacle [of nature] . . . covers it with reality and occupies our eyes to
the detriment of our minds. We must simplify in order to disclose its
meaning . . . reducing its lines to eloquent contrasts, its shades to the
seven fundamental colours of the prism."[8] Bernard felt he could achieve
the proper result in two ways: by confronting nature directly and sim-
plifying it with utmost rigor, and by relying on conception and memory.
As he states it: "The first possibility meant, so to speak, a simplified

handwriting which endeavoured to catch the symbolism inherent in nature; the second was an act of my will signifying through analogous means my sensibility, my imagination, and my soul."[9] The works of the postimpressionists, and most particularly Gauguin and the school of Pont-Aven, seemed to embody the new independence of nature in line with Bernard's ideas on the simplification of modes of expression.

Other artists and critics, in correspondence with the contemporary movement in literature, preferred to use the term *symbolism* rather than *synthetism*, though there are basic similarities between the two concepts. Its strongest nineteenth-century proponents were Maurice Denis and Albert Aurier.[10] The symbolists regarded internalized experience as providing an escape from the materialistic culture that surrounded them, and they wished to embody that experience in art. Their concentration upon the expression of emotion generated from within led them to criticize impressionist art and to deride it as materialistic because of its apparent preoccupation with the pure impression, the sensory response to the external environment. The postimpressionists' association with symbolism may stem from this common rejection of impressionism, however exaggerated the separation may have become between these various contemporary and, in many ways, interlocking movements.

The idea of distortion became a self-conscious means of artistic expression for the symbolists: "The 'distorted'—or, as we would be more inclined to say today, 'abstracted'—formal elements of line, color, shape and so on become the means of converting the particular sensation or emotion into a concretely manifest 'idea' (to use Aurier's term), a realized image of generalized meaning."[11]

The symbolist-synthetist point of view of the nineteenth century has also found wide acceptance among twentieth-century critics. For example, Herbert Read represents a modified position. He draws the distinction between a perceptual experience or the immediate perception of an image (which need not necessarily mean scientific perception in the sense of a norm) and the use of a symbol, the image plus its mental associations. Symbolism becomes one of the two ways in which the human mind functions. The other is the direct experience of the external world, what he calls the "presentational immediacy" of sense perception.[12]

The symbolist bias is most particularly seen in the treatment of Van Gogh and Gauguin: "His [Van Gogh's] aesthetic manifesto . . . resolved itself into the thesis that the artist's most important task was to interpret the fundamental emotions: joy, sorrow, anger and fear. . . . It was thus that Van Gogh formulated his solution of the artistic problems that were also the foundation of Seurat's and Gauguin's endeavours."[13] The artistic solution to which Sven Lövgren refers here is his concept of symbolism, the postimpressionist response to a "crisis in the concept of reality" which transvalued all values around 1885. Through the creation of sym-

bolic art, the artist could surpass the world of nature in the pursuit of a transcendental spirituality. Expressionism becomes the twentieth-century alternative for this kind of symbolist theory and actually encompasses symbolism, a term usually reserved for Gauguin and Van Gogh, while all three have been called expressionists by modern critics. The source of this point of view is the same as that for symbolism, with the difference that the conception of "distortion" of reality becomes more significant as the foundation of the new artistic style. This theory is best expressed by Roger Fry, for whom the postimpressionists imply an expressionist attitude in that these artists turned away from the impressionist overemphasis on naturalism toward a more individual kind of self-expression than the literal rendering of objects allows. According to Fry, the postimpressionists preferred to express the emotional significance of things that was felt to be truly more important in art than the vagaries of appearance.[14] As a result, deviations from naturalism became acceptable. In propounding this view, Fry assumes there is some kind of absolute standard of what natural appearances are like, that the artist may choose to use natural forms which approximate reality, or that he may deliberately distort them to express the emotions he wishes to arouse.[15]

It is easy to see why a critic such as Roger Fry could propose the term *expressionism* as an alternative for *postimpressionism* in that he mistakenly believed these artists consciously altered their natural vision of objective reality to express their intense subjective emotions. Although he is correct in assuming that art should not be judged by its scientific accuracy in rendering undigested sense data, he falls into error, however, when he suggests that any deviation from scientific naturalism implies intentional distortion or subjective expressionism: "Van Gogh's pictures are not the least like other pictures. Their origin is different. . . . Vincent's paintings are pure self-expressions. . . . His vision of nature is distorted into a reflection of . . . inner condition."[16] It is mistakenly assumed that even Cézanne, haunted by the desperate search for a reality hidden beneath the veil of appearance, must find it only by means of a planned distortion of normal vision. His calculation is presumed to be not the emotional effusion of Van Gogh, but rather a distortion which would appeal by means of formal harmony. Therefore, Fry, like many other critics, considered the postimpressionists to be expressionists rather than realists. "Cézanne has realized his early dream of a picture not only controlled but inspired by the necessities of the spirit, a picture which owes nothing to the data of any actual vision."[17] There are countless critics who follow Roger Fry's line of thinking. Van Gogh, Gauguin, and Cézanne are frequently described with the misused epithet *expressionists* in that they depart from the alleged natural look of the world. In the process of deviating from traditional concepts of painting (and particularly from the

scientific naturalism of the preceding era) they are said to distort visual reality "in the interest of expression of inner realities that are important to the artist."[18] It is this turning away from the literal rendering of objects toward an emphasis on individual self-expression that accounts for their designation as expressionists, a necessary categorization for such a radical departure from previous art history.

The difference between simply describing an object and expressing emotions evoked by an object is said to be one of artistic intention. The expressionist artist is more selective than the naturalistic artist. He is not concerned with mere appearance; i.e., the "treeness" of a tree is less important than its poetic or emotional associations.[19] As Roger Fry has explained, the expressionist or postimpressionist had to invent new pictorial means to replace outworn conventions in order to capture the "real" significance of things in nature. Within these new pictorial means, critics came to find the calculated deviations or distortions of reality commonly associated with expressionist art. As a result, Van Gogh, Gauguin, and Cézanne are credited with the creation of a new tradition in painting. The supporters of the theory of evolutionary development of art proclaim these artists, therefore, as the direct forerunners, if not the founders themselves, of major modern art movements: cubism, which is expressive distortion for decorative effects; and expressionism, which is expressive distortion for emotional effects.

Representation and Expression in Modern Aesthetic Theory

The legacy of the nineteenth century has been a rather restrictive view of the nature of representation and a linguistic distinction between representation and expression that should more properly be seen as a separation of function between naturalistic depiction and expression, the extremes of a continuum. To equate naturalism with the concept of representation is to risk ambiguity and semantic imprecision.

Although many art historians persist in collapsing the boundaries between naturalism and the broader category of representation in their discussions of nineteenth-century art, there have been various attempts in aesthetics to integrate representation with theories of expression. When representation is associated with traditional imitation theories emphasizing illusion or verisimilitude to an objective reality, and when expression is linked with a retreat into subjective emotionalism or ego projection, such a dualistic polarity does not readily admit of any logical fusion. However, despite philosophical differences, the theories of Susanne Langer, Rudolf Arnheim, and E. H. Gombrich share a common concern with modified definitions of representation and expression which allow for an integrated framework that best describes the situation of a majority of styles in the history of art including the transitional

movement of postimpressionism. A glance at several more contemporary theorists will provide an indication of future directions for resolving the problem surrounding the logical usage of these terms.

While the nineteenth century accepted a positivistic conception of nature, it was also in the nineteenth century that critical research into the intimate constitution of matter and the exploration of the human mind by psychological experiment resulted in the proposition that the so-called facts of reality are not absolute. Psychological theorists such as Emile Littré, Théodale Ribot, and Hippolyte Taine, as well as others (such as the "psychophysicists" Gustave Fechner and Charles Henry), concluded that the observed nature of external "objective" phenomena is a product of human consciousness and depends upon the method of observation of the perceiving subject.

The application of related ideas to art has been the contribution of E. H. Gombrich, whose *Art and Illusion* draws inspiration from the radical reorientation of traditional ideas about the human mind brought about by modern psychology.[20] The "sense data" theory of perception, which posits a mind in which sense data are deposited and processed, is deflated and replaced with a more relativistic conception of perception where the active contributions of the mind (synthesizing, organizing, selecting, integrating) obviate the possibility of passive reception of sense impressions from reality. Perception depends upon the basic structure of the mind and upon past knowledge and expectations based upon known experiences.

Works of art are also dependent upon these factors. Thus, if there is no pure vision of reality (the "innocent eye" theory), the theories of the impressionists are invalid in purporting to capture the true nature of visual experience. If all seeing is interpreting, there is no neutral naturalism, no direct artistic revelation of what we see unmediated by any perceptual judgment.

There have been subsequent critical assessments of Gombrich's views centering upon his faulty equation of representation and illusion. Gombrich also suffers from lapses of logical consistency when he seems to treat Constable as a norm of representation in art and speaks of "matching" reality as a possible form of "making" it. Nelson Goodman offers a contemporary reappraisal of representation as denotation which is independent of any requisite resemblance to reality. Goodman accepts and clarifies Gombrich's sound contention that the history of styles in art is the product of a system of classification, of characterizing objects according to conventional systems that are standard for a given culture or person at a given time (Gombrich's "schema"). Thus, realism or naturalism is not a matter of any constant or absolute relationship between the system of representation employed in a picture and the standard system. The fact that the traditional system is taken as a standard prob-

ably accounts for the erroneous assumptions about postimpressionism when measured against such a standard in the mid-nineteenth century. Goodman's statement, "A picture looks like nature often means only that it looks the way nature is usually painted,"[21] could be reversed to elucidate the problem of postimpressionism in which a novel, unconventional style was not accepted as a perspective on nature simply because this was not the way that nature was customarily portrayed.

Gombrich, in tandem with Goodman, thus offers a concept of representation that allows for the unique vision of the postimpressionists who are nevertheless the antithesis of naturalism. Whether or not the artist intended to depict the appearance of nature is not always relevant.[22] If reality cannot be perceived in its actuality, and if there are countless alternative systems of representation and description, then there is insufficient reason to believe that an artist cannot depict reality with flattened space, simplified form and color, or distinguished by emphatic outlines or geometric fragmentation. Whether intentional or not, the postimpressionists' depiction of reality in these terms has become as valid and as convincing a manner today as the naturalistic mode no doubt had been to the positivist. It is simply a question of acquiring familiarity with new relationships between forms and space as the prerequisite for accepting new art styles as genuine perspectives on nature. (In essence, life imitates art.) The issue of intentional distortion must be reexamined in this new context, not as a deviation from naturalism, but as the necessary process of transformation that reality inevitably undergoes in order to be reproduced in any given medium and as the consequence of diverse culturally conditioned standards of representational accuracy. Goodman states that an innovating representation "may bring out neglected likenesses and differences, force unaccustomed associations, and in some measure remake our world."[23]

If all art involves subjective interpretation because of the fundamental nature of perception as well as the demands of a medium, it remains to clarify the relationship of representation to expression.[24] Can expression, in the light of the evidence, remain distinct from representation? Is there a logical dissimilarity between correspondences to nature, on the one hand, and the deliberate reassembling of artistic elements in the interests of expression, on the other? A critical analysis of the appropriate application of terms such as *expression* or *expressionism* in propositions about postimpressionism will reveal that no such radical dissimilarity exists.

Traditionally in art history, expression is taken to be the logical antithesis of representation in that a predominant intention to embody personal feelings in material form is felt to compromise the intention to depict a visual experience of reality. The art-historical term *expressionism* was invented to emphasize the contrast between an art which was based

on purely visual impressions (e.g., impressionism) and a new movement that sought, instead, the intentional expression of ideas and emotions. (This could be achieved by the exploitation of visible subjects to accentuate their symbolic or emotive character.) Because of the apparent personal nature of postimpressionism, many critics found such a theory applicable to their art.

This distinction is unacceptable and reflects, as with the concept of naturalism, a presupposed dichotomy between the subjective and the objective components of experience. Furthermore, it suggests an uncomfortable fusion of expression and emotional catharsis. An examination of the issue compels the assertion that the postimpressionist's dislike of the literal rendering of objects practiced by the naturalists and impressionists does not necessarily imply an antirepresentational intention on their part or an interest in emotive effusion. Even if the artists themselves should have misconstrued the nature of representation, it would still not entail an accurate designation of these artists as expressionists by contemporary standards.

The traditional expression theory in aesthetics reinforces this error and, if it is to be upheld at all, is perhaps better suited to describe the situation following the postimpressionists, such as the German expressionists or the abstract expressionists who sought the deliberate and intentional creation of works that embody or objectify feeling. Whereas the postimpressionist artist might also seek such embodiment in the forms and images of reality, the avowed expressionist completely negates an adherence to external perception and retreats consciously into a subjective dimension deemed more "real." Thus, if a work of art can no longer be conventionally (publicly) accepted, according to conceptual and perceptual habit as a possible perspective on reality, then it is not a representation.

The criticism of the expression theory centers around the locus of anthropomorphic qualities projected into works of art, i.e., whether emotive qualities can be traceable to features of the medium, the subject matter, or by virtue of what an artist does in a work. Such criticism also concerns the contention that uses of anthropomorphic predicates are metaphorical, and can be discerned by attending to the work in question even when it presupposes something about the artist. The shift of attention from a preoccupation with the artist (in theorists such as Véron, Ducasse, and Collingwood) to a concentration upon the work itself is an attempt to free the older theory from the misassumption that a necessary link exists between the qualities of a work and certain mental states of an artist.

Advocates of the expression theory, however, have perpetuated a necessary but illogical split on the level of analysis between emotional expression as a product of intentional acts and the work that presents it,

despite the fact that on the level of experience, a work does not display such a division. How, then, can a reconciliation be attained between contradictory attitudes toward the same work of art? The expression theory will not stand up against the fact that "subjective" phenomena do not always exist independently of an "objective" context.

Thus, just as it is true that the perception of reality is the product of a human perspective that includes one's subjective nature as well as culturally conditioned values, and that expression as a consequence cannot be divorced from the work of art based on that reality, so it is true that the embodiment of reality in a work of art must necessarily become something other than a literal equivalent or a mere corollary to a prior "act" of perception or expression. Attempts to redefine expression in terms of formal embodiment in a work itself can be seen in the theories of Susanne Langer and Rudolf Arnheim.

According to Langer, art is basically an illusion or semblance in the sense that it abstracts from the multiple perceivable qualities in reality and must translate this abstraction into terms permitted by a medium.[25] As such, it becomes a metaphorical image which she calls "presentational symbolism." We might discard the debatable theory that art is a product of the intuition whose purpose is to "set forth directly what feeling is like" because Langer's conception of feeling as "living form" is too generalized, and it is speculative as to whether or not the cognitive value of art lies solely in the exposition and elucidation of the nature of feeling. We might, however, consider the validity of her designation of art as "expressive form," as "a visible, individual form produced by the interaction of colors, lines, surfaces, lights and shadows, or whatever entered into a specific work."[26] This helps to clarify why representational art can be so variable in appearance (as with naturalism and postimpressionism). The elements of a work are not independent constituents with each element individually expressive. Rather, expression is bound up with the totality of the visual elements.[27]

Rudolf Arnheim offers a specific application of the idea that expression in art is "transmitted to the eye with powerful directness by the perceptual characteristics of the compositional pattern. . . . It is indispensable as to a precise interpreter of the idea the work is meant to express. . . . Neither the formal pattern nor the subject matter is the final content of the work of art."[28] In other words, every work of art is expressive of something beyond so-called objective reality in the sense of passively observed material objects. Expression is a fundamental fact of perception whether in art or in life. Because perception is the product of a subject's interaction with an object, every experienced reality is necessarily expressive.[29] One must not forget that art does not function as a camera in recording an experience. There will necessarily be some degree of subjective interpretation on the part of the artist simply because

of his aesthetic sensibility as well as his overall mental conditioning. Furthermore, an interest in the inherent properties of the medium does not preclude an interest in the convincing representation of reality. Thus, because of the subjective nature of perception and the influence of the medium on representational imagery, the traditional notions of realism or naturalism in art become mere time-bound, historically conditioned terms applicable to the mid-nineteenth century. There can be no unhistorical usage of such concepts if there is no absolute norm to determine accuracy in rendering reality.

While contemporary aestheticians have voiced various objections to Langer's and Arnheim's versions of the expression theory, it nevertheless appears that many valiant efforts to distinguish representation and expression as linguistic categories have not unequivocally proved that they are always mutually exclusive types of art. A great deal of the problem can be resolved by noting the semantic confusion over terms such as *expression*, denoting artistic acts, and *expressiveness*, denoting properties of artworks. While most expression theories of art seem to succumb variously to the fallacy of projecting too great a degree of specificity of emotional representation, one can avoid this dilemma by postulating a logical relationship between the structure of the formal elements of a work of art and its expressive dimension. Artists such as Van Gogh, Gauguin, or Cézanne do not express feeling states about reality in an art object such that the work is merely the qualitative analogue of those states. The expressiveness of their work does not exist independently of the artist's medium or the particular schema of his personal style.

Style is a product of the artist's subjective interaction with objective reality in the case of representational art, and although a work may well emerge from an intended act of emotional expression (in a different sense of the term), it is not thereby symptomatic of that act, nor does knowledge of such an act affect our perception of the work. The aesthetician and art historian would find it more fruitful to direct their attention to the expressive object in Langer's and Arnheim's senses of the term in order to avoid perpetuating the inadequacies of the more traditional expression theory, whether in its attribution of feeling states to the creating artist or in its hypostatization of affective states inhering in nonsentient works of art.

I am attempting to make the same kind of argument for the visual arts that has frequently been made about music: "Let us grant, then, that music-sadness is different from life-sadness, and that whatever the psychological causes of the felt similarity may be, it is the music-sadness and not the life-sadness that the music evokes. . . . The expressiveness of the music is dependent on neither the experiences of the artist nor the experiences of the audience."[30]

Most recent theories of expression have carefully delineated the concept from representation, but they do not conflict with my proposition about the merger of the two would-be divergent kinds of art which is to take them a step further. Nelson Goodman associates representation with denotation and expression with converse denotation or "possession" such that the crucial difference between the usage of the terms is not "a difference in domain" as much as "a difference in direction." In fact, although the terms are distinct and run in opposite directions in terms of the logical relationship of the picture to the things it represents and to the things it expresses, they are intimately related models of symbolization. The dichotomy of representation and expression is a linguistic distinction, but clearly not an essential one. The terms are applicable as convenient labels to such extreme instances as naturalism and German or abstract expressionism, although it is often just a question of degree. Goodman's distinction points more properly to different aspects of the same work of art. The representational content of Cézanne's *Mont Sainte-Victoire* is (denotes) the actual mountain in Southern France. The expressive content is (is denoted by) the style or form by means of which the scene is depicted and the metaphoric designation of these forms as emotive. The question of a possible fusion, hinted at but not fully discussed by Goodman, depends upon the nature of the artistic style (e.g., postimpressionism) and the manner in which it is perceived.

Richard Wollheim's criticism of Goodman's thesis—that for all its neatness his formula does not give us anything that we can look on as a final resolution of the traditional questions about representation and expression—also applies to the work of Alan Tormey.[31] However, in his book *The Concept of Expression*, Tormey's clarification of the usage of the term *expression* has resulted in a widening of the gap between expressive objects and artistic acts and intentions in keeping with my position on the postimpressionists.

It is Tormey's contention that all forms of the expression theory lean too heavily upon anthropomorphic predicates with reference to an artistic personality. He prefers to distinguish between the expressive properties *of* a work and represented expressions *within* a work. For example, Bernini's *David* represents David-expressing-intense-determination, but the work itself is not necessarily (although it may be) expressive of intense determination.

Thus, a kind of reconciliation is achieved between representation and expression in the sense that the representational arts can make expressive comments on their represented content.[32] I interpret this as a nonliteral kind of artistically mediated expressiveness to which we erroneously ascribe the intentional acts or private states of persons, but which can more properly be seen as attributes of the perceptual surface of a work. Tormey illustrates expressive ambiguity as an inherent feature of most,

if not all, works of art in the sense that a work may express various kinds of properties (such as tenderness, yearning, or nostalgia), and these seem to eliminate the possibility of a definitive reading of the work in terms of specific artistic intentions. Tormey's greatest insight for the purposes of this issue is the effort to prevent the expression theory from treating all of the cognate forms of expression as terms whose logical behavior is similar. The particular mistake he notes is the assumption that the existence of expressive qualities of an artwork implies a prior act of expression. He guides us into reasserting the fact that expressive qualities of an artwork remain, irresolutely, statements about the work. In the analytic tradition, Tormey thus clarifies, but does not reverse, aspects of the modified expression theories of Langer and Arnheim, whose focus of attention was on the form of the work in exclusion of the creating artist.

I have argued here for the reformulation of postimpressionism and for the reinterpretation of its meaning based upon contemporary theories regarding the nature of representation and expression. I have also argued conversely that an integration of these concepts, rather than a strict opposition, is now mandatory for aesthetics and art history in the light of the evidence provided by the art movement itself. Expression is a fundamental component of representation, and only a theory that takes this relationship into consideration is applicable to the history of art in general, and to the postimpressionists in particular.

Thus, it must be concluded that, although the art of the postimpressionists does prefigure certain concepts in modern painting, the case for their tremendous legacy is usually given at the expense of an important element in their art, their role as representational painters. The popular misconceptions concerning the postimpressionists as a group, such as their designation as a variation of expressionism or symbolism, have been shown to be philosophically illogical by virtue of the nature of perception, of the theory that all art is to be considered to some degree expressive, and of the idea that naturalism is not a norm of representational art, as is commonly held. It is apparent that the art of the postimpressionists has been widely misunderstood and can no longer be considered a consciously expressionistic art and a deliberate defiance of realism and impressionism. On the contrary, these artists provide viable forms of representing reality. They can no longer be viewed solely as revolutionary fathers of modern art because they happen chronologically to follow (although reject) a period of scientific naturalism which many subsequent historians have erroneously taken as the norm for images of visual reality. Because representation and expression can no longer be considered two incompatible and distinct types of art, if art strikes one as expressive, as occurs with postimpressionist art, it is not on that account less objectively real or less truly representational. It is really a question of whether or not we are prepared to surrender ourselves to the painter's

personal vision. This vision will now be explored individually in the following chapters.

Notes

1. Charles Baudelaire, "Salon de 1958," *Escrits sur l'art*, ed. Yves Florenne (Paris, 1971), 2: 36–37.

2. Roger Fry, *Manet and the Post-Impressionists at the Grafton Galleries, November 8 to January 15, 1910–1911* (London: Ballantyne & Co., 1911). The name was given by Fry when he helped arrange the first exhibition in England of these artists' work.

3. John Ingamells, "Cézanne in England 1900–1930," *The British Journal of Aesthetics* 5 (1964): 344 (quoting Roger Fry, *Vision and Design*).

4. Ibid., p. 347.

5. Jerome Stolnitz, *Aesthetics and Philosophy of Art Criticism* (Boston: Houghton Mifflin, 1960), p. 110.

6. Thomas Munro, "Meanings of 'Naturalism' in Philosophy and Aesthetics," *The Journal of Aesthetics and Art Criticism* 19 (1960: 133–37.

7. H. R. Rookmaaker, *Synthetist Art Theories* (Amsterdam: Swets & Zeitlinger, 1959), p. 72.

8. John Rewald, *Post-Impressionism* (New York: Museum of Modern Art, 1956), p. 193.

9. Ibid.

10. Maurice Denis said that a painting is a "flat surface covered with colours organized in a certain way." He also remarked that the symbol implies the existence of correspondence between line, form, and color on the one hand and various states of mind on the other (Lionello Venturi, *Art Criticism Now* [Baltimore: Johns Hopkins Press, 1941], p. 16).

11. Richard Shiff, "The End of Impressionism: A Study in Theories of Artistic Expression," *The Art Quarterly* n.s. 1 (1978: 364. The "idea" as an objective entity is postulated: "The symbolist was not seen as presenting an internalized subjective experience of an objective world, but as bringing his personal intuitions or emotions out into a world of universal knowledge and experience. What Denis, Aurier, Kahn and others called subjective and objective distortion are fused if the artist's personal vision (his 'ideal') is in immediate correspondence with an image of universal expressive power (the 'idea')—the individual artist would feel and express what all can feel and come to know. In such a case, the art of the individual impression would merge with the art of the universal symbol" (ibid., pp. 364–65).

12. Herbert Read, *The Philosophy of Modern Art* (New York: World Publishing Co., 1965), pp. 10–12.

13. Sven Lövgren, *The Genesis of Modernism* (Stockholm: Almquist & Wiksell, 1959), p. 155.

14. "In no school does individual temperament count for more. In fact, it is the boast of those who believe in this school that its methods enable the individuality of the artist to find complete self-expression in his work than is possible to those who have committed themselves to representing objects more literally. This, indeed, is the first source of their quarrel with the impressionists. The postimpressionists consider the impressionists too naturalistic" (Fry, *Manet and the Post-Impressionists*, p. 7).

15. "When the artist passes from pure sensations to emotions aroused by means of sensations, he uses natural forms which, in themselves, are calculated to move our emotions. . . . The artist's attitude to natural form is infinitely various according to the

emotions he wishes to arouse. He may require for his purpose the most complete representation of a figure, he may be intensely realistic . . . or he may give us the merest suggesting of natural forms and rely almost entirely upon the force and intensity of the emotional elements involved in his presentment" (Roger Fry, *Vision and Design* [New York: Brentano's, 1925], p. 25).

16. Ibid., p. 184 (referring to Van Gogh's St. Rémy period).

17. Roger Fry, *Cézanne* (New York: Macmillan Co., 1927), p. 77, referring to the artist's later work.

18. John Canaday, *Mainstreams of Modern Art* (New York: Holt, Rinehart & Winston, 1959), p. 234.

19. "The post-impressionists were not concerned with recording impressions of colour or light. They were interested in the discoveries of the impressionists only insofar as these discoveries helped them to express emotions which the objects themselves evoked" (Fry, *Manet and the Post-Impressionists*, p. 8).

20. E. H. Gombrich, *Art and Illusion: A Study of the Psychology of Pictorial Representation*, 4th ed. (London: Phaidon, 1972).

21. Nelson Goodman, *Languages of Art* (Indianapolis: Hackett Publishing Co., 1975), p. 39. Similarly: "Representation is . . . disengaged from perverted ideas of it as an idiosyncratic physical process like memory, and is recognized as a symbolic relationship that is relative and variable" (ibid., p. 43).

22. Although it does not constitute a complete argument because of the debate over artistic intentions and the Intentional Fallacy, recourse to statements by the postimpressionists can document the view that they did consider themselves as painters of the appearance of nature (albeit not in impressionists terms). It is the evidence of the paintings themselves and their ability to be perceived in a certain manner, however, that suggest a strong case for expressive representation, not mimetic representation nor pure expressionistic distortion.

23. Goodman, p. 33. Note the similarity of Rudolf Arnheim's statement that "imagination is sometimes misunderstood as the invention of new subject matter. . . . Actually the achievement of artistic imagination could be described more correctly as the finding of new form for old content. . . . Rather than distorting reality, imaginative form reaffirms the truth" (Rudolf Arnheim, *Art and Visual Perception* [Berkeley: University of California Press, 1966], p. 141).

24. "The representation of the work of art offers a structural equivalent of the experience that gave rise to it, but the particular concrete form in which the equivalent appears cannot be derived only from the object. It is also determined by the medium" (Arnheim, p. ix).

25. "Imitation of other things is not the essential power of images. . . . The true power of the image lies in the fact that it is an abstraction, a symbol, the bearer of an idea. . . . An image . . . abstracted from the physical and causal order, is the artist's creation" (Susanne Langer, *Feeling and Form: A Theory of Art* [New York: Scribner, 1953], p. 47).

26. Ibid., p. 128.

27. "A work of art is a single, indivisible symbol. . . . It is not, like a discourse . . . composite, analyzable into more elementary symbols. . . . It can never be constructed by a process of synthesis of elements because no such elements exist outside it. They only occur in a total form" (ibid., p. 369).

28. Arnheim, pp. 436–38.

29. "Expression can be described as the primary content of vision. . . . If expression is the primary content of vision in daily life, the same should be all the more true for the way the artist looks at the world. The expressive qualities are his means of communication. They capture his attention, through them he understands and interprets his experience, and they determine the form patterns he creates" (ibid., pp. 430–31).

30. John Hospers, "The Concept of Artistic Expression," *Problems in Aesthetics*, ed. Morris Weitz (London: The Macmillan Co., 1970), pp. 232, 242. O. K. Bowsma, in "The Expression Theory of Art," *Aesthetics and Language*, ed. William Elton (New York: Philosophical Library, 1954), similarly releases expression in music from the bondage of anthropomorphic emotion-connotation predicates.

31. "To associate representation with denotation and expression with converse denotation (or 'possession,' as Goodman calls it) is not to give their sufficient conditions: at best, it is to give their necessary conditions. Or, to put it another way, Goodman's thesis, as so far unfolded, may bring out the difference, or a very important difference, between representation and expression, but it does not exhibit the nature of either" (Richard Wollheim, *On Art and the Mind* [London: Allen Lane, 1973], p. 292).

32. Alan Tormey, *The Concept of Expression* (Princeton: Princeton University Press, 1971), p. 139. Also, "It will be convenient to refer to the properties denoted by predicates of this sort as 'expressive' properties. Thus, a work expressive of anguish will be said to have the 'expressive property anguish rather than simply the property anguish, the modification serving both to indicate affinities with instances where 'anguish' has unqualified application and to obviate absurdities engendered by taking art to exhibit full-blooded sentient states" (ibid., p. 127).

3
Gauguin and the Art of Reintegration

Modern criticism of Gauguin is preoccupied, for the most part, with his contribution to modern art. Though he does prefigure certain concepts in modern painting, the case for his tremendous legacy is usually given at the expense of his role as a representational painter. In general, the criticism of Gauguin tends to follow three basic interpretations: (1) Gauguin as an expressionist, whose break with impressionism is construed as a rejection of nature; (2) Gauguin as a synthetist and symbolist; and (3) Gauguin as a decorative and abstract painter concerned more with style and the surface arrangement of the canvas than with subject matter. Though these interpretations involve separate issues, they are also interconnected, and the adherence to one often leads to the acceptance of the others.

One of the most basic misconceptions in art that has spawned these views is the assumption that naturalism is the norm for representational accuracy in art, and that the rejection of it implies a conscious rejection of the representation of nature on the part of the artist. Because naturalism is commonly associated with a certain traditional method of rendering objects through the use of perspective, modeling, and an emphasis on visual description, any deviation from this norm is labeled antinaturalistic and becomes confused with a rejection of nature itself. As a result of this misconception, the art of Gauguin becomes commonly associated with emotional expression (or expressionism) in order to account for the liberties taken with nature. The artist is said to exaggerate or distort reality in the interest of lyrical or poetic self-expression as in the "musicality" of his colors, expressive in themselves of the inner forces of nature.[1] "[In *The Yellow Christ*] . . . the flaming yellow of the Christ is already expressionistic in the manner of a Franz Marc or Chagall painting. . . . Distortions in this kind of painting serve a double purpose. On the one hand, they enable the artist to create his form pattern or rhythmic effect, to subordinate his figures to a general aesthetic idea. Beyond that, they permit a certain emotional expressiveness,

necessary in this instance for the religious and mystical purpose of the artist."[2]

The art of Gauguin came to be called expressionistic and symbolic in that he disparaged naturalistic techniques in his intuitive reaction against the positivism of his era. Gauguin falls into the prevailing custom of opposing mind to matter in the way he phrases his criticism of impressionism; however, it will become evident that he does not in fact accept this doctrine. In order to justify and support the view that Gauguin rejected reality in the interest of self-expression, critics rely upon statements by the artist that have been conveniently misinterpreted:

> I consider impressionism as a completely new quest which must necessarily separate itself from everything mechanical like photography, etc. That is why I will get as far away as possible from that which gives the illusion of a thing, and since shadows are the *trompe-l'oeil* of the sun, I am inclined to do away with them.[3]

> "It is good for young people to have a model," wrote Gauguin in 1888, "but let them draw the curtain on it while they are painting."[4]

> The impressionists . . . heed only the eye and neglect the mysterious centers of thought, so falling into merely scientific reasoning. . . . A purely superficial art, full of affectations and purely material. . . . A technique which I apply in my own manner [is] to express my own thought without any concern for the truth of the common, exterior aspects of Nature.[5]

> It is better to paint from memory. Thus your work will be your own; your sensation, your intelligence and your soul will then survive the scrutiny of the amateur. He goes to his stable if he wishes to count the hairs of his donkey and to determine the place of each of them.[6]

> They [the impressionists] pursued their searches in accordance with the eye and not toward the mysterious center of thought, and consequently fell into scientific rationalizations.[7]

> I find everything poetic and it is in the dark corners of my heart, which are sometimes mysterious, that I perceive poetry.[8]

> A hint—don't paint too much direct from nature. Art is an abstraction! Study nature, then brood on it, and treasure the creation which will result.[9]

> Color . . . can logically only be used enigmatically every time it is employed, not for drawing but for giving the musical sensations which proceed not of its own nature, [but from] its own interior, mysterious, enigmatic force.[10]

The second basic interpretation, which associates Gauguin with the

concepts of synthetism and symbolism, is actually a derivation of the
idea that the artist is an expressionist.[11] (The term *expressionism*, which
was not used widely until after 1910, became equated with antinatural-
ism, as well as the nineteenth-century *symbolism* and *synthetism*.) In his
discussion of the development of synthetist art theories, H. R. Rook-
maaker explains how a realistic attitude toward art, rejected by post-
impressionism, is replaced by an aesthetic interest in "choosing, arrang-
ing, and simplifying" one's impression of nature in what is called a
"synthesis" in the work of art. In this way, the artist asserts his freedom
over against nature. Synthetism, practiced more consistently by Emile
Bernard, stems from the ideas of Albert Aurier and Maurice Denis, who
are among the better known exponents of symbolism of the time.[12]
"L'artiste, de toute nécessité, aura la tâche de soigneusement éviter cette
antinomie de tout art: la vérité concrète, l'illusionisme, le trompe-l'oeil
de façon á ne point donner par son tableau cette fallacieuse impression de
nature qui agirait sur le spectateur comme la nature elle même. . . . Le
strict devoir de peinture idéiste est, par conséquent, d'affectuer une
sélection raisonnée parmi les multiples éléments combinés en
l'objectivité . . . quelques symboles partiels corroborant le symbole
général."[13] It was a false assumption on the part of these critics and
theorists that the rejection of naturalism prevalent at the end of the
nineteenth century implied a rejection of representational intent. Such
critics adopted the positivists' commonplace philosophical dualism con-
sidering objective reality to be materialistic, devoid of mind, of any value
dimension, and of all feeling. In his *Théories 1890–1910*, Denis laments
the banality of trompe-l'oeil illusionism and the imbecilic imitative at-
titude of this "sot préjugé." Therefore, Gauguin's antinaturalistic art is
seen only as an expression of a state of mind, not as an experience of
reality. It is assumed that the function of the artist differs from that of
the scientist in that he deliberately distorts objective reality to express a
personal mental condition.

Gauguin's synthetism is also closely associated with the symbolist
movement in that both theories are a product of this kind of dualistic
thinking. Albert Aurier includes synthetism within his definition of
symbolist art. Because he considered this movement closely akin to
symbolism in literature, he formulated an aesthetic based on theories
already expounded for the literary movement.[14] In the process, he falls
into the common error of assuming that a norm of true illusionism exists
in art. When he instructs the symbolist artist to avoid this deception by
selecting only certain aspects of reality that correspond to an "Idea," he
neglects to see that all art is an abstraction of realtiy and is expressive and
symbolic according to the subjective interpretation of the artist. A con-
temporary of Gauguin and a close friend, Charles Morice, recognized
the "verbal excesses" of Aurier, and the general applicability of his
theories to art as a whole, not simply to Gauguin's style.[15]

Nevertheless, adopting such theories as Aurier's, many critics assume that the art of Gauguin implies a turning away from representational art and nature. For Aurier and those who follow his point of view, the ultimate goal of symbolist painting was to express "Ideas" (whether of dreams, the subconscious, the imagination, or intuition) through a special kind of language that allows the artist to exaggerate or deform reality according to his individual inclination as well as according to the needs of the "Ideas" to be expressed. The following quotation from Antoine de la Rochefoucauld confirms this view:

> Il [Gauguin] sut dire . . . que l'Art est étroitement uni à l'Idée, qu'une oeuvre n'est belle que si elle reflète l'âme du peintre qui la conçut et l'âme de la Nature qui servait simplement de prétexte. Par ses toiles, d'essentielle ordonnance décorative, executées sans nul souci d'imitation, il montra l'inanité de toute objective recherche. . . . Gauguin osa, l'un des premiers, la déformation et méprise la science de l'anatomie, les très discutables axiomes de la perspective, par ses hardiesses de dessin, il discrédita quelque peu les illusoires "canons" professés dans les académies ou à la sinistre officine de la rue Bonaparte. . . . Il eut la grande mérite de suivre jusqu'à la fin la voie du symbolisme qu'il avait découverte.[16]

In addition to the writings of Aurier, one finds statements such as the following by Octave Mirbeau:

> Le naturalisme est la suppression de l'art, comme il est la négation de la poésie, que la source de toute émotion, de toute beauté, de toute vie, n'est pas à la surface des êtres et des choses, et qu'elles résident dans les profondeurs où n'atteint plus le crochet des nocturnes chiffonniers. . . . Il y a dans cette oeuvre [de Gauguin] un mélange inquiétant et savoureux de splendeur barbare, de liturgie catholique, de rêverie hindoue, d'imagerie gothique, de symbolisme obscur et subtil.[17]

These symbolists theories are not in error in claiming that naturalism is the suppression of art in the sense that scientific description suppresses poetry on the grounds that poetry (or a poetic view of reality) is presumed by science to be a distortion of the real. But the critics of this view also assume that nineteenth-century naturalism is synonymous with true representation, which in the long view of history is incorrect. In the criticism of Gauguin, however, the emphasis is always placed on the subjective, imaginative, and enigmatic quality of his art, not upon its authenticity as a representation of an objective visual experience.

There are many paintings by Gauguin which fall into the category of symbolic art, not only because of their titles, but because they are said to be more overtly symbolic than other paintings based closely on reality (such as many of his Breton and Tahitian landscapes). The *Perte deu Pucelage*, for example, is not interpreted as the result of any visual experi-

ence, but as a purely intellectual product for which the artist sought out
an appropriate and not too pretty model.[18] Similarly, in regard to *The
Moon and the Earth*, 1893,

> During the first years in Tahiti, Gauguin evolved a heavy-legged, narrow-
> hipped, square-shouldered female figure type not at all reflective of the
> rounded sensuous bodies of the Tahitian women but appropriate to his idea
> of savage monumentality and a fit participant to his allegories of primitive
> man's union with earth, sky, and the mystical forces behind nature. . . . [This
> was] a reversal of the impressionist idea that the world must be met on its
> own terms and interpreted through its own appearance. Instead, Gauguin
> rejects the world; the painter's assignment becomes the exploration of univer-
> sal mysteries through symbols rather than the observation of temporary fact
> through fragments of tangible reality. This is Gauguin's importance.[19]

Numerous other critics accept this point of view: "Gauguin does not
need to create an illusion of particular presence, or even of a particular
time and place; his discourse is universal and must be expressed in
symbolic signs, which are never aspects of reality. . . . In the end,
symbolism and realism are incompatible. The symbol is an intuitive
grasp of realities that remain beyond the range of analytical intelli-
gence."[20] In this example, Herbert Read incorrectly maintains that sym-
bolic art and representational art (here equated with naturalism) are two
alternate ways of presenting reality.

Lionello Venturi also expresses the view that synthetism and symbol-
ism are incompatible with the representation of reality in that the artist
paints from memory. He reminds us just how much Gauguin opposed
impressionism beginning with cloisonnism and continuing with synthet-
ism, all the while renouncing the direct and complete impression of
reality. For Venturi, Gauguin painted only the memories of that which
he had seen, but that memory had also clearly simplified. The object was
no longer before his eyes in living reality. Memory retained a few ab-
stract elements whose relationship had to be established by the imagina-
tion; and when a new content was given this combination of abstract
elements, symbolism was born.[21]

The third interpretation of Gauguin, as an abstract painter whose
decorative designs originate in purely imaginative invention, is a
simplification of the expressionist-symbolist viewpoint. Like the other
two related views, this interpretation is based upon the artist's rejection
of naturalism. The decorative element in Gauguin's art is seen as a
calculated distortion of nature rather than as a viable image of nature.
Numerous adherents to this view can be found in twentieth-century
criticism as well as in Gauguin's own time.[22] Many critics relegate Gau-
guin to a field where painters are more concerned to evoke aesthetic
emotions by means of formal orchestration rather than to tell stories in

paint, to moralize, or to depict a scene or effect in nature. Nature, for Gauguin, is seen as merely a pretext for decorative design. As with the other interpretations of Gauguin, critics and historians misinterpret statements by the artist to support their views:

> One day, working under Gauguin's direction in the . . . "Bois d'amour," he [Sérusier] painted on the lid of a cigar box the small picture he later called *The Talisman*. "How do you see those trees?" "Well, put on some yellow. That shadow is rather blue, paint it in pure ultramarine. Those red leaves, put them on in vermilion."[23]

> Gauguin encouraged them [Bernard and Sérusier] not only to paint what they saw, "but to bring out, solidify and materialize in form and colour 'la pensée intime des choses et des êtres'," and he implored them to do away with chiaroscuro and *trompe-l'oeil*. . . . "The only thing permissible is the noble arabesque which enables the sensibility to follow its capricious labyrinths right to the heart. In art, every means is good. Nature can be violated and brought back to permanent beauty through sublime contortion."[24]

The story of Gauguin and Sérusier has been taken as the symbol and object lesson of modern painting and the hallmark of expressive distortion. It is interesting to note that it is remarkably close to a statement by Van Gogh as an explanation of Gauguin's unique way of rendering his vision of reality:

> They [Bernard and Gauguin] do not care at all about the exact form of a tree, but they do insist that one should be able to say whether its form is round or square—and, by God, they are right, exasperated as they are by photography and silly perfection of some painters. They won't ask for the exact color of mountains, but they will say: . . . those mountains, were they blue? Well then, make them blue and don't tell me that it was blue a little bit like this or a little bit like that. . . . Make them blue and that's all.[25]

Maurice Denis is also partially responsible for the erroneous belief that Gauguin is a decorative expressionist, since he associated Gauguin with the symbolists and emphasized the decorative, antinaturalistic aspects of his art. Using dualistic language, he affirms that the subjective deformation of nature is practically what we could call style.[26] In his famous quotation, he states his definition of art as a picture which is a "flat surface covered with colors arranged in a certain order."[27] Thus, art becomes expression through decoration (the harmony of forms and colors) or by other modes of calculated distortion of reality. The artist must ignore a naturalistic representation of nature because of its inherent disorder; and his main problem as an artist is to learn how to distort the truth of vision in the interest of self-expression.

It is the period in Gauguin's career beginning in 1888 to which such theories find a particular application. At this time, the artist was associated with the group at Le Pouldu and Pont-Aven, consisting of Meyer de Haan, Séguin, Laval, Filiger, Emile Bernard, Anquetin, Schuffenecker, Monfried, among others. The short-lived group endured from 1889 to about 1893, and was linked by a common interest in the imaginative revitalization of representation inspired by the popular art of the day as well as more antique sources. It was also at this time that the style of "cloisonnisme" was developed, arising out of the influence of Manet, the Japanese, and gothic stained-glass windows where areas of color are composed on the surface of a canvas like the sections of enamel in cloisonné. The *Vision after the Sermon (Jacob Wrestling the Angel)* of 1888 is often given as the characteristic example of the new style. Aurier describes the work as visionary and dreamlike, having nothing to do with recording sense data as impressionism (and, of course, naturalism) attempted to do. This kind of art which expressed "Ideas" pictorially rather than presenting a description of reality must be, above all, decorative[28] and is exemplified by the flat areas of color rimmed with contour lines that were a product of Gauguin's short stay in Martinique, where he seems to have discovered new possibilities for form and color. Thus, he begins his so-called decorative or synthetic style, in which he begins to interpret nature rather than describe it, while flattening space by denying traditional perspective. His color, with its intense, pure tones, is said not to be based on true visual observations but becomes "expressionistic" and "symbolic."

Other examples include the *Self-portrait with Halo* of 1889, with its references to the Garden of Eden and the Fall of Man, and *The Yellow Christ* of the same year, painted at Le Pouldu. The latter is seen as the masterpiece of Gauguin's new style. Certainly one cannot discount the emotional impact of the work, the intense primitivism, and the preoccupation with a new kind of religious content influenced in part by his interest in the Romanesque crucifix.[29] Although both works exemplify Gauguin's interest in the flat surface of a painting, articulated into a decorative pattern of curvilinear lines and flat areas of bright color, they are more than pure pictorial designs.

Thus, the view that Gauguin's style—his primitive simplification of forms and colors and the flattening of space, etc.—is indicative of his deliberate deviation from nature is one of the most basic misunderstandings of his art in the twentieth century. "Our eyes were filled with the splendours that Gauguin had brought back from Martinique and from Pont-Aven. . . . At that time we hardly felt Gauguin's exotic savor, the quasi-barbaric refinements of this impressionism. We saw him only as the decisive example of expression through decor."[30] As a result of this view, Gauguin is postulated as one of the founders of modern art, creat-

ing something new and revolutionary when, in fact, his art and his comments should be viewed as quite traditional. All three of the basic misinterpretations of Gauguin can be said to evaluate him as a programmatic antinaturalist who deliberately distorts his visual perceptions in order to make art. It cannot be denied that Gauguin's art, like any other, involves a certain degree of abstraction or simplification, and that his perceptions were conditioned by a tremendous sense for the decorative. But in all three interpretations, it has become apparent that his profound relationship to nature has been overlooked or devalued. (While most of the examples of criticism given are from the first half of the twentieth century, they set the tone for ensuing historical interpretations. No new trends in the scholarship have significantly altered the picture presented here.)

The inherent misconception in the above theories is the assumption that the representation of nature is inconsistent with the expression of one's feelings. One then declares that there is a higher value in a work of art which expresses the "subjective" emotions of the artist than in one that presents an unemotional description of nature in the form of a factual record of surface appearances. Description should be replaced by an arbitrary compositional arrangement of lines and colors, and a conscious distortion of the old representational image becomes of prime importance in expressionist-symbolist aesthetics. The formal elements of the work of art become a vehicle for the expression of the inner states of the artist, freed from all responsibility to create an image of a viable public reality.

Contrary to this view, Gauguin's art is firmly rooted in nature—the whole canvas being an equivalent or symbol for man's experience of nature (as in Susanne Langer's sense of the "Art Symbol").[31] Gauguin's art does deviate from a naturalistic description, but it is a convincing representation or interpretation of visual reality nonetheless. His stylistic deviations from naturalism are not evidence of a deliberate rejection of nature in order to express mental states (as in the case of true expressionist styles). One must, like Gauguin, become aware of the fact that an artist's decorative sensibility as well as the medium influence the translation of one's vision of reality into a work of art. Gauguin's sense of style is a natural product of his interest in representation. It is not a question of decorative abstractions or expressionistic distortions for their own sake. Furthermore, the alliance of decoration and representation in art is by no means a new idea at this juncture, but occurs throughout the history of art.

With particular regard to the second basic misinterpretation of Gauguin as a symbolist (and synthetist), the false assumption that a work of art is representational only if it is painted directly from nature and rendered as a naturalistic imitation of a motif has led such critics as

Albert Aurier to add that the expression of "Ideas" is even superior to the imitation of reality when, in fact, there is no conflict between the two purposes. These two objectives are mutually supporting motivations in the work of most major artists of all periods. In answer to those critics who rely on a literal interpretation of Gauguin's statements, it must be made clear that his art, like most historic art, is a kind of poetic representation, although in his comments about art he shares with his critics the linguistic opposition of "objective" versus "subjective" images. As theorists such as Langer have explained, the role of imagination plays an important part in perception as well as in artistic creation.[32] It is incorrect to suppose that Gauguin deliberately departs from a viable perspective upon nature to portray some kind of esoteric, private world that can be understood only symbolically. He slips into the recurring error of dualistic thinking when he speaks of the "imitation of nature," as though there can be an exact representation of objective reality, which is in no sense an abstraction dependent on a point of view. Living subsequent to the victory of scientific objectivity, which affected everyone's concept of perception as neutral and passive, Gauguin could not avoid the prevailing dualistic language in discussing works of art. However, as an artist, he could not believe in the scientist's distinction between objective and subjective reality. He speaks of finding poetry in nature and not in the mind as dualism maintains. Gauguin's experience of a "deeper reality" suffused with poetic values lends credibility to the view that the expression of one's feelings need not compromise one's vision of reality, provided that it is nature itself that evokes these feelings and conditions their expression. Thus, even where he exerts his imagination, Gauguin insists that his image is "begotten by the union of his mind with reality."[33] Despite his own usage of dualistic language, as an artist, Gauguin reintegrates what has been artificially separated in our thinking and our language (subjective versus objective, mind versus sense data, thought versus feelings, values versus facts). Though the aesthetic ideals verbally expressed by Gauguin are a reaction against naturalism, it is naturalism as such which is condemned, not representation. For example, when he states, "Don't paint too much from nature. Art is an abstraction. Study nature, then brood on it and treasure the creation which will result,"[34] he does not, as many critics assume, mean abstraction in terms of arbitrary style. Rather, he means that a work of art is a symbol of a reality more profound than that of naturalism. (Twentieth-century abstraction and expressionism do break the link with nature and are not intended to be representational styles, like that of Gauguin, whose own style is among any number of possible perspectives abstracted from an infinitely variable nature.) If Gauguin uses decorative or semiabstract forms, it is not in the interest of "art for art's sake," but is directly related to the need to express his unique perception of reality, however reordered by his

artistic sensibility. Even one of his more "symbolic" paintings, *The Vision after the Sermon*, can demonstrate how symbolism and abstraction of natural forms can be compatible with an expression essentially tied to nature.

Gauguin was certainly influenced stylistically by the synthetism of Emile Bernard. He referred to the term in speaking of particular portraits, although this was only a temporary phase of Gauguin's career. The term is more properly associated with the ideas of Bernard.[35] Gauguin not only fails to refer to himself as a synthetist, but particularly objects to the term *symbolist*. "Vous connaissez mes idées sur toutes ces fausses idées de littérature symboliste ou autre en peinture. . . . Peut être trop orgueilleusement je me loue de ne pas être tombé dans tous ces travers ou la presse louangeuse m'aurait entraîné comme tant d'autres."[36] It appears that such terms as *synthetism* and *symbolism* were more the creation of contemporary literary figures, poets, and critics, who applied their theories to Gauguin's art until he became identified with them and came to be called the father of these new movements in painting. A critical analysis of Gauguin's own statements reveals, however, not a turning away from nature, but a reexamination of nature's role in the creation of art.

The last issue in need of refutation is the view that emphasizes Gauguin's decorative inclinations, i.e., his self-conscious stylization, and his tendency to abstraction. The same arguments presented above are instrumental in reaffirming Gauguin's representational intentions, although one additional error surrounding his art associates his work, particularly that which reflects his experience in Tahiti, with arbitrary decorative design. Legend says that Gauguin went to Tahiti because it fit a preconceived ideal or dream. For example, "Gauguin's notion of the primitive . . . this conception of primitive religion has little to do with the rather cheerful mythology of the Society Islands, but this only emphasizes the eclectic nature of Gauguin's ideas and the degree to which he came to Oceania with established preconceptions of the primitive."[37] There are, however, alternative views:

> He was proud to be called "barbarian." Even his colour and draughtsmanship should be "barbaric" to do justice to the unspoilt children of nature he had come to admire during his stay on Tahiti. . . . It is not only the subject matter of his pictures that is strange and exotic. He tried to enter into the spirit of the natives and to look at things as they do. He studied the methods of native craftsmen and often included representations of their works in his pictures. He strove to bring his own portraits of the natives into harmony with this "primitive" art. . . . He gladly ignored the century-old problems of Western art when he thought that this helped him to render the unspoilt intensity of nature's children.[38]

In addition, it is believed that Gauguin's interest in the "primitive" (including the Persians, the Egyptians, Marquesan art, or any of the other numerous influences on his art) is a result of his desire to express himself symbolically and mysteriously, qualities he found in primitive art that are not possible in the Western tradition of naturalistic representation. It is true that Gauguin's interest in the primitive is related basically to his rejection of Western civilization and the kind of naturalistic representation in art he associates with it, as these were not conducive to his intense feelings for nature. However, few critics have come to realize that his Tahitian style is faithful to his direct experience of nature on the islands. One of the exceptions is Henri Perruchot:

> Gauguin part à la découverte des terres d'où la civilisation soit absente où l'homme soit encore lui-même. Il va en Bretagne parce que la Bretagne est "cette vieille et dure terre de l'extrême-Occident, que peuplent des êtres primitifs, simples, fidèles à leurs coutumes et à leur langue," parce que "la civilisation s'y brise comme la mer se brise sur les rochers des côtes," que "le passé y survit, intact comme le sol rude." Il va à la Martinique afin de se plonger dans "la lumière violente des tropiques," dans "une nature sauvage dont rien ne calme la luxuriance." Il va à Tahiti parce que le *Mariage de Loti* qu'il a lu, lui laisse croire qu'il trouvera dans l'île lointaine un paradis épargné.[39]

In *Noa Noa*, in which he collaborated with Gauguin, Charles Morice provides evidence that Gauguin's art in Tahiti was inspired by perceptions of nature: "But the landscape with its violent, pure colors dazzled and blinded me. I was always uncertain; I was seeking, seeking. . . . In the meantime, it was so simple to paint things as I saw them; to put without special calculation a red close to a blue. . . . Why did I hesitate to put all this glory of the sun on my canvas?"[40] This quotation, expressing the feelings of Gauguin in response to nature, demonstrates that, for him, nature in Tahiti was more than a pretext for decorative abstraction or generalized symbolic meanings. His was an interpretation, suffused with feeling, of a particular location at a particular time; and he captured it on canvas in forms that are convincingly real. His works are icons of a life that is free, close to nature, and spiritually alive. His description of a scene he watched one day from his hut corresponds exactly with the features in the painting *Man with an Axe* (1891), which is particularly renowned for its decorative color:

> It is morning. On the sea, by the shore, I see a pirogue and in the pirogue is a woman. On the shore a man almost naked; next to him a sick coconut tree appears like a tremendous parrot. . . . With an harmonious and subtle gesture the man raises with his two hands a heavy axe which leaves a blue mark

against the silvery sky and—below—its incision on the dead tree. . . . On the
purple soil long serpentine leaves of a metallic yellow seemed to me like the
written characters of a faraway oriental language. . . . The blue line of the sea
was frequently broken by the green crests of the rolling surf crashing against
coral reefs.[41]

Many similar examples could be given to illustrate that Gauguin's colors
and forms are not arbitrary decorations for their own sake. They would
also help to invalidate the view that his art is concerned essentially with
the legends, myths, and symbolic devices of the Tahitians rather than
with a direct response to the scenery itself. On the contrary, the re-
sponse to nature must have come first; and with this, he could freely
integrate the Tahitian legends and symbolic connotations. In fact, these
so-called symbolic meanings are often obscure in his works. He admits,
for example, titling *D'où venons-nous? Que sommes-nous? Où allons-nous?*
after the completion of the work. In 1889, André Fontainas published a
review of Gauguin's exhibition in *Mercure de France* which included this
work. "To represent a philosophical ideal he creates harmonious groups
of figures whose attitudes convey to us a dream analogous to his own. In
the large picture . . . nothing . . . would reveal to us the meaning of the
allegory if he had not taken the trouble to write high up in a corner of the
canvas: 'Whence do we come? What are we? Where are we going?'" In
reply, Gauguin wrote in 1889:

> "In the large panel that Gauguin exhibits there is nothing that explains the
> meaning of the allegory." Yes, there is: my dream is intangible, it comprises
> no allegory; as Mallarmé said, "It is a musical poem, it needs no libretto."
> Consequently the essence of a work . . . consists precisely of "that which is
> not expressed; it flows by implication from the lines without color or words;
> it is not a material structure." . . . To go back to the panel: the idol is there not
> as a literary symbol but as a statue . . . combining my dream before my cabin
> with all nature . . . [and] the unearthly consolation of our sufferings to the
> extent that they are vague and incomprehensible before the mystery of our
> origin and of our future. And all this sings with sadness in my soul and in my
> design while I paint and dream at the same time with no tangible allegory
> within my reach—due perhaps to a lack of literary education. Awakening
> with my work finished, I ask myself: 'Whence do we come? What are we?
> Where are we going?' A thought expressed in words quite apart on the wall
> which surrounds it. Not a title but a signature. . . . I have tried to interpret
> my vision in an appropriate decor without recourse to literary means."[42]

He did not paint, then, to illustrate a symbolic concept; rather, the
figures in his paintings represented for him a oneness with nature which
he began to experience himself. ("Gauguin is realistic, and any symbol-
ism trying to clarify the atmosphere and the object by means of allegor-

ical figures or metaphorical indications is alien to him.")[43] He chose
Tahiti, most likely, as a place where the freedom of life as well as the
scenery would bring him closer to the essence of nature: "I plunged
eagerly and passionately into the wilderness, as if in the hope of thus
penetrating into the very heart of this Nature, powerful and maternal,
there to blend with her living elements."[44] When Gauguin chose a corre-
sponding primitive style to depict nature as he knew it, without the
trappings of civilization (perspective, illusionism, etc.) which are absent
in many forms of representation throughout history, it was not merely to
invent a decorative style. It is only necessary to accept the idea that the
mentally conditioned nature of perception and the consequently varied
nature of representation permit the artist to render viable images of
reality by the use of many varied schemata.[45] Gauguin intuitively recog-
nized the variability of nature and the authenticity of diverse perspec-
tives upon it, as seen in the long history of representational forms in art.
For example, the meticulous detail of a Jan Van Eyck painting is one
convincing icon of reality. The broad, simple forms and outline that
Gauguin uses provide another convincing image of nature. One may be
culturally conditioned to see nature in terms of either one and, with a
little effort, may learn to accept both as valid alternatives.

Even where Gauguin is consciously influenced by Japanese and other
non-Western styles, as in *Les Trois Petits Chiens* (1888), *Nature Morte à
l'Estampe Japonaise* (1889), *Ta Matete* (1892), and *Old Women at Arles*
(1888), they are not inconsistent with his primary concern with nature
and representation. "You discuss shadows . . . and ask me if I care about
them. . . . Insofar as an explanation of light, yes! Look at the Japanese
who certainly draw admirably, and you will see life in the outdoors and
sunlight without shadows . . . giving the impression of warmth, etc."[46]
Certainly a primitive point of view is no less valid than a scientific one,
even though most people are conditioned (after setting up Renaissance
perspective or naturalism as the model) to seeing it as distorted and
therefore nonrepresentational. For Gauguin, primitive styles of varied
sources are just as convincing as representations as the art of the Renais-
sance is to Western man, or as naturalism was to the common man in
Gauguin's time.

Furthermore, though the influence of diverse styles is incontestable in
the art of Gauguin, they become barely identifiable as a result of their
subtle integration into his own style, based on a personal response to
nature. For Gauguin, perspective and other similar devices used to ren-
der an image of an object are schemata intended to create an emotionally
neutral illusion, a literal description of reality. Such schemata were
limited and inadequate, and the artist's keen decorative sense and his
awareness of the medium influenced the translation of his vision of
reality into art. Unlike the window-into-nature approach, artistic space

and real space became fused in the image that Gauguin created. When he states, "You will always find nourishing milk in the primitive arts, but I doubt if you will find it in the arts of ripe civilizations,"[47] he underscores the fact that these influences were a stimulus toward a new and valid method of representing reality, not simply styles to be copied merely for their decorative or expressionistic effect.

Gauguin himself justifies his exaggerations of style and color: "You have fewer means than nature, and you condemn yourself to renounce all those which it puts at your disposal. Will you ever have as much light as nature, as much heat as the sun? And you speak of exaggeration—but how can you exaggerate since you remain below nature? . . . Is there then a science of harmony? Yes. In that respect the feeling of the colorist is exactly the natural harmony."[48] Nature, for Gauguin, is above rules and formulae, and lends itself to infinite ways of representation according to the inner feeling and special perspective of the artist. Although Gauguin's art is imaginative, it is nevertheless expressive of a reality he knew, studied, and loved. It appears that in each locale where he chose to live and paint, Gauguin was carefully observant of his environment:

"I love Brittany," he soon wrote to his friend Schuffenecker. "I find wilderness and primitiveness there. When my wooden shoes ring on the granite, I hear the muffled, dull, and powerful tone which I try to achieve in painting."[49]

Vincent is inspired to paint here [Arles] like Daumier, while I on the contrary find here a combination of colorful Puvis and Japanese art. The women here have elegant headdresses and Greek beauty. Their shawls fall into folds as in primitive paintings. . . . Here is a source of beautiful modern style.[50]

Thus, if Gauguin found it necessary to represent nature in a primitive style, or with Japanese or some other stylistic influence (which have erroneously served as arguments in favor of his conscious departure from reality), it is because he actually envisioned nature in this way, with the eyes of one steeped in the history of art, including popular culture. In creating a work such as *The Yellow Christ*, Gauguin drew upon the local scene in Pont-Aven. There seems every reason to believe that the crucifix in the work was inspired by the wooden cross in the chapel of Trémalo while the hill is based on the colline Saint-Marguerite which also appears in *The Village*.[51]

In conclusion, it is clear that Gauguin's art is inextricably tied to a vision of nature; but the acknowledgment of this fact is painfully lacking in the bulk of modern criticism of this artist. Even those critics who accept the vision usually misinterpret its essence perpetuating the old dichotomy of representation and expression. For example: "Si par exam-

ple, au fond de sa toile *D'où venons-nous? Que sommes-nous? Où allons-nous?*, les arbres, les buissons, les fleurs, jaillissent de terre, montent, descendent, se tordent, s'enchevêtrent, sans se soucier le moins du monde des lois de la botanique, Gauguin n'en crée que mieux l'impression de puissance que dégage la nature tropicale."[52]

Though historian John Rewald unjustly restricts Gauguin's direct observation of nature to this last phase of his art, he interprets Gauguin's relationship to nature as important, but then minimizes the significance of his icons by reducing their reality to the level of sensations. He distinguishes sensations in the perceiver from the sense data to which he would reduce Gauguin's normal observation, as though Gauguin were basically a naturalist who let his sensations warp what he observed. "Gauguin studied nature around him for elements of form and color which he reconstructed in his paintings, not so much in an attempt to reproduce what he had observed, but as if preoccupied with capturing the sensations which the sight of his subject had released in him."[53] Similarly, concerning *Spirit of the Dead Watching*, 1892, Linda Nochlin states: "Reality was a point of departure rather than a complete subject . . . an element within the total aesthetic structure of line and color which at once intensified and expressed a more manifold, complex, imaginative reality than could be provided by mere physical vision alone."[54]

Rather than emphasize Gauguin's anticipation of twentieth-century nonrepresentational expressionism, it would be more pertinent to reveal his effort to reconcile the antinomy between the world of the senses and the world of the mind. What Gauguin achieves is to reintegrate what has been artificially separated in our thinking and in our language and to maintain a permeable boundary between the ego and the world. The interpretations of Gauguin's art as essentially expressionistic, symbolic, or decorative are based on erroneous assumptions and analyses that obscure the real meaning of his art—an art based on an intensely personal vision of reality conditioned by his pervasive aesthetic sensibility, his keen sense of style, and his frank exploitation of the unique qualities of the oil-paint medium.

Notes

1. "He broke off from objectivity to which painting was compelled, thus deliberately breaking with six centuries of western tradition. He claimed the right to complete subjectivity, only keeping Nature's necessary material to imprint thought and sensibility" (Réné Huyghe, *Gauguin* [New York: Crown Publishers, 1959], p. 7).

"[Vincent Van Gogh and] Paul Gauguin were spectacular climaxes in the romantic tradition. . . . Their painting led in turn to the romantic art of the twentieth century, which was expressionism and its variants. Expressionism in painting is the free distortion

of form and color for the expression of inner sensations or emotions" (John Canaday, *Mainstreams in Modern Art* [New York: Holt, Rinehart and Winston, Inc., 1959], p. 360).

2. Bernard Myers, *Modern Art in the Making* (New York: McGraw-Hill, 1959), pp. 253–54.

3. Herschel B. Chipp, *Theories of Modern Art* (Berkeley: University of California Press, 1968), p. 60 (from a letter to Emile Bernard, Arles, November, 1888.)

4. F. B. Blanshard, *Retreat from Likeness in the Theory of Painting* (New York: Columbia University Press, 1949), p. 97.

5. Chipp, p. 65.

6. Ibid.

7. Charles E. Gauss, *The Aesthetic Theories of French Artists* (Baltimore: Johns Hopkins Press, 1966), p. 55.

8. *Gauguin and the Pont-Aven Group: Catalogue of an Exhibition at the Tate Gallery* (London: Arts Council of Great Britain, 1966), p. 9.

9. Paul Gauguin, *Paul Gauguin: Letters to His Wife and Friends*, ed. Maurice Malingue (London: Saturn Press, 1948), p. 100.

10. Gauss, p. 56.

11. "His [Gauguin] powerful, harsh pictures impressed them [symbolists] particularly by the boldness of conception, the naked brutality of form, the radical simplification of drawing, the brilliance of the pure bright colors used to express states of mind rather than reality, by the ornamental character of his composition and the willful flatness of planes" (John Rewald, *History of Impressionism* [New York: Simon & Schuster, 1946], pp. 423–24. From an article by E. Tardieu in *Echo de Paris*, May 13, 1895).

" 'Dans l'un c'est la forme qui est expressive, dans l'autre c'est la nature qui veut l'être.' . . . [Synthetists] aimed at elucidating the meaning of nature, and at expressing their idea of it with the aid of purely artistic means, without expressing this idea in an explicitly figurative way by means of allegory and the like. And for this purpose they sought for the expressive power implied in particular lines and colours" (H. R. Rookmaaker, *Synthetist Art Theories*, p. 116. From Maurice Denis, *Théories, 1890–1910* [Paris: L. Rouart et J. Watelin, 1920], p. 10).

12. See Emile Bernard, *Souvenirs inédits* (Paris: Nouvelliste du Morbihan, 1941).

13. Denis, p. 264 (quoting Albert Aurier).

14. See Albert Aurier, "Symbolisme en peinture, Paul Gauguin," *Mercure de France* (1891):162.

15. "Il se peut qu'on reproche [Aurier] aujourd'hui à ces formules quelque excès de verbalisme. . . . Leur tort est d'être trop générales. . . . Si en effet sont synthétiques toutes les oeuvres d'art ou les formes, les signes de l'idée sont écrites selon un mode de compréhension générale, il n'y a guère et il n'y a jamais eu que, bonnes ou mauvaises, des oeuvres d'art synthétiques. . . . La définition d'Albert Aurier vise tous les genres et toutes les techniques d'art" (Charles Morice, *Paul Gauguin* [Paris: H. Floury, 1920], p. 178).

16. Charles Morice, "Quelques opinions sur Paul Gauguin," *Mercure de France* (1903):420–22 (quoting Antoine de la Rochefoucauld).

17. Paul Gauguin, *Cahier pour Aline* (Paris: Société des Amis de la Bibliothèque d'Art et d'Archéologie de l'Université de Paris, 1963) (quoting Octave Mirbeau).

18. John Rewald, *Post-Impressionism* (New York: Museum of Modern Art, 1956), p. 467.

19. Canaday, p. 385.

20. Herbert Read, "Gauguin: Return to Symbolism," *Art News Annual* 25 (1956):158.

21. Lionello Venturi, "The Early Style of Cézanne and the Post-Impressionists," *Parnassus* 9 (1937):16.

22. For example: "Gauguin vit dans ces images que l'oeuvre picturale n'était pas la représentation du réel mais une manière intellectuelle de la concevoir et de la traduire: il

y découvrit la suggestion d'un art abstrait . . . Gauguin retrouve la formule d'un art plus décoratif que sincèrement représentatif. . . . Il chercha le style" (Y. Thirion, "L'influence de l'estampe japonaise dans l'oeuvre de Gauguin," in G. Wildenstein, *Gauguin: sa vie, son oeuvre* [Paris: Gazette des Beaux-Arts, 1948], p. 114.

"Gauguin anticipates much that is basic to modern painting; its predominant anti-naturalism, its increasing reliance on the means of pure painting, its willingness to allow the work under the hand of the artist" (T. B. Hess, "Gauguin, The Hidden Tradition," *Art News* 65 [1966]: 26–28, quoting Robert Goldwater).

"Gauguin was less interested in nature or inanimate objects than in the human figure whose mystery and plastic dignity he rediscovered, not indeed in its anatomical structure, but a rhythm and arabesque. . . . For him invention counted less than decorative arrangement and rhythm" (Jean Leymarie, *Paul Gauguin: Water-colours, Pastels and Drawings in Colour* [London: Faber & Faber, 1961], pp. 11, 15).

"He avoided the direct imitation of nature and searched for purity in color, for strength and rhythm in line, and for simplified form. . . . With extraordinary courage he renounced all the time-honored conventions of Western art. . . . He concentrated on making the picture's surface both decorative and expressive, the problem that obsessed the artists of the twentieth century. By insisting that color and line alone, regardless of their representational values, can make a powerful emotional impact, Gauguin cleared the way for abstract art and theory" (Charles Sterling and Margaretta Salinger, *French Painting* [New York: Metropolitan Museum of Art, 1967], 3:170).

23. Charles Estienne, *Gauguin: Biographical and Critical Studies* (Genève: Skira, 1953), p. 16.

24. G. San Lazzarro, *Painting in France, 1995–1949* (New York: Philosophical Library, 1959), p. 33 (quoting from *Noa Noa*).

25. Rewald, *Post-Impressionism*, p. 347 (quoting Vincent Van Gogh).

26. "L'art n'est plus une sensation seulement visuelle que nous receuillons, une photographie, si reffinée soit-elle, de la nature. Non, c'est une création de notre esprit dont la nature n'est que l'occasion. . . . L'imagination redevient ainsi, selon le voeu de Baudelaire, la reine des facultés . . . et l'art, au lieu d'être la copie, devenait la déformation subjective de la nature" (Denis, pp. 267–68; refer also to chapter 2, p. 20).

27. "Un tableau avant d'être une représentation de quoi que ce soit, c'est une surface plane recouverte de couleurs en un certain ordre assemblées, et pour le plaisir des yeux" (Denis, p. 26). Actually this particular statement only indicates the influence of the medium on the depiction of perceptions. It has been misinterpreted as a justification for expressionism because it was convenient to misread it that way.

28. Sven Lövgren, p. 124. It is interesting to note that Aurier's ideas were not entirely new, but that similar ideas had been expressed by Fenéon in his articles on neo-impressionism and synthetism.

29. For pictures of Breton art that influenced Gauguin, and particularly the Crucifix mentioned, refer to Charles Chassé, *Gauguin et son temps* (Paris: Bibliothèque des Arts, 1955).

30. Chipp, p. 103 (fron Denis, "The Influence of Paul Gauguin," in *Théories*).

31. In her definition of art as an "emotive symbol," Susanne Langer makes a distinction between an "Art Symbol" and the usual concept of the "symbol in art." The former is the expressive form of the work of art, "a visible, individual form produced by interaction of colours, lines, surfaces, lights and shadows, or whatever entered into a specific work" (Susanne Langer, *Problems of Art* [New York: Scribner, 1957], p. 128). It has what she calls "artistic import": "In an articulate symbol the symbolic import permeates the whole structure, because every articulation of that structure is an articulation of the idea it conveys: the meaning . . . is the content of the symbolic form, given with it, as it were, to perception" (Susanne Langer, *Feeling and Form: A Theory of Art* [New York:

Scribner, 1953], p. 52). The work of art, or the "Art Symbol," becomes the image of an integrated reality; and its elements are not independent constituents, each individually expressive (like symbolism in the usual sense of communicating by the use of conventional, definable linguistic symbols). The nature of the "Art Symbol" illustrates why representational art can be so variable in appearance (as with naturalism and postimpressionism): "A work of art is a single, indivisible symbol. . . . It is not, like a discourse . . . composite, analysable into more elementary symbols. . . . It can never be constructed by a process of synthesis of elements because no elements exist outside it. They only occur in a total form" (ibid., p. 369).

32. Also see R. G. Collingwood, *The Principles of Art* (Oxford: Clarendon Press, 1938).

33. Rewald, p. 206.

34. Gauguin, *Paul Gauguin: Letters to His Wife and Friends*, p. 100.

35. "I have this year sacrificed everything—execution, color—for style. . . . I have done the self-portrait which Vincent asked for. . . . [which is] absolutely incomprehensible . . . it is so abstract. Head of a bandit in the foreground, a Jean Valjean *(Les Misérables)* personifying also a disreputable impressionist painter. . . . The design is absolutely special, a complete abstraction. The eyes, mouth, and nose are like the flowers of a Persian carpet, thus personifying the symbolic aspect. The color is far from nature. . . . The impressionist is pure, still unsullied by the putrid kiss of the Ecole des Beaux Arts" (Chipp, p. 67; from a letter to Emile Schuffenecker, Quimperlé, 1888).

36. Paul Gauguin, *Lettrès de Paul Gauguin à George Daniel de Monfried* (Paris: G. Crès, 1918), p. 332.

"Gauguin was really after at Tahiti . . . to go beyond the rind to the sap within, to the harmonic, primitive source of art and being. He had toyed with the word 'symbol' but Parisian 'symbolism' . . . had not been of the slightest use to him in his search for 'nature's inmost force.' . . . He wrote to Maurice Denis in 1889: 'My Papuan art would lose its meaning beside the symbolists and idéistes' " (Estienne, p. 60).

"Avide de domination, il accepta l'encens des littérateurs symbolistes. 'Va pour le symbolisme,' avait-il dit. Quand on voulut affecter d'une étiquette sa conception picturale et qu'on fit de Gauguin le maître du 'synthétisme,' il accepta avec hauteur cette platonique magistrature et pensa: 'Va pour le synthétisme!' Au fond il ne prit jamais au sérieux ces titres et ces coteries. On a, de sa main, les témoignages qu'il en faisait peu de cas" (Robert Rey, *La Renaissance du sentiment classique dans la peinture français à la fin du XIX siècle* [Paris: Les Beaux-Arts, édition d'études et de documents, 1931], p. 68).

" 'Si vous saviez,' m'écri M. de Monfreid, 'combien Gauguin se . . . foutait de toutes ces théories, même en 1888 ou 1889! . . . et même le fameux 'synthétisme' le faisait . . . hausser les épaules et sourire avec ironie. . . . Du reste voyez dans ses 'lettres' ce qu'il en dit. Si j'insiste là-dessus, c'est qu'à cette époque-là, précisément, il y a eu parmi les jeunes littérateurs un mouvement assez retentissant: le symbolisme. Gauguin, qui fréquentait ce milieu littéraire, avait eu la faiblesse de se laisser un peu encenser par quelques-uns de ces écrivains qui le proclamaient le chef des symbolistes en peinture. Mais au fond, il considérait ce vocable et toutes les théories qui en dérivaient comme des jeux d'enfant. Il souriait avec un petit air fort approbatif quand Verlaine, au café Voltaire . . . répétait en clignotant de ses yeux malins 'Hé! Zut!' Ils m'embêtent, les 'cimbalistes [*sic*], etc." (Charles Chassé, *Gauguin et le groupe de Pont-Aven* [Paris: H. Floury, 1921], p. 25).

"Dans son ingénuité, Gauguin avouera une aversion sans cesse grandissante pour les théories picturales et les doctrines littéraires (on constate d'ailleurs que durant toute sa vie, Gauguin manifesta un goût très vif pour la littérature. A partir de 1888, il proposa des articles à Albert Aurier. . . . Il n'aimait pas les journalistes mais désira sans cesse s'exprimer dans les journaux . . .) mais dès la naissance de la synthèse, en août 1888, alors qu'il abandonnera brusquement la simple représentation de l'objet et du paysage. Il élabora, malgré ses dénégations, toute sa peinture sur cette donnée: qu'une oeuvre d'art

doit avoir une double naissance, dans l'esprit et une dans la matière" (Maurice Malingue, *Gauguin, le peintre et son oeuvre* [Paris: Presses de la Cité, 1948], p. 51).

37. Robert Goldwater, *Primitivism in Modern Art* (New York: Vintage Books, 1967), p. 74 (discussing *Poèmes barbares*, 1896).

38. E. H. Gombrich, *The Story of Art* (Greenwich, Conn.: Phaidon, 1966), p. 417.

39. Henri Perruchot, *La Révolte de 1870* (Paris: Macléval, 1951), pp. 59–60.

40. Paul Gauguin, *Noa Noa* (Oxford: B. Cassirer, 1961), p. 30.

41. Rewald, *Post-Impressionism*, pp. 493–97.

42. Chipp, pp. 75–76.

43. Rookmaaker, p. 230.

44. Gauguin, *Noa Noa*, p. 49.

45. See E. H. Gombrich, *Art and Illusion* (New York: Phaidon, 1968).

46. Chipp, p. 60 (from a letter to Emile Bernard, Arles, November, 1888).

47. Goldwater, p. 66.

48. Paul Gauguin, *Carnet de croquis* (New York: Hammer Galleries, 1962), p. 63.

49. Rewald, *Post-Impressionism*, p. 189.

50. *Gauguin and the Pont-Aven Group: Catalogue of an Exhibition at the Tate Gallery*, p. 10.

51. Ibid., p. 11. See also Rewald, *Post-Impressionism*, p. 305, for photographs of the yellow wooden Christ in the chapel of Trémalo near Pont-Aven and the moss-covered stone Pietà from the Calvary of Brasparts, Brittany.

52. Bernard Dorival, *Les Etapes de la peinture française contemporaine* (Paris: Gallimard, 1943–48), p. 88.

53. Rewald, *Post-Impressionism*, pp. 308–9.

54. Linda Nochlin, *Impressionism and Post-Impressionism, 1874–1904: Sources and Documents* (Englewood Cliffs, N. J.: Prentice-Hall, Inc., 1966), pp. 168–69. Compare: "A young Tahitian girl is lying on her stomach, showing part of her frightened face. . . . Captured by a form, a movement, I paint them with no other preoccupation than to execute a nude figure. . . . I wish to . . . imbue it with the spirit of the native, its character and tradition. . . . The *tupapau* (Spirit of the Dead) is clearly indicated. For the natives it is a constant dread . . . the literary part: the spirit of a living person [is] linked to the spirit of the dead. . . . This genesis is written for those who must always know the why and the wherefore. Otherwise it is simply a study of an Oceanian nude" (Chipp, pp. 67–69 [from *Cahier pour Aline*, Tahiti, 1893]).

4
Vincent Van Gogh:
Mysticism, Madness, and Misrepresentation

> Ordinary people have almost no idea of what things really look
> like so that, oddly enough, the one standard that popular criti-
> cism applies to painting, namely whether it is like nature or
> not, is one which most people are by the whole tenour of their
> lives prevented from applying properly.[1]

These words of critic Roger Fry reveal one of the most significant and
controversial problems in art criticism today when confronting repre-
sentational art. In regard to the art of Vincent Van Gogh, critics with a
prefixed notion of realism in art succumb to the fallacy of judging art by
its ability to approximate a standard experience of nature. They errone-
ously assume that art can literally duplicate a visual experience; and
when faced with an artist such as Van Gogh, they become convinced of
his untruth to reality and proclaim him an expressionist. As evidence,
they cite his distorted perspective, his flattening of space through the
influence of Japanese prints, his exaggerated and intensified use of color,
his recurrent themes and symbols, and the violent emotional tempera-
ment that pervades his work, among other qualities found in his art.
Some historians of postimpressionism feel that the invention of the cam-
era with the resultant mechanically exact image freed artists from the
responsibility of recording visual reality. They could, as a result, convey
a more expressive and emotional message in their art. Those who follow
this theory often assume that this new interest in emotional expression
necessarily involves a turning away from or conscious distortion of real-
ity.

Proponents of the "expressionist" interpretation tend to overem-
phasize the artist's personal problems and emotional states by projecting
so much of his biography into his paintings from nature that they be-
come mere surrogates for his psychological imbalance, such as the

56

Sunflowers of 1887, "his favorite flowers perhaps, because like him, they always turn toward the sun."² Similarly, as Kenneth Clark maintains,

> Van Gogh was forced more and more to twist what he saw into an expression of his own despair. . . . Expressionist art is essentially tragic . . . [and] involves a dangerous tension of the spirit. . . . The frenzied writings of Van Gogh are further out of control than anything in El Greco, and are in fact painfully similar to the paintings of actual madmen. . . . The assault they make on our feelings is so violent that people who are not normally moved recognize that something unusual is going on.³

One critic, Lionello Venturi, sees Van Gogh as a supposed realist who was overtaken by self-expression:

> Rocks . . . and olive trees are the natural motifs most suited to express Van Gogh's tragic passion. . . . There is no better mirror of Van Gogh's spirit: he feels his own drama projected not only in the trees, but also in the earth. Everything throbs in an invocation to life, in a struggle against evil. . . . Van Gogh does not paint rocks, but his own torment, which he projects into a legendary upheaval of gigantic rocks as though he were witnessing the chaos that preceded the creation of the world.⁴

This type of criticism often succumbs to melodramatic phraseology:

> Van Gogh seemed hardly to paint his pictures, but rather to breathe them onto the canvas, panting and gasping. . . . It is gruesome to see him paint—a kind of orgy, in which the colours were splashed about like blood. He did not paint with hands, but with naked senses. . . . He became one with the Nature he created, and painted himself in the flaming clouds, wherein a thousand suns threaten the earth with destruction, in the startled trees that seem to cry aloud to Heaven, in the awful immensity of his plains. . . . His was animal art. . . . It is the cry of the human animal . . . who yearns to penetrate into his environment, into Nature, and destroys this or himself if he does not succeed. Van Gogh did not produce his art; it was as much a part of himself as is some material function a part of the body.⁵

> Cet homme fut un fou; c'est vite dit! Toute la peinture explose, picrate, fulgure, flambe par son oeuvre. Partout il ne voit que flammes et incendie. C'est de la peinture d'Enfer, creusée, ravinée par les furieux coups de ringard d'un peintre "epilepsié" par le génie.⁶

Further examples of the expressionist fallacy are particularly evident in descriptions of Van Gogh's *Starry Night* of 1889: "His *Starry Night* . . . is a deliberate attempt to represent a vision of incredible urgency, to liberate himself from overpowering emotions rather than to study lovingly the peaceful aspects of nature around him."⁷ Here John Rewald main-

tains that Van Gogh chose subjects that could release specific emotions or associations in him, which could then be expressed in paint. Similarly, Alfred Barr, Jr. states:

> It was in the Saint Rémy pictures with their flamboyant cypresses, twisted olive trees and heaving mountains that Van Gogh was finally able to free his art from the objective realistic vision of the impressionists. The surging lines not only bind the composition into active rhythmic unity, they express magnificently the vehemence and passion of Van Gogh's spirit. . . . The *Starry Night* goes further: it is fundamentally an imaginative invention. The cypress and the distant hills, it is true, occur in other Saint Rémy pictures. But the village with its northern church . . . seems remote from Provence. And the sky, the dazzling moon, the Milky Way turned to meteors, the stars like bursting bombshells—this is the unique and overwhelming vision of a mystic, a man in ecstatic communion with heavenly powers.[8]

The idea that Van Gogh's art is the product of a madman is not uncommon in the criticism of his art:

> His pictures display an entire lack of order. . . . His work is plainly the labour of the fanatic who, in a fury of pent-up desire to express himself, suddenly seizes a palette and brush and applies colours at random. Van Gogh . . . was an illustrator of the abstract gropings of an unbalanced mind avid for dramatic emotions, rather than of exterior nature. In [landscapes] there are frenzied lines running zigzag and at random, and rolling clouds of purple and lurid yellow hanging over raucously bright roofs. His portraits . . . are too hollow and immaterial to appear even as a depiction of form. His colours carried out this feeling of dramatic terror, and because they were not harmonized with either line or tone, they became all the more chaotic.[9]

> Nous passons à présent à la période de la psychose manifeste; un nouvel élément à pénétrer dans l'oeuvre de Van Gogh. C'est la ligne serpentueuse qui se répète toujours à nouveau, qui envahit tout. . . . *La Route aux Cyprès* fait ressortir un monde de vision particulier que nous retrouverons par la suite chez les adultes et les enfants du type épileptoïde et sensoriel, et qui s'exprime aussi bien dans le langage à l'occasion du test de Rorschach que dans le dessin.[10]

> An obsessed and doomed individual in life, an expressionist in art. No wonder when Freud's disciples examined art that they found Van Gogh's a perfect illustration of their darkest theories, of art as a funnel for personal distress, of graphic representation serving as a discharge for psychic disorder. Nor did the nonpathological enemies of modern art fail to link the man's insanity with the distorted look of his, and so much other post-impressionist painting.[11]

> The surface of the picture is as revealing of his [Van Gogh's] neuroses

when held upside down as a psychiatrist's chart—a high-pitched rhythm results curiously from his intensity of statement, saturation of color, and pressure of line. . . . His destiny was to become the inspiration for the fauves and those German painters to whom he is psychologically related, and for whom harsh exaggeration of statement is synonymous with esthetic feeling.[12]

From the above expressionistic interpretations, it is assumed that an artist, in order to "express" himself, must discard the interest in conventional representation in order to reveal the emotional intensity of his inner being. Critics, with a tireless redundancy, maintain that Van Gogh did not care much for what he called "stereoscopic reality," that is to say, the photographically exact picture of nature. He would exaggerate and even change the appearance of things if this suited him in order to express himself. If distortion helped him to achieve this aim, then he would use distortion.

Such critics are unable to accept Van Gogh's style as an alternative depiction of nature because they uphold naturalism as the norm of representation. Therefore, a particular interest in the intrinsic quality of lines and dabs of paint becomes a sign of expressionistic distortion.[13] Of course Van Gogh liked the technique of painting in dots and strokes; but under his hand, it became something rather different from what the impressionists had meant it to be. Nevertheless, the critics of this viewpoint maintain that Van Gogh used individual brushstrokes not only to break up color but also to convey his own excitement. These brushstrokes tell us something of his state of mind, and thus he would choose scenes and motifs which specifically give this new means full scope.

Although he may have been the first painter to discover the beauty of stubbles, hedgerows, and cornfields, of the gnarled branches of olive trees and the dark, flamelike shapes of the cypress, in such criticism it is assumed that Van Gogh utilized nature only as a pretext for emotional expression as conveyed in line and color. They did not serve him as a means of expressing a visual experience but enabled him to exteriorize his emotions. It is thought that his influence on twentieth-century expressionism derives from the spiritual significance he attributed to color, while every one of Van Gogh's brushstrokes is said to carry the imprint of his personal handwriting—so vital, so full of his own joys and sorrows.

Often, this type of criticism becomes negative; and the word "distortion" becomes a derogatory evaluation:

Van Gogh's bizarre power . . . [produced] pure lyrical expressions hacked out with broad strokes of a brush charged with pure color. The line writhed across the canvas, giving a vivid sense of motion and direction but a weak and approximate notion of forms which in the haste and fury of the creative act were often violently distorted. Alongside the ugly constructional streaks, the

canvas was left bare, the whole thing looked harrowed in the pigment, rather than painted. . . . Nothing could be farther from the discretion of the time-of-day school. We have to do with a new symbolism for frenzy in abstract splendours of color and denatured forms. . . . As we have to do with a diseased brain in Van Gogh, we probably have also with a diseased retina. What the critic calls creative distortion may have been something near his actual vision of the world, but of this we are not certain.[14]

As these citations have shown, the examples of this point of view are numerous. It is apparent that many critics base their ideas upon statements actually made by the artist, twisted and misinterpreted to support their theories. The following excerpts are typical: "What Pissarro says is true; we should exaggerate the effects which colours produce by their harmonies or dissonances . . . the study of colour. I am always hoping to find something in that. . . . I should like to paint men or women with an indefinable external something about them; the halo used to be the symbol of what I mean, and now we seek it in radiance itself, in the vibrancy of our colouring."[15] "In my picture of the *Night Café*, I have tried to express the idea that the cafe is a place where one can ruin oneself, run mad, or commit a crime."[16] "Je cherche maintenant à exagérer l'essentiel, à laisser dans le vague exprès le banal. 'Au lieu de chercher à rendre exactement ce que j'ai devant les yeux, je me sers de la couleur plus arbitrairement pour m'exprimer fortement.'"[17] Most critics presuppose that Van Gogh was conscious of his transformation of reality into an expressive distortion. Rather than recognize in Van Gogh a vision of a reality more profound, more poetic, more full of character than scientific naturalism could render, one critic goes on to proclaim, "The realist is transformed into a visionary; from his hallucinations he recreates the universe and colors it from the image he makes of it. . . . Actual forms are abolished and replaced by spatial forms which turn and writhe like flames, surge and leap like balls of fire. This frenzy is expressed in thick brushstrokes continually broken up into commas, spots, dots, dashes."[18]

Allied with the previous notion that Van Gogh's art is self-expressive and a distorted vision of reality in the interest of catharsis is the idea that his art abounds in intentional symbols of his personal emotional and psychotic temperament. In essence, his art has been described as symbolic in several senses. The most typical view rests on the assumption that when an artist is concerned with emotional expression rather than the representation of reality, his art is "symbolic."[19]

In still a different usage of symbolic, Albert Aurier considers Van Gogh as a symbolist in that, like Gauguin, he is really expressing an "Idea" rather than representing external reality: "Van Gogh . . . is almost always a symbolist . . . who feels the continual need to clothe his ideas in precise, ponderable, tangible forms, in intensely sensual and

material envelopes. . . . An Idea . . . the essential substratum of the work, is, at the same time, its efficient and final cause. . . . Color and line are merely simple, expressive means, simple methods of symbolization."[20]

Other later critics echo this viewpoint, singling out, in particular, Van Gogh's "symbolic" use of line and color. They maintain that he was trying to give a new meaning to color, using it as a derivative of his moods. Thus, Van Gogh treats figures, landscapes, and interiors quite differently according to his physical or mental state at the time of the painting. He sees yellow as signifying love or friendship, and, as he once remarked, "with red and green I have tried to depict those terrible things, men's passions." In this way, he was always seeking for strongly affective tones corresponding to his emotions. In his search for "psychological color," Van Gogh's conception of painting was essentially a sort of color symbolism, not without analogies to Christian symbolism. "Color in itself expresses something," Van Gogh had said. Thus to express his emotions, he did not depend on the subject only, but also on the feeling and form assumed by the color. In this respect he ranks as a pioneer of expressionism.[21]

Critics vary as to the nature of Van Gogh's symbolism of line and color, some preferring a more Freudian interpretation. "Cet isolement dont le peintre hollandais a tant souffert . . . se traduit dans son oeuvre par un exaltation intense de la couleur et de la ligne. . . . Pour le psychanalyste, le jaune, que les soleils et les tournesols ont fourni à Van Gogh, symbolise sa libido. . . . Il anthropomorphise la nature, il érotise l'univers."[22] It seems to be a popularized opinion that the symbolic content of Van Gogh's works is a reflection of a psychological, emotional condition. No other painter is so perfect an example of the romantic artist beyond control, who is seized by inspiration and pours it out in frenzied activity. In the words of Henri Focillon, "il était assiégé par un songe qui ne lui venait pas d'une impression fugitive, mais des sourdes exigences de son âme."[23] Similarly, John Rewald states:

> "A work of art is a bit of nature seen through the eyes of a temperament." This celebrated definition of Zola's, inspired by the canvases of Manet, might have been devised expressly for the paintings of Van Gogh. . . . Van Gogh was primarily swayed by temperament. If he loved nature passionately, he was never subject to her. On the contrary he availed himself of her shapes and colors only for the purpose of transforming them along the lines of his turbulent temperament and according to an inspiration often tinged with symbolism.[24]

In addition, some critics view Van Gogh's art as an aesthetic transformation of the "absolute" that they claim he seeks. Stars, sun, sky,

sunflowers, cypresses, curving lines, etc., become symbols of his search. It is as if a painting were strictly a psychological or spiritual release rather than a product of an interest in nature and the associations the artist may derive from it. For example:

> Il constate une certaine identité entre le tournesol et le cyprès. "Les cyprès me préoccupent toujours, je voudrais en faire une chose comme les toiles des tournesols, parce que cela m'étonne qu'on ne les ait pas encore faits comme je les vois." Il définit ainsi leur rapport: "Lorsque j'ai fait ces tournesols, je cherchais le contraire et pourtant l'équivalent et je disais: c'est le cyprès." . . . Van Gogh vise toujours l'absolu, c'est pourquoi il voit une identité entre ces deux symboles, mais l'un est la lumière, l'autre l'obscurité, l'un se dresse vers le soleil, l'autre vers les étoiles. Le soleil était le symbole de l'absolu saisi dans la vie, les étoiles deviennent le symbole de l'absolu atteint par la mort.[25]

To such critics, Van Gogh painted reality only as a means to one end, as it is assumed that the artist felt the "absolute" was present in reality, in the essence or "l'essentiel" behind it rather than its surface appearances. This is reflective of the dualistic philosophy common to his critics.

H. Graetz presents perhaps the most exaggerated explanation of Van Gogh's art along the lines presented above, evaluating it solely in terms of its psychological and symbolic content. He believes that landscapes, still lifes, compositions—like handwriting—can convey the inner condition of a human being. He particularly likes to associate Vincent's mental condition with symbolism of various individual objects that supposedly express his inner situation—his impulses, urges, yearnings, frustrations, etc. "The bent and cut trees, broken branches and stumps in his art . . . impart his feeling of masculine inferiority and frustrated love [*Blossoming Pear Tree*]. . . . Their symbolic portrayal gives his art its particular capacity to communicate between his life and ours."[26] A volume of examples is provided ranging from lamps, candles, the sun, moon, and stars as symbols of the "light of the world" and Vincent's love, to the trees which symbolize his struggle for life, to the pairs of sunflowers and shoes and other objects denoting negative feelings toward his brother, Theo, and to the still-life objects symbolizing the ever-present awareness of maleness and femaleness in the world.

Individual symbols such as the sower take on particular significance as the image of humanity and the symbol of creation (including artistic creation) in that Vincent once wrote: "Painting is sometimes sowing, though the painter may not reap."[27] Graetz also likes to single out particular themes such as the contrast of opposing forces of dark and light or positive and negative which he raises to the cosmic level by comparing any contrasts in Vincent's work to the oriental symbols Yin and Yang, symbols of the urge to unite.

In any case, Graetz's symbols are always interpreted as indications of the artist's inner turmoil. The spiral symbol is seen as the representation of Van Gogh's spiritual force and fight against disintegration. His self-portraits are symbols of his struggle against physical frustration. His yearning for companionship is seen in his continuous doubling or pairing of objects. His preoccupation with female sexual and male phallic symbolism is constantly emphasized as are the sunflowers and cypresses which are indicative of his struggle for love and friendship and his search for the infinite.[28] Soon every element of Van Gogh's art becomes imbued with psychological meaning—the stars, the moon, the most ordinary object. His color, as well, is seen as part of the overall symbolic language of art. In short, his entire oeuvre is seen to be the medium for the portrayal of his life as a whole.

Though Graetz finds ample quotations by the artist to support his evidence, they never prove to be conclusive evidence for his theory. In fact, they often reveal his blatant misinterpretation of the artist's use of such a word as *symbol*. For example, Graetz cites the following quotation from Van Gogh, apparently disregarding its obvious meaning, which directly contradicts his thesis: "I believe that one thinks more soundly if the thoughts arise from direct contact with things than if one looks at things with the aim of finding this or that in them."[29] Another proponent of the idea that Van Gogh is basically a symbolist, Sven Lövgren, accounts for the lack of symbolic references in Van Gogh's letters by assuming an aversion on the part of the artist to discussing the symbolic content of his works. Lövgren's alternative is to try to justify his theory by reading symbolic overtones into Vincent's letters, as Graetz does. Both approaches are equally false and misleading. Nevertheless, the temptation to distort and exaggerate is irrepressible:

> To express the love of two lovers by the marriage of two complementaries, their blending and their oppositions, the mysterious vibrations of kindred tones. To express the thought of a brow by the radiance of a light tone on a somber background. To express hope by some star, the ardor of a being by the radiance of a setting sun. Certainly there is nothing in that of delusive optical realism, but is it not something that really exists?[30]

It is not difficult to see how Graetz's unbridled imagination arrives at the unifying symbol of Yin and Yang to "express the love of two lovers by the marriage of two complementaries" or the symbolic meaning of stars in Van Gogh's paintings. However, Van Gogh himself shows no consciousness of the use of these ideas as symbols in the literal sense. When he speaks of "expression," it is not a reference to symbolism. When he speaks of "delusive optical realism," he is merely shunning naturalism. There is no reason to suppose that this necessarily means his only alternative is symbolism.

Some critics like to emphasize Van Gogh's sexual relationship with nature, alluding to a "love affair with Dame Nature" mentioned in a letter written by Van Gogh to Van Rappard, which he intended in a metaphorical way rather than the Freudian interpretation popular in modern criticism: "Rappard, this academy is a mistress who prevents a more serious, a warmer, a more fruitful love from awakening in you. Let this mistress go and fall desperately in love with . . . Dame Nature of Reality. I fell in love the same way . . . though she is still resisting me cruelly."[31]

Here Van Gogh means to tell Rappard to tear himself away from the academic approach to painting and look instead toward nature. The "fruitful love" is the richness of possibilities nature allows the creative artist: "resisting me cruelly" is the fact that nature is illusive and ever-changing. There is no indication of a sexual denial implied or any other kind of overt female symbolism. Van Gogh states clearly that he meant the quotation in a purely artistic sense in a portion conveniently left out by the critics: "But I told you, old fellow, this is only meant in a purely artistic sense—and so I compare the first kind of mistress, those who scorch, to that school in art which lapses into vulgarity, and I compare the other kind of mistress (the *collets montés*) those who freeze and petrify, to the academic reality, or . . . if you want me to coat the pill, to the unacademic reality."[32]

Other critics prefer to emphasize the religious connotations of such paintings as the *Starry Night*, which is said to be infused with "astronomical symbols of the infinity and divine love . . . the object of man's eternal longing."[33] Meyer Schapiro believes the painting to have been stimulated by the apocalyptic theme in the twelfth chapter of the Book of Revelation.[34] Though Van Gogh may have been preoccupied with universal themes and eternal questions about life, death, religion, science, etc., as witnessed by his letters on these subjects, it cannot be inferred that any given painting is making a specific reference to the Bible or any other religious source. It is assuming too much on the part of the artist that he intended a still life of 1885 to be "a new variant of the individual-symbolic theme, the sufferings and glorification of the servants of the Lord as expressed in the still life . . . Joseph's dream of glory (Genesis 37: 9–11) is a motif that suits Vincent Van Gogh's situation at Saint Rémy in June, 1889."[35] His letters indicate that he had no desire to represent religious subjects in the way Emile Bernard did. Just as the *Starry Night* has been abused by too many interpretations, so it is with the art of Van Gogh as a whole. The "symbolic" critics seem to believe that the value of his art lies in his highly developed religious or Freudian symbolism, rather than in the impassioned portrayal of scenes from his environment.

The foregoing sampling presents some of the problematical interpre-

tive categories surrounding the art of Vincent Van Gogh. The predominance of criticism on Van Gogh emphasizing the expression of personality and correlative emotional states leads one to believe that there is a strong adherence to the kind of outmoded aesthetic theory that promulgates the view that the greatest artist is he who records a personal response to some event or object. As Eugène Véron states, "A work is beautiful when it bears strong marks of the individuality of its author, of the permanent personality of the artist, and of the more or less accidental impression produced upon him by the sight of the object or event rendered. In a word, it is from the worth of the artist that [the worth of] his work is derived."[36] Véron is implying here that what is most important and valuable about a work of art is the distinctive personality that the work reveals, and that the aesthetic experience is essentially admiration for the artist. While many arguments may be presented against such a theory, it is sufficient to stress that it is highly speculative to attribute anything found in a work of art to the artist himself. Works of art are experienced in a variety of ways such that interpretations of an artist's personality would be at variance. If the theory were taken literally, we would have to attribute to an artist a whole range of contradictory and diverse traits of personality. Furthermore, if art is merely a revelation of personality, attention is not fixed upon the intrinsic qualities of the work and a misidentification occurs of the creator (or the creative process) and the resultant work of art. The work of art, in sum, is not an infallible clue to the personality or character of the artist.

While almost any kind of art is potentially expressive, it is not thereby self-expressive. The artist is, of course, a self, but seldom an autonomous one. In his interaction with the external world embodied in a work of art, the artist reveals a qualitative self that is praised as the artist's style. The expressive aspects of a work, then, are not to be construed as revelations of personality, congruent with the emotional constitution of an artist. There is frequently a lack of recognition of the distinction between emotion in the perceiver and the feeling or emotion that is allegedly the motive for the creation of a work. A valid argument in aesthetics questions the necessity of an artist to be in personal despair or upheaval when working on a tragedy, refuting the old theories of emotional expression that claim there is a close connection between artistic excellence and the genuine sincerity of the emotional expression, that is, whether or not the viewer is convinced that the artist truly experienced the emotions embodied in the work. (Véron believed that sincerity in art takes the place of truth: an artist of true feeling has but to abandon himself to his emotion and it will become contagious. The praise that he deserves will be awarded to him.) In some emotive theories, then, it is assumed that a good work of art duplicates the generative feelings of its author. However, it cannot be discerned whether a spectator's experi-

ence is congruent with that of the artist's, nor is there reason to think that the most rewarding aesthetic experience is that which is identical to the artist's. The spectator hardly expects to pattern his response according to the dictates of the artist.

Certainly much of Van Gogh's criticism and much of his popularity is predicated on such a misunderstanding of the nature of the aesthetic object and experience. The emotive outpourings of this ingenious madman take precedence in the critical eye over their formal embodiment, as if they are ends in themselves which need no further justification. As C. J. Ducasse maintains, the emotion does not simply discharge itself upon some objective medium, but the artist manipulates and shapes the medium in order to find embodiment for his emotions. The musical scale may be employed, or the body, as in the performing arts, but whatever the art form, the subordination of emotion to the demands and limitations of a medium is requisite. The work of art is more than an imprint of subjective effusion but transcends individual emotional expression. If emotions exist at all they are part and parcel of the sensory structure of the work itself. Emotion cannot be extricated as existing somehow separately.[37] The heavy, textured effects associated with Van Gogh are markedly different visually from the smooth color planes of Gauguin or the thin, transparent strokes of Cézanne. The expressiveness of a work of art rests on the laurels of formal eloquence and succeeds without reference to preexisting emotions in the artist. There is an obvious overemphasis on the subjective life of the artist in expression theories, as exemplified by the tendentious criticism of Vincent Van Gogh. An artist does not simply unburden himself of emotion by creating an object, but rather the qualitative dimension of a motif arises in the interaction of artist as subject with object in reality. Thus, by means of feelings, Van Gogh grasps the expressive qualities of the people or places he wishes to portray, intuiting the correlative emotive qualities of the colors and the composition. Aesthetic value is the product of the union of vision and design, form and content, feeling and quality, message and medium, whereby there is no artificial cleavage between what is expressed and how it is expressed. "The values expressed in a work of art even if originally drawn from real life, are transmuted in the act of artistic embodiment."[38]

Nevertheless, the emphasis on personality and emotional form has obscured the representational content of Van Gogh's art. Most critics erroneously equate his "distortion" of reality with a form of deliberate antinaturalism in the interest of personal cathartic release. They seem cavalierly to assume that his interest was not in representing his visual experience of nature, and that he used motifs from reality merely as a pretext for emotional expression. Although Van Gogh's art is certainly not naturalistic, it must be considered representational in that it is based

on and presents a direct visual response to nature. In fact, although the conventional usage of the term *realism* is not applicable to his art, Van Gogh is a realist in the sense that his art is rooted in visual impressions of everyday reality.[39]

From the first work to the last, his drawing is directed to the rendering of character and expression. His study of modeling is pursued with the vision of the realist who wants his work to give the effect of nature with a maximum of conviction. In a letter to Émile Bernard, from the last months of Van Gogh's life, there is a passage by the artist that seems to belie the interpretation that has been advanced by those who would see him a protagonist of pure expression.

> When Gauguin was at Arles, as you know, I let myself turn to abstraction . . . and at that time abstract painting seemed to me to offer a charming path. But it is a land of sorcery . . . and one quickly finds oneself standing before a wall. I do deny that, after a lifetime filled with research, with hand-to-hand battling with nature, one may take a chance at such things; but for my part I don't want to bother my head with them. . . . I am working at present among the olive trees. . . . I seek out the varying effects of a gray sky against a yellow earth, with a note of black-green on the foliage; another time, the earth and the foliage are streaked with violet against a yellow sky; then again the earth will be of red ochre and the sky of a greenish pink. And I tell you that that interests me more than the abstractions mentioned above.[40]

Despite the uniqueness of his personal vision and approach, Van Gogh's art is nevertheless an attempt to re-create his experience with real people and real locations as described in his numerous letters to his brother, family, and friends: "I won't say that I don't turn my back on nature ruthlessly in order to turn a study into a picture . . . but in the matter of form I am too afraid of departing from the possible and the true . . . I exaggerate, sometimes I make changes in a motif; but for all that, I do not invent the whole picture; on the contrary, I find it all ready in nature, only it must be disentangled."[41] Considering such a statement, it should not be inconceivable to the critics of Van Gogh that his roots were planted in the soil of Dutch realism.[42] He is known to have admired painters such as Rembrandt and Hals who shared the same concern for reality and expressive form. In response to the critics who value Van Gogh as the archetype and forerunner of modern expressionism, it must be pointed out that his art is deeply rooted in the past, in the European tradition of realism and representational art. It is this close bond between the artist and reality which distinguishes the postimpressionists from the expressionist painters of the twentieth century.

The innate taste for reality present in Van Gogh was so strong that in his early paintings he identified reality with conventional realism. During the Nuenen period, many of his works are "all darkness and gloom."

The *Potato Eaters* (1885) is perhaps the best example of his preference for contemporary realism of subject matter and style[43]: "I have tried to emphasize that those people, eating their potatoes in the lamplight, have dug the earth . . . so it speaks of manual labor and how they have honestly earned their food. . . . I get better results by painting them in their roughness than by giving them a conventional charm. . . . A peasant is more real in his fustian clothes in the fields. . . . If a peasant picture smells of bacon, smoke, potato steam—all right. . . . If the field has an odor of ripe corn or potatoes or of guano or manure—that's healthy."[44] Van Gogh felt that he had truly captured the reality of his subject, a reality that was familiar and meaningful to him. A work such as the *Potato Eaters* expresses a view of life and the world in which the humanistic motif of nature was given the main stress. Vincent considered living beings as tightly bound to nature. "That is why he objected to working from a dream. . . . He much rather started from thought which is much more bound to natural reality."[45] This perhaps best demonstrates the way in which the artist's visual experience of reality and the subjective feelings aroused by it are inseparable. It is also the reason why the artist's medium of expression and his particular style of rendering forms are clearly derived from his impression of the subject rather than from arbitrary distortions. Van Gogh's own concept of realism in art pervades this painting on every level: "Working and seeking and living with nature . . . there is nothing that gives me such a solid base for my theory as that saying which expresses Millet's color and technique so perfectly: 'Son paysan semble peint avec la terre même qu'il ensemence.' "[46]

After passing through an impressionist period in Paris, the art of Van Gogh underwent a metamorphosis in Arles, suggesting an awakening and a change in attitude toward nature: As he stated it, "I feel that what I learned in Paris is leaving me. . . . Instead of trying to reproduce exactly what I have before my eyes, I use color more arbitrarily so as to express myself vigorously."[47] This remark has been the basis of much error surrounding the criticism of the artist. The change in attitude toward nature is not so radical as many critics maintain. It was more of a return to previous ideas about reality after an unfulfilling impressionist phase than any substantial reversal of attitude. Since the time of his early paintings at Nuenen, Van Gogh had developed an extraordinary sense of color; but he never lost his ambition to depict what he believed to be the essential character of his subjects. It can be maintained that his art, like that of any major artist, is personal and expressive, yet, rather than being an expressionist, Van Gogh creates images of reality which unite artist and nature, mood and design. He was an artist who could identify himself with the tremors of nature, inevitably employing his imagination

in the service of its representation. The expressionist theorists have failed to see that an honest endeavor to represent may be combined with an unusually strong emotional reaction to one's perceptions, so that one's feelings become a permeating quality.

In view of these facts, the art of Van Gogh is not unique simply because it is expressive, as so many critics claim. In the light of the aesthetic theories of Langer, Arnheim, and others, it can be seen that all art must be considered expressive in some degree regardless of the artist's attitude toward the subject depicted. The idea of "self-expression" as a primary goal in art does not appear until the following generation of fauves and German expressionists. On the contrary, with Van Gogh, it is still easy to reconcile expressiveness in art with the artist's vision of reality. No art is more immediately personal than Van Gogh's. Everything he did turned into a self-portrait—landscape, still life, and figure—into which he injected himself, inventing a new handwriting of line and color to record his intense feelings for nature. What his eye revealed was instantly blended with what he felt about his subject. Increasingly, he tried to reduce the interval between vision and execution, fusing everything into a tense, expressive unity. This, perhaps, is true of all good artists and clarifies the paradox that Van Gogh's art is expressive, yet not radically expressionistic.

Van Gogh himself provides the best evidence to invalidate the expressionist fallacy (and particularly the controversy surrounding the *Starry Night*): "At present I absolutely want to paint a starry sky. It often seems to me that the night is still more richly colored than the day, having hues of the most intense violets, blues and greens. If only you pay attention to it you will see that certainly stars are citron-yellow, others have a pink glow or a green, blue and forget-me-not brilliance. . . . Putting little white dots on a blue-black surface is not enough."[48] This quotation demonstrates, first of all, that rather than being a product of violent self-expression, Van Gogh's art is, to a certain extent, calculated and controlled. Another example involves Van Gogh's description of a scene which he planned to paint (*Vue du Parc de la Maison de Santé*, 1889):

The edge of the park is planted with tall pine trees. . . . These two stand out against the evening sky, the yellow ground of which is streaked with violet stripes. . . . The first tree has a gigantic trunk which has been struck and split by lightning. . . . This gloomy giant—a vanquished hero—which one can regard as a living being is a strange contrast to the smile of a belated rose that is fading away on a rosebush opposite. . . . The sky produces yellow reflections—after a shower—in a pool of water. In a ray of sunshine—the last reflection—the deep yellow ochre is intensified to a glowing orange. Dark figures steal in and out between the tree trunks. You can well imagine that

this combination of red ochre, of green bedimmed with grey, and of black lines defining the forms, may help to call forth the feeling of fright which often seizes many of my fellow sufferers.[49]

The importance of these quotations cannot be overstated. They point out the fact that what many critics see as intentional distortions and exaggerations in the interest of purely personal expression is really representation firmly grounded in the artist's perception of nature, however colored by his imagination and emotions. (This is common enough with all artists and need not compromise a primary intention to represent, provided the emotions are conceived as inherent in the objects perceived.)

Van Gogh provides further evidence that the expressiveness conveyed by his subjects is not purely of a personal nature but is often an expression inherent in the subject: "There are vast fields of wheat under troubled skies, and I did not need to go out of my way to express sadness and extreme loneliness."[50] Or: "I rather like the *Entrance to a Quarry*. . . . The somber greens go well with the ochre tones; there is something sad in it which is healthy. . . . Perhaps this is true of *The Mountain* too. They will tell me that mountains are not like that and that there are black outlines of a finger's width. But after all it seemed to me it expressed . . . a desolate country of somber mountains."[51] Unlike the impressionists, Van Gogh felt there was more to nature than a transitional state of fleeting glance. Rather, his vision and his emotional response are so united that nature becomes inherently expressive, surging with underlying life. He not only saw a cornfield but felt the stalks swaying with the surrounding air, moving and swirling in rhythm. His experience of synaesthesia was as real and vibrant to him as his feeling of the vibrations of the sun's rays.

It is apparent that Vincent Van Gogh saw nature as inherently charged with diverse moods—from the anguish of a twisted cypress to the peaceful calm of *La Berceuse*.[52] As one critic aptly expresses it: "A high tensioned animism instantly distinguished his work from that of the impressionists. . . . For their lyricism of light and color he offered images charged with violence and love."[53] The fact that he was impelled to emphasize the feelings that were evoked in him by his subjects is not reason enough to label him as a doctrinaire expressionist, or is it evidence tht he was not interested in representing reality as it appeared to be. He was aware of and shunned naturalistic representation in the interest of a higher truth about the nature of reality; but in this, he resembles many leading artists before the advent of nineteenth-century naturalism.

Van Gogh was well aware of the deviations from naturalism present in his work. He was cognizant of the fact that descriptive accuracy and literalness alone do not constitute great art. Instead, he unconsciously

sought an expressive realism, balancing his visual impressions of reality with an irrepressible sensitivity to style, color, and composition:

> Accurate drawing, accurate color, is perhaps not the essential thing to aim at, because the reflection of reality in a mirror, if it could be caught, color and all, would not be a picture at all, no more than a photograph.[54]

> I should be desperate if my fingers were correct. . . . I do not want them to be academically correct. . . . If one photographs a digger, he certainly would not be digging them. . . . My great longing is to learn to make those changes in reality so that they may become, yes, lies if you like, but truer than the literal truth.[55]

> It is one's duty to express better, more accurately, more earnestly what one feels . . . and the less verboseness the better.[56]

These statements could apply equally well to many great artists such as Rembrandt, Botticelli, Géricault, Daumier, Millet, and others. Van Gogh had an abhorrence for the "stupid photographic perfection of some painting," but this does not mean that he rejected nature in favor of an antithetical personal expression for its own sake, as most critics incorrectly assume when reading his statements.

If Van Gogh's paintings express something beyond or beneath conventional visual reality, such as "inner life" or personal meaning, it is not because he intended them to convey purely subjective meaning. Rather, any meaning found in his art was, for him, as for most artists before nineteenth-century naturalism, inextricable from the reality which inspired it. His problem was not so much to remain photographically faithful to his subject, as it was to find an expression that would convey his feelings within the framework of accuracy. "When the thing represented," he asked his brother, "is in point of character, absolutely in agreement with the manner of representing it, isn't it just that which gives a work of art its quality?"[57]

With these statements in mind, it can no longer be assumed, despite the stylistic changes that may have taken place from his work in Holland or Paris, that Van Gogh is purely interested in a decorative design modeled after Japanese prints. This was merely a popular idea that arose out of the "distortion" theory of Van Gogh's art. No doubt the artist was influenced by these prints (as seen in such paintings as *Blossoming Pear Tree, Japonaiserie: The Bridge, Japonaiserie: The Tree,* and *Japonaiserie: The Actor*), as he also was by the art of Daumier, Millet, and others. However, it must be stated that, as with the art of Gauguin, this influence has become subtly integrated within his own vision—a vision still based on a faithful response to nature, expressed in poetic (aesthetic) form.[58]

It can be concluded from the artist's own statements and from the

experience of the paintings that the means by which he renders reality is inextricably tied to his visual perception of it. If Van Gogh simplifies form, it is because he wanted to give a "true idea of the simplicity in Arles."[59] If some of his paintings appear to resemble Japanese prints in the flattening of space, it is because, as Van Gogh says, "here in Arles the country seems flat . . . and the landscapes in the snow, with the summits white against a sky as luminous as the snow, were just like the winter landscapes that the Japanese have painted."[60] It is unlikely that Van Gogh consciously distorted and flattened space or simplified forms for the sake of decorative design alone or through a desire to imitate the Japanese. It was, rather, that the Japanese had taught him to look at reality in a new way, with "an eye more Japanese," as Van Gogh liked to state it.[61]

Along with the idea that Renaissance perspective is the one true method of indicating space, we must discard the idea that Van Gogh could not envision reality much in the way he depicted it in paint.[62] Vincent himself provides the best evidence for the idea that by adopting the perception of various artists, one can envision reality in a variety of ways, all equally valid as representations. Van Gogh's preconception of Southern France had combined everything that he cherished in art: the vividness of Moroccan colors in Delacroix's work, the rigid and simple masses he admired in Cézanne's landscapes, the scintillation of Monticelli's palette, the incisive outlines of vistas in Japanese prints, peasants who seemed to come straight out of Millet's paintings, townspeople who made him think of Daumier, as well as wide plains that reminded him of the flatness of his native Holland and, except for a more intense coloration, of Ruysdael, Hobbema, Ostade.[63]

Thus, in his perception of the South, Van Gogh was able to see Vermeer, Monticelli, Delacroix, Daumier, Millet, the Japanese, and others. There are numerous other quotations by the artist to attest to the fact that "life imitates art:"

I saw another very quiet and lovely thing the other day, a girl with coffee-tinted skin . . . ash-blond hair, gray eyes . . . the mother . . . in dirty yellow and faded blue standing out in strong sunlight against a square of brilliant snow-white and citron yellow flowers. A perfect Van der Meer of Delft.[64]

When I left Paris I did not think that I should once think Monticelli and Delacroix so true. It is only now . . . that I begin to realize that they did not imagine at all. And I think that next year you are going to see the same subjects all over again, orchards and harvest, but with a different coloring, and above all a change in the workmanship.[65]

Here you will see nothing more beautiful than Daumier; for very often the figures here are absolutely Daumier.[66]

Le pays me paraît [écrit-il en arrivant à Arles] aussi beau que le Japon. . . . Les eaux font des taches d'un bel eméraude et d'un riche bleu dans le paysage ainsi que nous le voyons dans les crépons.[67]

In addition to this evidence, it is necessary to reiterate the importance of the influence of the medium on Van Gogh's art in order to demonstrate his convincing alternative perspectives of reality obtained through oil on canvas. The role of the medium in recording perceptions has been discussed by Rudolf Arnheim, who maintains that a pictorial representation is neither a copy nor a manipulation of a perceptual concept.[68] In other words, the artist cannot reproduce with exactitude that which he perceives in nature. He can only create a structural equivalent or a configuration that may correspond to reality but which will be transformed by the medium employed by the artist as well as by his own imagination. In the light of Arnheim's theories and the fact that percepts are inherently expressive, the term *representation* in art cannot be uniquely equated with the naturalism of a Courbet of Meissonier or with the realism of Rembrandt and Daumier. It is, rather, simply a pictorial equivalent of an inherently expressive perceptual concept expressed in terms of a particular medium.

Because of the subjective nature of vision, it cannot be assumed that expressiveness necessarily denotes a turning away from nature. Any personal style must be seen as a valid way of representing reality in proportion as it is convincing to the viewer as a perspective upon nature. To make the representation of a visual reality into an expression of a thought, it is, of course, necessary to lay some particular emphasis on color and line that deviates from what is perceived with the eye. Naturalism has had such a profound influence on the contemporary Western mentality, however, that a deviation from a strict version was felt to be something arbitrary, even by those who practiced it with full conviction. Van Gogh made the rediscovery of what is iconic, i.e., he became conscious of the fact that an artist's painting is intended to express a human vision by the use of the means of pictorial art, without copying reality in a naturalistic, photographic way.

The goal of postimpressionistic art is not to render reality naturalistically, but to render it convincingly. Van Gogh's art expresses his vision of nature in a style he felt was true to reality, as true as any artist's illusion can ever be. When he describes forms in what may seem exaggerated line or color, it is simply because, for him, in Arles "things here have so much line."[69] It is not because of his violent temperament that he emphasizes brushwork. "Is it not intensity of thought that we seek, rather than a calm brush? And in the conditions of spontaneous work, work done on the scene in the immediate presence of nature, is a calm and well-controlled brush always possible? To me it seems no more possible

to be calm at such times than when lunging with a foil."[70] On his brushwork in the South, Van Gogh provides another, seldom-considered, interpretation: "I think that the continual wind here must have something to do with the haggard look the painted studies have. Because you see it in Cézanne, too. . . . As half the time I am faced with the same difficulties, I get an idea of why Cézanne's touch is sometimes so sure, whereas at other times it appears awkward. It's his easel that's reeling."[71] In this statement Van Gogh is referring to the effects of Mistral, the strong Provençal winds, which he felt had an impact on the formal values of his own work as well as that of Cézanne.

If Van Gogh's forms and colors seem exaggerated, it is because he sought "the real character of things," a truer reality than a mechanical description of surface appearances, but one that exists for everyone to see in nature, and one that can be captured through the interpretive medium of art:

> It's a mighty tricky bit of country this: everything is difficult to do if one wants to get at its inner character so that it is not merely something vaguely experienced, but the true soil of Provence. And to manage that one has to work very hard, whereupon the results become a bit abstract; for it's a question of giving the sun and the blue sky their full force and brilliance, of retaining the fine aroma of wild thyme which pervades the baked and often melancholy earth.[72]

> I also have two views of the park and the asylum. . . . I have tried to reconstruct the things as it might have been, simplifying and accentuating the haughty, unchanging character of the pines and cedar clumps against the blue . . . pines growing among a jumble of rocks, coloring the trunks and foliage with orange fire, while other pines in the distance stood out in Prussian blue against a sky of tender blue-green.[73]

> They [Bernard and Gauguin] do not care at all about the exact form of a tree, but they do insist that one should be able to say whether its form is round or square—and, by God, they are right, exasperated as they are by the photographic and silly perfection of some painters. They won't ask for the exact color of mountains, but they will say . . . those mountains, were they blue? Well then, make them blue and don't tell me that it was a blue a little bit like this or a little bit like that. . . . Make them blue and that's all.[74]

Certainly the artist was not imagining colors in nature, nor were his colors purely the result of a psychotic mind seeking pure emotional expression. In a letter, Van Gogh justifies his colorful perception of reality: "Fromentin and Gérôme see the soil of the South as colorless. . . . My God, yes, if you take some sand in your hand . . . and

also water, and also air, they are all colorless looked at in this way. . . .
There is no blue without yellow and without orange."[75] In addition, in
another letter that responds to an article by Albert Aurier, Van Gogh
specifically denies that his usage of color is imaginary: "Aurier's article
would encourage me, if I dared let myself go, to run greater risks in
leaving reality behind, and in creating a kind of tonal music with color,
as in certain works by Monticelli. But the truth is so dear to me, and the
effort to create what is true! After all, I really believe that I should rather
be a shoemaker than a musician in color."[76] It must be assumed, there-
fore, that Van Gogh's palette is the result of the perception of nature by
an artist with an acute sensibility for color. What he paints on the canvas
is essentially what he sees in reality.[77] Statements by the artist provide
the best evidence to contradict the theories of the critics who particularly
emphasize his use of arbitrary complementary colors as willful distor-
tions of reality in the interest of psychologically expressive design.
Though his colors may appear to be exaggerated in terms of established
nineteenth century conventions of depicting reality, we cannot ignore
the fact that Van Gogh did see violet in the fields or citron yellow
reflected by the sun in the sky. He claims that it was the clearness of the
air on the Mediterranean coast that distinguished the color in the south
from the tones of the north. Whether or not this is verifiable is unimpor-
tant. Because nature is ever-changing and presents a new aspect every
day, reality has multiple aspects even to scientifically descriptive vision.
Moreover, it is unimportant how much Vincent's own moods or senti-
ments may be responsible for the characteristics he saw in nature, for
everyone's perception of reality is unique and reflects his disposition, a
product of the union of psyche and environment. The irrelevance of
descriptive accuracy in art, as in poetry, becomes clear when one con-
siders the active role of the imagination in vision, a faculty that Van
Gogh felt should be developed in order to lead the artist toward the
creation of "a more exalting and consoling nature than the single brief
glance at reality—which in our sight is everchanging, passing like a flash
of lightning—can let us perceive."[78] Critics have become so involved
with interpreting Van Gogh's art as a reflection of his personality, par-
ticularly his emotional states and psychoses, that they have failed to see
expressiveness in his work apart from a preoccupation with conceptual
symbols. The idea that Van Gogh's art is uniquely symbolic is errone-
ous in that all art is symbolic, including all forms of representation, even
naturalism. To be symbolic of emotional states, detached from authentic
representation, is to be symbolic in a special, unusual, and unjustifiable
sense of the term.

Furthermore, there is no evidence that Van Gogh himself acknowl-
edged the position of the symbolist theorists; and he makes few

references in his letters to any conscious interest in symbols in his art. (The sower and the sheaf, for example, are mentioned as symbols of the infinite; added meanings are created by critics such as Graetz.) In other words, Van Gogh did not simply seek objects in nature in which he could express his psychic condition. Many letters show a concern, not for symbols, but with describing his works in terms of the artistic problems involved in color and composition. Actually, as Sven Lövgren points out in his book *The Genesis of Modernism*, Van Gogh and his critics differed greatly in their conception of the content of his work. "While Aurier found in original pictures thoughts and ideas, symbols of a higher reality, Van Gogh declared stubbornly his respect for nature and his obligation to artistic tradition."[79] Aurier's ideas about the symbolic nature of art could be accommodated as forerunners of Susanne Langer's theory that art, in general, is expressive of ideas through the medium of forms, and that it need not be a pictorial imitation of reality to be expressive. However, despite the fact that he recognized Van Gogh's close tie with nature, Aurier's error lies in the assumption that the purpose of his art is to express "Ideas" divorced from and existing apart from the expression of the reality that inspired them. This may be the purpose of some expressionists, but Van Gogh specifically denies that it applies to him. "Apparently the painter was reluctant to discuss at greater length Aurier's endeavors to make him appear as a symbolist, endeavors which he had tactfully disposed in his reply to Aurier by taking a stand against sectarianism. . . . Vincent simply confided to Theo: 'Aurier's article might have encouraged me . . . to venture farther away from reality and to make with colors something like a music or tones . . . but truth is so dear to me, and the search for being truthful, too. Well, I think I still prefer being a cobbler to being a musician who works with colors.' "[80] In addition, in answer to critics such as Graetz, it becomes apparent that finding psychological symbols in art is not a component of the direct aesthetic experience of a work of art. It is easy to understand how, under the compulsive influence of an analytical system, a critic can read symbols into any object in a painting by projecting his own subjective associations. Not only are these often unrelated to the conscious intentions of the artist, but they generally lead away from the work of art rather than elucidate it.

Van Gogh was incapable of constructing an elaborate set of predetermined symbols such as Graetz and other critics imply. It is also doubtful that he calculated a certain effect on the viewer by using symbols, as distinguished from discovering value dimensions inherent in nature. His letters adequately show that he thought of reality as suffused with value to its very core. He didn't have to use it as a mere scaffold into which his own values were injected. Therefore, any belabored investigation or

discussion of individual symbols in Van Gogh's art is not relevant to the issue of expressive versus expressionistic intent.

As opposed to the exaggeration of the individual symbols in his art, some critics like to view Van Gogh's oeuvre as a whole as symbolic of his mental illness. There is little defense against the charge that his art is a function of his madness, although Antonin Artaud expresses the problem as a question of social nonconformity: "Non, Van Gogh n'était pas fou, mais ses peintures étaient des faux gregeois, des bombes atomiques, dont l'angle de vision, à côté de toutes les autres peintures qui sévissaient à cette époque, eût été capable de déranger gravement le conformisme larvaire de la bourgeoisie Second Empire . . . car ce n'est pas un certain conformisme de moeurs que la peinture de Van Gogh attaque, mais celui même des institutions. Et même la nature extérieure, avec ses climats, ses marées et ses tempêtes d'équinoxe ne peut plus, après le passage de Van Gogh sur terre, garder la même gravitation."[81] Also in agreement on this point is J. B. de la Faille, author of the *Catalogue raisonné* of Van Gogh's oeuvre.[82] The question of Van Gogh's illness is highly debatable. Yet, it is difficult to ignore the truth of Artaud's and de la Faille's passionate defense of Van Gogh's purpose.

If Van Gogh's art is not to be valued in terms of its symbolic communication of psychological states, how is the meaning of his work imparted to the viewer? It must be through the expressive form of the representation. Susanne Langer explains that art is not to be considered either as the sum of its individual parts or as communication by discursive symbols. Any symbols that exist in the work enter into and become inseparable from the expressive form of the whole. This expressive "art symbol" does not need to convey something referentially, for its import lies in its unique form. In Van Gogh's representational art, the viewer can and should experience the expressiveness inherent in the representation without reference to circumstances in the artist's life and without presuming a preoccupation with self-expression as conscious goal.

Van Gogh's art is universal and symbolic because it is a way of visualizing reality that is convincing and available to everyone. It need not rely on psychological or conceptual symbols unique to his own life. His expressiveness is the expressiveness inherent in nature. Self-expression for its own sake may be less universal, more idiosyncratic, and often less significant in content.[83] ("His *Night Café* of 1888, explicitly designed to 'express the terrible passions of humanity by means of red and green,' remains, whatever else it may be, a cafe at night.")[84]

It is apparent that the expressiveness in Van Gogh's art corresponds to the artist's perception and experience of reality. What is expressed is based on visual experience and is congruent with such experience. Because of the subjective component of all perception, all representations

will naturally involve personal feelings and psychic associations. These feelings awakened in the moment of vision, and inextricably tied to it, pervade Van Gogh's work.

Critics who value Van Gogh's art for its symbolism or its expressive distortions and emotional intensity are forgetting its origin in a strong response to nature. In their persistent attempt to evaluate art in terms of its contrast to scientific naturalism, which is their standard concept of visual reality, they fail to witness the union in art of man, imagination, and reality. Both the "symbolist" critics and the "expressionist" critics suffer from a narrowness of viewpoint, erroneously assuming a dichotomy between meaning and symbol, and between reality and human psychology. With Van Gogh, it is not a question of dispensing with nature in favor of expressionism, since his expressiveness is derived from experiences with reality. If representation in art is in itself unimportant and, in fact, impossible in a literal way, his "distortions" for expressiveness can be understood as revealing his true relationship to nature, not as signaling a deliberate deviation from it.

Critics often obscure the true nature of Van Gogh's art and the primary means by which it is appreciated. It has become extremely difficult to divorce the appreciation of his art from the great myths obscuring it, particularly his passionate and violent temperament, and his religious and sexual anxieties with which he is presumed to be preoccupied. Art becomes a mere therapeutic activity as novelists inflame his story and as psychiatrists debate the exact etiology of his madness. The artist is in critical danger of disappearing altogether, lost amid the clutter of so many exaggerated popular biographies.

Notes

1. Roger Fry, *Vision and Design* (New York: Brentano's, 1924), p. 17.
2. Stephen Spender, "The Painter as a Poet," *Art News Annual* 19 (1950):79.
3. Kenneth Clark, *Landscape Painting* (New York: Scribner, 1950), pp. 110–11.
4. Lionello Venturi, *Impressionists and Symbolists* (New York: Charles Scribner's Sons, 1950), pp. 196–97.
5. J. Meier-Graefe, *Modern Art* (New York: G. P. Putnam's Sons, 1908), p. 205.
6. Gustave Coquiot, *Les Indépendants* (Paris: Librairie Ollendorff, 1920), p. 74.
7. John Rewald, *Post-Impressionism* (New York: Museum of Modern Art, 1956), p. 344.
8. Alfred Barr, Jr., *Masters of Modern Art* (New York: Museum of Modern Art, 1954), pp. 28–29.
9. W. Wright, *Modern Painting* (New York: John Lane Co., 1915), pp. 183–84.
10. Dr. F. Minkowska, *Van Gogh, sa vie, sa maladie et son oeuvre* (Paris: Presses du Temps Présent, 1963), p. 59. This applies to Van Gogh's work of 1890 and after. The

article also describes the use of lines and directions of forms in his art as psychologically revealing signs of his illness.

11. Sheldon Cheney, *The Story of Modern Art* (New York: Viking Press, 1958), p. 271.

12. M. Davidson, *Approach to Modern Painting* (New York: Coward-McCann, 1948), p. 74.

13. "La peintre d'Arles nous donne toujours le sentiment de dessiner quand il peint. Chaque fragment de couleur est chez lui en même temps un trait, une ligne, un signe expressif. Ses touches n'imitent rien, elles suscitent, elles créent, elles évoquent . . . [*Champ de blé au faucheur*] . . . le système expressif de l'artiste s'est encore accentué emporté par la passion des extrêmes, le peintre est entraîné à des distortions, à des charges, à des déformations outrancières. . . . Dès lors la frénésie de l'artiste se communique à tout ce qu'il touche. La terre se dilate et craque, les montagnes entrent en convulsion. Les nuées tourbillonnent à un rythme furieux, les astres tournoient comme des pièces de pyrotechnie, les arbres se tordent de colère, la végétation roule en vagues déforlantes. . . . Dans ce monde disloqué, dans cette nature en délire, les règles de mesure, de proportion, d'architecture volent en éclats sous l'attaque d'un pouvoir maléfique. La perspective se fractionne et les lignes de vision fuient, éperdues" (Frank Elgar, *Van Gogh* [Paris: Fernand Hazan, 1958], pp. 182, 230).

14. F. Mather, *Modern Painting, a Study of Tendencies* (New York: H. Holt & Co., 1927), pp. 326–27.

15. Venturi, p. 186.

16. Bernard Myers, *Modern Art in the Making* (New York: McGraw-Hill, 1959), p. 239.

17. Pierre Guastalla, *Essai sur Van Gogh* (Paris: Michel de Romilly, 1952), pp. 25–26.

18. Maurice Sérullaz, *The Impressionist Painters* (New York: Universe Books, 1960), p. 140.

19. Along these lines: "Unlike many realists, Van Gogh was not content to stop with simple description. Gradually he transformed realism into a powerful, symbolic method. . . . It was color which ultimately served best to symbolize emotional states and meanings. . . . No longer did he try to reproduce exactly what he saw, but expressed, arbitrarily and forcibly, what he felt" (*Van Gogh, Paintings and Drawings, a Special Loan Exhibition* [New York: Metropolitan Museum of Art, 1949], p. 9). And, "Van Gogh annonce les artistes du XXᵉ siècle pour que l'art ne sera plus l'exacte imitation de la nature, mais sa transfiguration dans le symbole. Par l'ardeur de ses couleurs, par la netteté de son trait, par la simplification de sa ligne, par le rythme qu'il donne aux contrastes, Van Gogh apporte à la peinture les pouvoirs de l'expressionisme" (Gerald Knuttel, *Van Gogh* [Holland: Marabout University, 1960], p. 84).

20. Linda Nochlin, *Impressionism and Post-Impressionism 1874–1904, Sources and Documents*, ed. H. W. Janson, (Englewood Cliffs, N.J.: Prentice-Hall, 1966), p. 135. Quotation from Albert Aurier. Similarly: "C'est, presque toujours, un symboliste. Non point, je le sais, un symboliste à la manière des primitifs italiens, ces mystiques qui éprouvaient à peine le besoin de désimmatérialiser leurs rêves, mais un symboliste sentant la continuelle nécessité de revêtir ses idées de formes précises, pondérables, tangibles, d'enveloppes intensément charnelles et matérielles. Dans presque toutes ses toiles, sous cette enveloppe morphique, sous cette chair très chair, sous cette matière très matière, gît, pour l'esprit qui sait l'y voir, une pensée, une Idée, et cette Idée essentiel substratum de l'oeuvre, un est, en même temps, la cause efficiente et finale. Quant aux brillantes et éclatantes symphonies de couleurs et de lignes, quelle que soit leur importance pour le peintre, elles ne sont dans son travail que de simples moyens expressifs, que de simples procédés de symbolisation" (Albert Aurier, "Les Isolés, Vincent Van Gogh," *Mercure de France* [1890], 27).

21. See Maurice Raynal, *History of Modern Painting* (Geneva: Skira, 1949), 1:66. Similarly: "S'il cherchait à s'exprimer, ce n'était plus de façon explicite, par le sujet du tableau ou le choix des personnages comme au têmps de sa période hollandaise, mais par la couleur même. Et, derrière chacune de ses oeuvres, nous trouvons maintenant un symbole que nous pressentons même quand nous ne pouvons l'expliquer. Non seulement le rouge et le vert servent à exprimer 'les terribles passions humaines,' mais un paysage de la Crau devient 'infini comme la mer,' un fauteuil de paille est 'une place vide' et la chambre de la maison jaune, le symbole 'du repos et du sommeil'" (Pierre Marois, *Le Secret de Van Gogh* [Paris: Librairie Stock, 1957], pp. 201–2).

22. A. Basler, *La Peinture indépendent en France* (Paris: G. Crès, 1929), pp. 42–43.

23. H. Focillon, *La Peinture aux XIXᵉ siècles du réalisme à nos jours* (Paris: H. Laurens, 1929), p. 278.

24. John Rewald, "Van Gogh versus Nature: Did Vincent or the Camera Lie?" *Art News* 41 (1942):8–11. Similarly: "Van Gogh . . . est lui aussi visionnaire, préoccupé de pénétrer le labyrinthe de son âme et d'atteindre l'absolu, au-delà de l'apparence changeante du monde et des choses" (Alberto Martini, *Van Gogh* [Milan: Fabbri, 1969], p. 2).

25. Michel Robin, *Van Gogh ou la remontée vers la lumière* (Paris: Plon, 1964), p. 136. Based on Van Gogh's statement "Si nous prenons le train pour nous rendre à Tarascon ou à Rouen, nous prenons la mort pour aller dans une étoile." Similarly: "Van Gogh was intoxicated by the sun . . . his work is a kind of sun-passion. It represents a mounting toward the sun, and a final assumption therein. The frequent sunflowers in his work are not merely artificial symbols or real objects in his familiar world. They are the daily or yearly reduplication of his sun-passion. . . . Scherder defines it thus: He, the creator-artist, identifies himself formlessly with light and darkness, with the sky in brief, the many-haloed suns and stars are his own eyes looking down upon and lighting up the earth" (Wallace Fowlie, "The Religious Experience of Van Gogh," *College Art Journal* 9 [1950]:321, 329).

26. H. Graetz, *The Symbolic Language of Vincent Van Gogh* (New York: McGraw-Hill, 1963), p. 76. Other psychoanalytic or religious symbolism can be found in Jean Paris, "Le Soleil de Van Gogh," in Camille Bourniquel and Pierre Cabanne, *Van Gogh* (Paris: Hachette, 1968), pp. 151 ff., and on his illness: Martha Robert, "Le Génie et son double," ibid., pp. 171 ff.

27. Graetz, p. 101.

28. "*The Breakfast Table* (1888–9) . . . in the center of the painting it [coffee-pot] takes the most important position amidst the other domestic objects on the table. The little yellow lemons nestling under the large round coffee-pot could give the idea of chicks with a hen. . . . As an inner reality Vincent's homesickness for a family life and his longing for a 'woman, a kind of domestic hen,' are portrayed in this still life. . . . The coffee-pot stands for the woman, the nourishing mother. . . . Both in mythological and psychological terms the coffee-pot is of a dual symbolism: the lower part, the pot, has a female meaning like the jugs and cups. But when the upper part, the filter, is fitted into it, the coffee-pot becomes the tallest object in the group and thus acquires a male character. . . . Male and femaleness appear here as one in the coffee-pot, which, together with the fruit, is a symbol of fertility" (ibid., pp. 86–87).

29. Ibid., p. 156.

30. Ibid., pp. 69–70.

31. Vincent Van Gogh, *Complete Letters* (Greenwich, Conn.: New York Graphic Society, 1958), 2:311.

32. Ibid.

33. Helen J. Dow, "Both Prometheus and Jupiter," *Journal of Aesthetics and Art Criticism* 22 (1964):274.

34. See Seven Lövgren, *The Genesis of Modernism* (Stockholm: Alquist & Wiksell, 1959), p. 148.

35. Ibid., p. 150.

36. Melvin Rader, *A Modern Book of Esthetics* (New York: Holt, Rinehart, Winston, Inc., 1973), p. 54 (from Eugene Véron, *Aesthetics*, 1878).

37. C. J. Ducasse, "Art and the Language of the Emotions," *The Journal of Aesthetics and Art Criticism* 23 (1964):109–12.

38. Melvin Rader, *Art and Human Values* (Englewood Cliffs, N.J.: Prentice Hall, 1976), p. 144. "What then does art express? What does it mean? As we have said, art expresses quality and feeling—not quality in cold isolation nor feeling detached from content, but feeling at one with the qualities felt. Art is not expression merely of what facts are in the world of human experience, but very much more; it is the expression of how the individual artist feels, and if his feelings are normal, how we too feel about facts and experience—how we feel about mountains, love, patriotism, sorrow, joy, adventure, death, a bowl of fruit, an assortment of bottles, and old woman's face. To be art the feeling expressed must be objectified, transmuted into beauty, detached from practical or intellectual concerns. The feeling is made into an object, into a felt quality, into a value. Or, starting with the other pole, the artist may begin with a quality and then attach feeling to it. Only when the subjective and objective poles are united and the value is embodied in a work of art, is the process complete" (ibid.).

39. "Both from his choice of books . . . and his predilection for particular artists—Lhermitte, Millet, etc.—it is clear that . . . from the moment he began to devote himself to the art of painting, he was a wholehearted adherent to realism. And so he remained all his life" (Rookmaaker, p. 100). Charles Morice considers Van Gogh to be a naturalist, apparently meaning by that what Rookmaaker meant by realist: "Van Gogh fut plutôt un naturaliste . . . [avec] un amour exalté pour la nature. . . . Il adore les ciels, les arbres, les routes, les fleurs, les hommes, il les voit à travers le prisme et les peint comme il les voit . . . car il voit riche, mais il voit juste aussi, et son art est souverainement expressif" (Charles Morice, *Paul Gauguin* [Paris: H. Floury, 1920], p. 176).

40. Walter Pach, *Vincent Van Gogh* (New York: Artbook Museum, 1936), pp. 52–53.

41. Van Gogh, p. 518. This quote has often been used by critics to justify Van Gogh's distortion of nature. Rather, it demonstrates his abhorrence for photographic naturalism in preference for a nature more real, more characterful and alive to him.

42. "Par ses origines, son education, son caractère, Van Gogh est un homme du Nord. . . . Sa Hollande à lui, c'est celle des campagnes austères, aux sols ingrats, aux climats rudes, c'est celle des travailleurs de la terre. Il choisit d'en montrer l'image exacte, rassemblante, sans nulle parure. Les grands maîtres hollandais ont peint la réalité bourgeoise de leur temps. Van Gogh peindra la réalité plébéienne du sien. Plutôt que de copier des moulages de plâtre, il préfère travailler sur le motif. 'Pourvu que je tienne debout, écrit-il à Theo, eh bien, je lutterai en silence en regardant tout simplement, par ma fenêtre, les choses de la nature, et en les dessinant avec une fidelité amoureuse'" (Bourniquel, pp. 31, 38).

43. "This becomes clear from his controversy with Emile Bernard over biblical subjects: 'Il est sans doute sage, juste, d'être ému par la Bible; mais la réalité moderne a tellement pris sur nous que même en cherchant abstraitement à reconstruire les jours anciens dans notre pensée, les petits événements de notre vie nous arrachent à ce moment à ces méditations et nos adventures propres nous rejettent de force dans les sensations personnelles—joie, ennui, souffrance, colère, ou sourire'" (Rookmaaker, p. 100).

44. Van Gogh, p. 370.

45. Rookmaaker, p. 100.

46. Van Gogh, p. 375.

47. Rewald, *Post-Impressionism*, p. 220.

48. Van Gogh, p. 443.

49. Jan Gordon, *Modern French Painters* (New York: Dodd, Mead, & Co., 1929), p. 45.

50. Van Gogh, p. 295.

51. Ibid., p. 217.

52. John Canaday, *Mainstreams of Modern Art* (New York: Holt, Rinehart and Winston, Inc., 1959), p. 374. According to John Canaday, Van Gogh painted the portrait of Madame Roulin or *La Berceuse* in such a way that it would recall lullabies to lonely sailors in their cabins and would enable them to feel "the old sense of cradling come over them." It was not only with people or nature that Van Gogh describes an expression of feelings or moods in this way, but also inanimate objects such as he found in his bedroom. To Theo, he says of the *Bedroom* (1888): "Here color is to do everything, and giving by its simplification a grander style to things, is to be suggestive of rest or of sleep in general. In a word, looking at the picture ought to rest the brain, or rather the imagination" (Van Gogh, p. 86). To Gauguin he states: "I enormously enjoyed doing this interior of nothing at all, of a Seurat-like simplicity; with flat tints, but brushed on roughly, and with a thick impasto, the walls pale lilac, the ground a faded broken red, the chairs and the bed chrome yellow, the pillows and the sheet a very pale green-citron, the counterpane blood red, the washstand orange, the washbasin blue, the window green. By means of all these diverse tones, I have wanted to express an 'absolute restfulness'" (ibid., p. 527).

53. *Van Gogh, Paintings and Drawings*, p. 8.

54. Van Gogh, p. 590.

55. Ibid., p. 401.

56. Ibid., p. 398.

57. Rewald, *Post-Impressionism*, p. 218. It would be more correct to say that he projected his feelings in integration with his factual visual sensations.

58. As John Rewald maintains: "When he selected Arles as a place to work in, Vincent hoped to find there the diverse elements which he felt were essential to his artistic development. His preconception about the south of France was a combination of everything that he loved and had dreamed of: the tapestry of Moroccan colors which Delacroix so admired, the incisive outlines of Japanese prints . . . the actual shape and nature of Provence as he had seen it in the canvases of Cézanne and Monticelli. Over and above this he was to discover, to his considerable surprise, that the country around Arles at times resembled his native Holland. But the color of this landscape impressed him even more than its character, and it was its richness under the ardor of southern sunshine which carried him away and offered new and absorbing problems" (Rewald, "Van Gogh Versus Nature: Did Vincent or the Camera Lie?," p. 9).

59. Van Gogh, p. 611.

60. Ibid., p. 525.

61. "This Oriental element [Japanese influence] which creeps into Van Gogh is very different from the pseudo-Japanese work which has become popular in recent years. It depends not upon a mere imitation of technical device . . . but it lies in a recognition of the vision of similar values in nature. . . . 'I have just done two large pen drawings . . . of a bird's eye view of an endless plain seen from the top of a hill . . . this flat stretch of country which contains nothing save infinity, eternity'" (Gordon, p. 46). Similarly: "Just as he sought to identify himself with the miners of the Borinage by blacking his face with coal dust, in Arles he is to paint a self-portrait in which he deliberately gives the eyes a slight Mongolian slant. 'I have slanted the eyes a bit in the Japanese manner,' he writes in letter 545 to Theo. What he admires in the art of the Japanese is 'the extreme clarity and sharpness of everything in their work,' and their ability to portray a figure 'in a few sure strokes'" (E. Andriesse and J. de Gruyter, *Le Monde de Van Gogh* [Bruxelles: Les Editions Lumière, 1953], p. 25).

62. "Pour l'artiste de 1890, les lois de la perspective académique ne correspondent plus

à une évidence absolue. Il sait confusément le caractère relatif de ces valeurs. . . . La découverte de la photographie et des procédés de reproduction mécanique est venue brusquement tout changer, au moment même ou le japonisme soulignait le caractère relatif et arbitraire de la perspective occidentale" (Pierre Francastel, *Nouveau Dessin, Nouvelle Peinture* [Paris: Librairie de Medicis, 1946], p. 111).

63. "Or c'est une attitude constante pour Van Gogh d'entrevoir le monde à travers l'optique d'autres artistes: 'Je trouve que quand on a essayé attentivement de decouvrir les maîtres, on les retrouve tous à certains moments dans la réalité. Je veux dire qu'on voit aussi dans la réalité ce qu'on appelle leurs créations, à mesure que l'oeil, le sentiment deviennent semblables aux leurs.' Ses descriptions font continuellement allusion à des peintres: 'une perspective à la Van Goyen . . . les vieux bateaux comme Daubigny en a peint . . . il y a des femmes comme des Fragonards. . . .' L'oeuvre d'art modifie donc la conscience de l'homme, c'est-à-dire les rapports de l'homme au monde: 'l'artiste, présentant les choses sous un jour nouveau, a renouvelé notre vision'" (Robin, p. 91).

64. Van Gogh, p. 11.

65. Ibid., p. 54.

66. Ibid., p. 65.

67. Francastel, p. 101.

68. "The percept or memory trace of an object of reality does not generally consist of lines or brushstrokes and is for the most part not two-dimensional. . . . Some of its qualities can be reproduced in drawing and painting, others cannot. . . . Wherever they cannot be reproduced directly, an equivalent must be developed from the means offered by the medium of representation" (Rudolf Arnheim, *Toward a Psychology of Art* [Berkeley: University of California Press, 1966], pp. 34–35).

69. Rewald, *Post-Impressionism*, p. 215.

70. Venturi, p. 189. (From *Lettres de Vincent Van Gogh à Emile Bernard*, 1911).

71. Basil Taylor, *Cézanne* (Middlesex: Paul Hamlyn, 1968), p. 23.

72. Rewald, *Post-Impressionism*, p. 361. (Quotation by Van Gogh.)

73. Van Gogh, p. 347.

74. Rewald, *Post-Impressionism*, p. 347.

75. Van Gogh, p. 491.

76. Venturi, p. 187. (From *Oeuvres posthumes;* also found in *Mercure de France,* January 1890.)

77. "Spring is tender, green, young and pink apple blossoms, Autumn is the contrast of the yellow leaves with violet tones. Winter is the snow with black silhouettes. But now if summer is the contrast of blues with an element of orange in the golden bronze of the corn, one could paint a picture which expressed the mood of the seasons in each of the contrasts of the complementary colors" (Van Gogh, p. 299).

"Décrit-il une nature morte: 'un cafetière de fer émaillé bleu, un vase et une soucoupe bleu de roi, un pot au lait carrelé cobalt pâle et blanc, une tasse avec dessins oranges et bleus sur fond blanc, un pot en majolique bleue, avec fleurs et feuillages verts, bruns, roses. Tout cela sur une nappe bleue, sur un fond jaune. Avec ces posteries deux oranges et trois citrons. C'est donc une variation de bleu égayée par une série de jaunes qui vont jusqu'à l'orange. . . . Puis une vue d'Arles: 'La ville est entourée d'immenses prairies toutes fleuries d'innombrables boutons d'or—une mer jaune. Ces prairies sont coupées sur le premier plan par un fosse rempli de fleurs d'iris violets. . . . Mais quel motif. Hein! Cette mer jaune avec une base d'iris violets. . . . Enfin, sur un croquis du *Semeur:* 'Grand terrain de mottes de terre labourées, franchement violet en grande partie. Champ de blé mur d'un ton d'ocre jaune avec un peu de carmin. Le ciel jaune de chrome . . . la blouse du Semeur est bleue et son pantalon blanc . . . le tableau est coupé en deux; une moitié est jaune, le haut; le bas est violet. Et bien, le pantalon blanc repose l'oeil et le distrait au moment ou le contraste simultané excessif de jaune et de violet l'agacerait'" (Francastel,

p. 101). Pierre Francastel sums it up appropriately: "il est tout à fait évident que chez Van Gogh la première impression, l'émotion fondamentale, est une émotion colorée" (ibid.).

78. Van Gogh, p. 478. This probably refers to impressionism.
79. Lövgren, p. xi.
80. Rewald, *Post-Impressionism*, pp. 372–73.
81. Antonin Artaud, *Le Suicidé de la société* (Paris: K éditeur, 1947), p. 11.

Furthermore, Artaud derides those critics that denounce Van Gogh's unusual antics as mad:

> "Il n'y a pas de délire à se promener la nuit avec un chapeau attaché de douze bougies pour poindre sur le motif d'un paysage. . . .
> Quant à la main cuite, c'est de l'héroîsme pur et simple;
> Quant à l'oreille coupée, c'est de la logique directe et je le répète
> un mode qui, jour et nuit, et de plus en plus, mange l'immangeable,
> pour amener sa mauvaise volonté à ses fins, n'a sur ce point
> qu'à la boucler" [ibid., p. 17].

In terms of technique, Artaud sees only a means of representing nature: "Van Gogh est peintre parce qu'il a recollecté la nature, qu'il l'a comme retranspirée et fait suer, qu'il a fait gicler en faisceaux sur ses toiles, en gerbes comme monumentales de couleurs, le seculaire concassement d'éléments, l'épouvantable pression élémentaire d'apostrophes, de stries, de virgules, de barres dont on ne peut plus croire après lui que les aspects naturels ne soient faits" (ibid., p. 47). In place of symbolism and madness, Artaud sees only nature without adornment: "il n'y a pas de fantômes, dans les tableaux de Van Gogh pas de visions, pas d'hallucinations. C'est de la vérité torride d'un soleil et deux heures de l'après-midi. . . . Non, il n'y a pas de fantômes dans les tableaux de Van Gogh, pas de drame, pas de sujet et je dirai même pas d'objet, car le motif lui-même qu'est-ce que c'est? . . . C'est la nature nue et pure vue, telle qu'elle se révèle, quand on sait l'approcher d'assez près" (ibid.). "Rien qu'un peintre Van Gogh et pas plus, pas de philosophie. De mystique, de rite, de physcurgie ou de liturgie. Pas d'histoire, de littérature ou de poésie, ces tournesols en nature, il faut maintenant en revenir à Van Gogh, de même, que pour comprendre un orage en nature, un ciel orageux, une pleine en nature" (ibid., p. 52).

82. "Le parti traditionnaliste ignore tout à fait que Vincent a rendu bien des fois la nature avec une vérité surprenante. Rien de truqué, rien d'ajouté, ni de changé. A Montmajour il a dessiné les rochers. Eh bien! Quand on se met à l'endroit même ou Vincent était installé, on est surpris de voir dans les blocs rocheux les mêmes crevasses, les mêmes formations, la même ligne déchiquetée, les mêmes excavations, que Vincent a observées en dessinant. Il est le grand maître d'un naturalisme exaspéré. Ceux qui ne comprennent pas sa vision, savent que Vincent a eu des crises mentales et épileptiques et dissimulent leur impuissance à le comprendre en le qualifiant de fou. . . . Aucun intellectuel n'oserait designer son oeuvre comme celle d'un fou. Les génies devancent toujours leur temps et il est bien rare que les contemporains les comprennent. . . . Quoiqu 'il soit très difficile de séparer l'homme de l'oeuvre, surtout ici, où ils sont presque confondus, il faut éviter en général de trop s'attarder à la personnalité d'un artiste et surtout il convient de ne pas troubler par des évocations indiscrètes la quiétude d'un mort" (J. B. de la Faille, *L'Epoque française de Van Gogh* [Paris: Bernheim-Jeune, 1927], pp. 76–77).

83. "His sitting at Arles under a scorching sun in the heat of the day, painting the cornfields, vineyards, perspectives of the Crau and the Camargue, amounted to a rite more than anything else. . . . He was not after pictorial flirtations with sunlight effects like his friends, the Parisian impressionists; what he sought was a direct communion with the light principle. He sees the sun's flaming disc as a sparkling wonder, as the power centre of the universe. . . . He sees the fructifying effect of the light, which causes the

seeds to germinate and the crops to spring up. Yet his vision is innocent of the embellish-
ments of [fantasy]. It is rather the ultimate result of his exploration of reality, his will to
delve into the laws of nature; the outcome of his need to probe the essential, the primary,
the fundamental. His point of departure is always the image before his eyes, whose form,
colour, structure and movement he investigates, be it the cornfield, the vineyard or the
perspective from Mont Majour. Unlike his friend, Bernard, he does not want to paint
Christ in the Garden of Olives, but real olive orchards and real people who resemble the
early Christian saints" (Andriesse and de Gruyter, p. 31).

 84. Peter Gay, *Art and Act* (New York: Harper & Row, 1976), p. 184.

5

Cézanne, Cubism, and the Destination Theory of Style

Paul Cézanne occupies an unusual position in the history of art: a painter who in his lifetime experienced only a lack of comprehension of his art and a plethora of scorn, yet an artist who has been widely claimed by so many modern movements. On the one hand, Cézanne was mocked and ridiculed, was treated as a madman and a barbarian and had no disciple in his own time. On the other hand, today he is revered as the father of modern art, the inspiration for countless artists; and he is idolatrized and eulogized by almost every major critic.

Despite the praise, the range of interpretations of Cézanne's art is vast; and the criticism of his art is plagued by a great deal of misreading of his theories and a narrowness of perspective. For example, in the criticism of Cézanne's art, during his own lifetime and subsequently, several stages can be detected. In the nineteenth century, the critics, conditioned by scientific naturalism, saw in his work only a reaction to or departure from the immediate past and present. They characterized the unexpected aspects of his art with such descriptive words as *brutal*, *gauche*, *childish*, and *primitive*.

> Even the most advanced and liberal among the Parisian critics, Marc de Montifaud, who treated Degas, Monet, Pissarro, and Renoir with respect, if not with enthusiasm, joined in the laughter of the most ignorant and prejudiced upon approaching the Cézannes: "Monsieur Cézanne can only be a kind of madman, afflicted with delirium tremens while painting. . . ."The artist's *Moderne Olympia* was described in a review as "one of the weird shapes generated by hashish, borrowed from a swarm of absurd dreams," and his two landscapes in the same show (one of them, the *Maison du Pendu*, is now in the Louvre), were "more than we can swallow."[1]

To spectators of the time, Cézanne's pictures seemed to be just representational pictures very badly done. This presupposes, of course, that

Cézanne was merely a descriptive painter who set out to depict mountains, trees, or apples in a naturalistic style but did not have the skill to render them convincingly.

The Impressionist Exhibition of 1877 prompted a barrage of noisy ridicule. Apparently the *Portrait of Chocquet*, because of its unusual and striking colors, became the offending canvas of the show. According to John Rewald, it is a very clear and calm painting, yet the blue-green reflections in the hair, beard, and mouth were quite disconcerting to the public. Chocquet himself attempted to explain to the derisive audience the fact that these were reflections cast by light upon objects, and that the "everlasting pink" of the skin shown in official portraits was done only as a blind convention.[2] However, the critic of *Charivari* in 1877 advised his readers not to linger before Cézanne's painting if they were visiting the exhibition with a pregnant woman, as this might give the infant yellow fever before its birth. In the *Sportsman* of the same year, a Mr. Barbouillote complained of seasickness and a critic named Ballu wrote that Manet and Cézanne "provoke laughter and . . . exhibit profound ignorance of drawing, composition, and color."[3]

Needless to say, criticism of Cézanne's art was negative and focused on characteristics that the next generation of critics, writing after the artist's death, considered as positive elements of his style. It is interesting to note that terms such as *brutal* then became synonymous with *rugged* or *powerful*; and *primitive* and *childish* were absorbed into the concept of Cézanne as the pioneer and forerunner of modern art. What had previously been considered awkward, unskilled, or gauche to nineteenth-century eyes became a conscious will-to-distortion in the twentieth century. These "distortions" later became the foundation of the formalistic art criticism of the artist based on Clive Bell and Roger Fry's "significant form."[4] Although there are symbolist and expressionist interpretations of the artist,[5] critics subsequent to Bell and Fry undertook a rigorous analysis of Cézanne's distortions largely in terms of the abstract formal structure of his work. From about 1910 on, he was hailed as the master of three-dimensional structural expression achieved through an exhaustive study of forms in space and their presentation in planes of color. He became valued, not solely as the rebel who released art from its representational function, but as the source for abstract and, most particularly, cubist art.[6]

A painting such as *Village of Gardanne*, 1885–86, becomes an archetype of proto-cubist innovation, finding its consummation in the analytical cubist work of Picasso and Braque, circa 1910. Incisive, geometric planes coalesce into the pictorial equivalent of the compressed hilltop town, rising vertically to an apex in the salient steepled church. The principle behind the artist's picturesque rendering underwent significant structural changes, only an early link in the expanding chain of contem-

porary evolutionary developments. Reality buckled under the subversive brush of Braque and Picasso. Forms and motifs shattered, while the stable, rational space of Gardanne exploded into off-kilter angles and ambiguously interpenetrating facets of free-floating kinetic fragments. But Cézanne's preemption of the emphatic, layered organization of the actual Provençal site was misinterpreted or ignored. His cubist successors stressed only the break with nature: the seeming arbitrariness of his pictorial structure, the apparent disinterest in the motif, and its treatment as nothing more than a pretext for semiabstract surface design.

Cézanne's legacy to the future is the central issue of this essay and the object of critical reevaluation. While it is true that, like the Phoenix myth, postimpressionism arose from the ashes of a disintegrating naturalism, theorists and critics, stressing Cézanne's repudiation of impressionism and naturalism and seeing some kind of evolutionary connection between him and cubism, assume that his rejection of these nineteenth-century styles corresponds to a rejection of representation in art. As a result, the use of color, space, line, brushwork, modeling, etc., has become a point of contention in the contemporary criticism of Cézanne, particularly among those critics who value his art solely in terms of the plastic achievements he conveyed to the twentieth-century. For example, "l'artiste considérant [in *Joueurs de Cartes*] la nature comme un monde de couleurs et de formes variables, sélectionne lentement et l'un après l'autre, après avoir réfléchi aux conséquences de chaque choix sur l'ensemble, les éléments de son tableau."[7] Cézanne's unique manner of rendering his subjects caused critics to become more and more concerned with the way he intentionally transposed and rearranged (i.e., distorted) the "facts" of nature into the components of a work of art (i.e., his style), than with the way he created a valid representation of his experience of reality in aesthetic form.[8] The step from Cézanne's abstract late paintings and watercolors to cubism is seen as a logical development of his theories and discoveries. Nature recedes into abstraction, the ultimate victory of form over subject matter.[9]

While many of Cézanne's critics do not openly compare the artist to the cubist movement, they tend to describe his works in such a way that it is difficult to believe they did not have cubism in mind.[10] The question is whether or not Cézanne in his late works was merely simplifying and omitting more detail, or whether he was truly shifting to a purely nonrepresentational play of forms. Some critics emphasize his geometrical volumes or patterns as examples of his deliberate departure from or "distortion" of anything natural in the interest of geometry for its own sake.[11] It is apparently assumed that a geometrization of form is not reconcilable with the representation of reality.

Other critics who mention cubism specifically in their discussion of Cézanne's "abstractions" maintain that there exists a direct line of in-

fluence between the artist and his cubist descendents. In their designation of Cézanne as the father and precursor of the movement, they imply a consciousness on the part of the artist that cubism was the ultimate "realization" of his aims and struggles, if only he had lived to fulfill them.[12]

The source of this insistent and misguided opinion stems from several factors: a belief in the art-historical process as an inevitable evolution according to intrinsically meaningful laws (such as the solution of formal problems), the inability to evaluate the artist and his work with unbiased pre-cubist eyes, and the equally invalid literal interpretation of two of the artist's own statements. These are the remark concerning the "cylinder, the cone, and the sphere,"[13] and the statement "I am the primitive of a new art. I am convinced I will have followers."[14] These remarks have often been used to support a view of Cézanne's art that arose after his death. On the basis of a radical misinterpretation of these statements, critics accuse Cézanne of rearranging nature and distorting perspective merely to make geometric patterns in three-dimensional space. It was but a short step to pure abstraction, already indicated in his late works, particularly the landscapes. The following statements illustrate the misuse of Cézanne's cylinder-cone-sphere remark:

> Paul Cézanne is the fountainhead of many of the movements of modern art. . . . Out of his theory that nature could be reduced to the cube, the cone, and the cylinder came cubism: out of his insistence that what he painted were his sensations in the presence of nature came expressionism and other "isms."[15]

> He called increasingly on geometry to second his vision and built on the firm foundation he had detected in nature herself: the "cylinder, the cone, and the sphere."[16]

> It is fascinating to entertain the possibility that, had he lived a decade or so longer . . . he himself might have "invented" cubism. . . . Those late abstract landscapes and the sphere-cone-cylinder principle constitute the source to which, a generation thence, Picasso and Braque turned, and the base on which were predicated their cubist experiments.[17]

> Lui impruntant les principes de leur doctrine, ce sont les cubistes que "réaliseront" jusqu'à ses dernières conséquences l'intention de Cézanne. Ce sont eux qui traiteront vraiment la nature "par le cylindre, la sphère, le cône," développant ainsi avec logique la plus grande découverte qu'un peintre ait jamais faite depuis Paolo Uccello. . . . Cézanne a donc été le père des cubistes.[18]

> C'est surtout au Cubisme, et par delà, à la peinture abstraite tout entière, que l'art de Cézanne semble avoir donné l'essor. . . .Pour avoir écrit à Emile

Bernard . . . traiter la nature par le cylindre, la sphère, le cône . . . Cézanne sera le point de départ des théories qui progressivement arracheront la peinture à la figuration visuelle et lanceront l'art moderne sur la voie ou nous le voyons engagé.[19]

The majority of critics over a substantial period of time seem to agree that Cézanne's abstract geometry owes little to formal relationships in nature. Rather, they interpret it as a reflection of a predilection for the play of volumes and rhythms in space as they fluctuate between surface and depth. This view has survived in the recent contention of Geneviève Monnier that Cézanne's late watercolors are to be understood as "geometrical layouts, modulating certain elements and facets of volumes that pave the way to cubism." Throughout her analysis, Monnier evokes cubist correspondences by aligning Cézanne's "fragmented vision," "effects of transparency," "contrasts, oppositions, and contradictions" with developments subsequent to his art.[20] This is a contemporary restatement of the previously dominant critical position on Cézanne that has emerged in various guises throughout the century. The various paintings of Gardanne and the renowned Mont Sainte-Victoire are seen as a succession of increasingly abstract works whose faceting and dissolution of form point provocatively to cubism.[21]

In addition to Cézanne's geometrization, his faceting of planes, his surface patterning, and his various other compositional distortions, his awareness of the flatness of the two-dimensional picture plane stands apart as a major contribution to cubism. Critic Clement Greenberg, one of the more ardent contemporary exponents of the cubist theory, proposes that Cézanne progressed from a literal rendition of the illusion of the third dimension to the configuration of the picture itself as an object or flat surface. Flatness, of course, need not compromise the representation of reality as the art of the Byzantine, Carolingian, or Gothic periods demonstrate, although these are nonnaturalistic conceptions. As Alois Riegl states, "every art style aims at the faithful reproduction of nature and nothing else, but each has its own mode of apprehending nature."[22] Greenberg's use of the term "literal" is ambiguous in any case, for Egyptian painting respected a flat surface whose "literal" nature did not necessitate the illusion of the third dimension. Nevertheless, Greenberg states, "Once 'human interest' had been excluded, every visual sensation produced by the subject became equally important. Both the picture as picture, and space as space, became tighter and tauter."[23] Greenberg erroneously assumes here that Cézanne's treatment of objects as having equal importance in the picture space implies a rejection of "human interest" or subject matter. He feels that the medium itself is the responsible agent in this development, as it led to the recognition of the shape and position of the flat rectangle that was being covered with

pigment (something which is true of most historic painting that is representational). Nevertheless, it is this element in Cézanne's works of the last ten to fifteen years of his life that Greenberg feels led to the discovery of cubism. "The illusion of depth is constructed with the surface plane more vividly . . . [and] the facet planes may jump back and forth between the surface and the images they create, yet they are one with both surface and image."[24]

Erle Loran provides support for Greenberg's cubistic descriptions with his emphasis on multiple eye levels in one picture; the shattered, intersecting planes; and the play and tension between axes throughout a painting as his detailed diagrams attempt to reveal. Whether or not they are intentional, the distortions in Cézanne's paintings imply, in Loran's opinion, a deviation from some kind of preestablished norm for representing reality. Like Roger Fry, he does not deny that Cézanne always worked from nature. Few critics would do so in light of the fact that his paintings are so easily traced to their subjects. Loran's point, however, is that it is not a direct translation of nature into paint, but a formalistic approach in which the artist uses nature as a pretext for a constructed "emotional, nonrealistic illusion of space."

> The last distortion explained in the diagram [*Still Life with Basket of Fruit*] recalls Cézanne's habit of tipping the vertical axes of nature to the right or left. . . . The play and tension between axes continues throughout the entire painting. . . . The conflict and dualism of static and dynamic axes, the plane tensions resulting from the shifting of eye levels, the action of three-dimensional space forced to maintain its relation to the picture plane—these are the elements of the inner life of Cézanne's art.[25]

Although somewhat exaggerated, this statement need not conflict with Cézanne's representational intentions. It ignores the possibility that these devices, for Cézanne, were the instruments by which he could make images look more real and convincing (compared to what he considered to be the lifeless quality of naturalism with its slavish imitation of reality). Instead, Loran and Greenberg justify their ideas of revolutionary development by exploiting the contradictions between Cézanne's statements and his art. As Greenberg states, "I prefer to think with Erle Loran . . . that the master himself was more than a little confused in his theorizing about his art. But did he not complain that Bernard, with his appetite for theories, forced him to theorize unduly?"[26] It is difficult to accept discrepancies between art theory and art practice on the grounds that Cézanne was not a theorist or, at best, was a contradictory or incoherent one, and that he apparently understood his own art less than critics who later chose to interpret it in their own fashion. It is true to a certain extent that Cézanne did not elaborate on many aspects of his art,

yet it also seems, in this case, that those critics who lament his inability to theorize and "realize" his goals are too heavily dependent upon his writings and not the visual evidence of his art which alone can illuminate them. Critics are perplexed by his contradictions, failing to see in them a projection of their own inconsistencies when an interpretation does not coincide with what Cézanne said he was attempting to achieve. For example: "Since Cézanne's space does not work in accordance with his formula, we ought completely to disregard the statement, except to note that it represents his failure to work out an intellectual theory coinciding with his creative production."[27] Rather than face the invalidation of their fashionable interpretations, critics accuse Cézanne of an insufficient comprehension of his own theories and an inability to verbalize clearly what he produced concretely. Lionello Venturi expresses this erroneous view with an aim to exonerate the artist:

> Cézanne n'élabora jamais de théorie. Il exprime, sans prétention, certaines de ses expériences et certaines de ses refléxions, qui n'avaient d'autre valeur que d'incitation au travail, d'affirmation du goût, de justification de son art, mais qui n'avaient pas la moindre prétention de devenir des règles de l'art à venir. Plusieurs écrivains interprétèrent les réflexions de Cézanne comme des lois esthétiques, et les organisèrent à leur façon en les modifiant, avec la meilleure intention du monde.[28]

On the other hand, Cézanne's aversion to abtruse theory is also evident. As a painter, he was concerned with the representation of nature and no doubt felt that he did not need to justify his art beyond the clear and simple statements he had already presented. Most likely he was totally unaware of the direction that the criticism of his art would take on the basis of a few aphoristic remarks. As he himself stated, "I do not want to be right in theory, but in nature."[29]

Nevertheless, rationalization is often provided by Cézanne's lamentations regarding his failure or inability to "realize his sensations" and his premonition that he was the "primitive of a new art." The interpretations of the exact meaning of such terms as *sensation* and *realization* vary among critics. Some critics feel that realizing meant the handling of his means of expression, and by not realizing, Cézanne did not have enough skill or fluency to permit the highest qualities of his art to be felt. His own quotations exhibit an awareness of his limitations and his lack of ability to carry out his prescribed goal. For this reason "he accepted certain objections concerning his 'lack of draftsmanship' and his 'immoderate use of color,' since he felt himself still far from the goal to be attained."[30]

In addition, it must be clarified that, like Gauguin and Van Gogh,

Cézanne, in several instances, inadvertently succumbs to the dualistic language of the nineteenth century. Sensation and emotion should not be considered as separate in experience since all perceptions have emotional components, including the emotion of being "emotionally neutral" or literal and the emotion of being materialistic or mechanistic. When a language separates and hypostatizes perception and emotion as separate entities, there is the difficult problem for the artist to express verbally experiences where these concepts are fused since the language blocks him, providing no appropriate words.

Kurt Badt has attempted to define Cézanne's use of the terms *realization* and *sensation* more precisely: "To represent the interrelationships which he discovered in the real world in such a fashion that clear images of objects ultimately emerged . . . and to obtain the means to do this through observation of nature itself, was what constituted the essence of the problem of realization in Cézanne's mind, a problem which he himself frequently described as the crux of his endeavors."[31] In this process of realization, Badt is careful to point out that nature played an important role as the goal, medium, and starting point for an artistic interpretation of the appearance of real things. The relationship between objects in space is the limit determining Cézanne's expression of what he felt to be the true nature of the real world; and this expression constituted what he wanted people to see as parallel to nature, not as a reproduction of her. Badt demonstrates the way in which Cézanne employed the term in three ways: (1) "'J'ai réalisé quelque progrès:' the normal usage which implies 'I have aimed at progress and have achieved something better than before.'" (2) "'Ma réalisation en art'—the absolute meaning—'I believe I come nearer to it everyday, even though it costs me some pain.'" (3) "'I am so slow in my 'realization' and an very sorrowful about it.'"[32] In every sense, however, realization is ultimately bound up with nature. As Cézanne said, "In order to realize any progress there is only nature. . . . I must realize in the presence of nature."[33] Cézanne's own statements actually reveal his intentions as a representational painter; and it is ironic that an artist supposedly so preoccupied with integrating impressionism with solidity of construction and spatial illusion could lead, within a few years of his death, to a kind of painting as flat as that of the gothic era.

Bringing the cubist equation up to date, although he is not the only recent critic to propose an evolutionary connection between Cézanne and cubism, William Rubin in his essay "Cézannisme and the Beginnings of Cubism"[34] has singularly provoked a complete reassessment of the exact historical origins of cubism. Rubin artfully demonstrates (on the basis of little-known work) a crucial continuity from Cézanne to cubism via Braque that has been virtually ignored in favor of the ac-

cepted standard position that attributes the invention of the new style largely to Picasso (with emergent developments resulting from the subsequent Picasso-Braque dialogue).

Predicating his argument upon a fundamental distinction between a conceptual versus a perceptual approach to representation in art, Rubin concludes that "the majority of the so-called 'distortions' in Cézanne's paintings . . . have no connection with perception. . . . These alternations of nature (I prefer this to 'distortions') in favor of the picture's compositional structure constitute collectively a sophisticated form of conceptualizing that challenges many of Cézanne's own dicta and suggest that the difference in method between him and the cubist was as much one of degree as of kind."[35]

The decisive evidence behind Rubin's allegations concerning Braque's preemption of credit for the invention of the "cubist syntax" consists of Cézanne's *passage* of planes, "precisely the means which—extrapolated to meet new needs—would henceforth characterize Braque's cubism and set it in advance of Picasso's."[36] Rubin continually reiterates notions of "advancement" and "a logical progression" of style. Because Picasso's work early in 1908 did not include a consistent system of *passage* (a stepwise linkage and fusion of close-valued planes in a shallow, bas-relief space heralded as the proto-cubist invention of Cézanne and perpetuated by Braque as early as 1907 in *Landscape with Houses*), he could not possibly be responsible for the origination of cubism. Cézanne is said never to play quite the role in Picasso's evolution that he did in Braque's. Thus, it must be concluded that if Braque is the true pioneer and real cubist innovator of the two artists, then his direct forebear in this regard is Paul Cézanne.

Rubin's argument provoked a polemical response from Leo Steinberg, who preferred to throw the whole issue into the open once again, rather than accept Rubin's tactical evolutionary theory of art.[37] "Rubin's position seems clear enough. He conceives the syntax of early analytical cubism as a procedural system 'extrapolated' by Braque from a single source [Cézanne], and subsequently obeyed by both Braque and Picasso. . . . He never forgets that if Braque is to be ahead of Picasso at any point, both men must first have been placed on the same track and given a common object."[38] Steinberg's disquisition on Rubin's critical shortcomings promptly elicited a new flexure of the critic's cerebral muscles in his turn, and the debate rages on.

Several conclusions can be drawn from this debate in which both parties refuse to succumb to the conflicting empirical evidence and impassioned postulates of the other. Discrepancies over the origins of cubism as well as over Cézanne's own intentions in this regard imply that a perceptual reading of the works themselves cannot arbitrate the lingering

dispute. Rubin's revolutionary reassignment of cubist stylistic invention from Picasso to Braque (in tandem with Cézanne) does not produce a conclusive argument for Steinberg, despite his self-imposed descriptive objectivity.

A portion of the problem stems from contradictory notions of cubism and the essential features by which one may define the style. Rubin's assumption that there exists a set of necessary and sufficient properties designating what is cubist and what is not is challenged by Steinberg. Of particular concern is the speculative role of African influence that Rubin eliminates from his essential definition but that Steinberg prefers to regard as more than a peripheral element. Despite the fact that both Rubin and Steinberg direct attention away from the previous superficial correlation of cubism with Cézanne's "geometricization" of forms in nature, Rubin appears to strain and struggle through a linear conception of stylistic development by which cubism springs, presumably full-blown, from Braque's "integral awareness" of Cézanne's work. To dismiss African art as circumstantial (most likely because it dilutes Cézanne's importance), is almost to imply that somehow cubism is foretold in the artist's late work. Rubin's overall argument postulating the culmination of Cézanne's art in cubism is an erroneous product of an adherence, consciously or not, to the "destination model" of period styles.

The arguments presented by previous critics advocating Cézanne's steady progression to cubism, as he evolved from incompetent representation to formalistic abstraction, corroborate the prevalence of this destination model which continues to underlie more recent criticism. In order to account for the innate dynamics of style, James Ackerman states that all of the major art-historical theories have been determinist in the sense that they define a preordained pattern of evolution: the earlier phase of a style is destined to move toward the later. If it is the destiny of styles to evolve as they did, then those works of art that promoted the evolution (such as Cézanne to cubism) are destiny-fulfilling, and those works that did not are destiny-denying. Placing Cézanne's later work in the former category immediately denotes a value judgment. The implication is that the chief function of any work of art is to contribute toward the works that follow it in a sequence: the greater the contribution, the more significant the work.

Though it is not the purpose of this essay to deny significance to the art of Paul Cézanne, nor to deny that, in retrospect, his influence on cubism is indisputable, it is nevertheless important to demonstrate that his legacy alone should not be the determining factor of his role in the history of art. Should Cézanne be considered any less important if he were merely an artist representative of his time in the late nineteenth

century, in the tradition of representational conventions, and an artist very much inspired by the art of the past? Ackerman is again instructive here in pointing out that

> we cannot erase our image of the totality of a style process in the past, but this need not discourage us from trying to interpret a work of art in terms of its proper context rather than its effects by gaining perspectives *within* the process at points short of its termination. . . . Given our habits of hindsight, it is necessary to add that he [the artist] is not aware of the works that will follow his; he knows only the past and present. He accepts and rejects aspects of what he finds in things about him and he adds something of his own. By this choice and by his contribution he moves a step—sometimes a leap—away from the past. Are we, then, justified in saying that he has moved toward the future?[39]

The artist, then, may happen to contribute to the future, but only by having concentrated primarily on making something intrinsically worthwhile in the present. What is called evolution in the arts should therefore not be described as a succession of steps toward a solution to a given problem, but as a succession of steps away from one or more original statements of a problem. Each step is a probe that exhausts a given imaginative range; he cannot consciously make a transition to a succeeding step, for if he conceives of something new he presumably will engage himself in the task. We cannot properly speak of a sequence of solutions to a given problem, since with each solution the nature of the problem changes.

Arnold Hauser concurs with this view in his *Philosophy of Art History* when he warns of mechanistic conceptions of history. He maintains that a style comes gradually into being and develops as the result of a dialectic between the works that are in progress at the moment and those that already exist and are influential. Just as the true meaning and the success or failure of a work of art remains an open question and the goal of doubtful struggle until the last finishing touch has been given, so we can hardly tell where a style will lead until it has finished its course and spoken its last word.[40] Hauser further asserts that, although works of art acquire historical meaning in relationship to works that have gone before and come after, this has no bearing on the artist's intentions nor on the aesthetic apprehension of individual works. He warns that a great danger for art history is that it should become a mere history of forms and problems. Let it once yield to this danger, and not only the individual works and the personalities of the artists, but also the particular conditions of the historical situation, come to seem more or less irrelevant. Art history is concerned mainly with trends and movements in the field of art; yet the only artistic reality is the work of art. All concepts are risky

abstractions if they go beyond the single, individual, concrete object of an aesthetic experience in order to embrace a number of different works in some later style.[41]

Hauser's admonition that a work of art can become just an illustration of problems of form seems to have gone unheeded by the adherents of the viewpoint that Cézanne was consciously paving the way toward complete abstraction. It must be remembered that Cézanne was never completely abstract, however simplified some canvasses may appear to those unfamiliar with his motifs. Though he eliminated what he felt to be nonessential, he never renounced representation or attempted to manipulate visual reality in the manner of the cubists.[42] All artists are to a degree involved in "formal problems," however this must not be admired as the exclusive interest of an artist such as Cézanne.

E. H. Gombrich in *Art and Illusion* points out that these kinds of assumptions can occur when complete fidelity to a current form of objective visual experience becomes both a moral and an aesthetic imperative, as was the case in the late nineteenth century. Cézanne had realized that if you were faithful to your localized vision of every detail of surfaces, the equation would not work out, i.e., the elements would not fuse into convincing whole. New principles of selection, emphasis, and organization had to be designed to express nature when seen as a unified architecture of volumes. For Gombrich, style rules even where the artist wishes to reproduce nature faithfully from an integral point of view. Moreover, "the artist, clearly, can render only what his tool and his medium are capable of rendering. His technique restricts his freedom of choice."[43]

Apparently, the key to the misinterpretation of Cézanne's method stems from his relationship to traditional concepts of space. The disregard of the rules of scientific perspective or the rearrangement of forms to solve particular pictorial problems that did not coincide with traditional methods were clear indications to critics conditioned by naturalism that Cézanne was consciously distorting his vision of things in a proto-cubist manner. Loran and others fail to see that this disregard for "infallible pictorial perspective" is seen in the work of many great representational painters, whether it be in the construction of the human anatomy or in the arbitrary use of cast shadows or different eye levels. Furthermore, Gombrich's well-known theories negate completely the conceptual-perceptual dichotomy that is at the heart of Rubin's argument. If all art is conceptual to some degree, it must not be assumed that an artist who deviates from his perceptual experience is thereby rejecting reality in favor of a plastic orientation that is somehow at odds with representation. Rubin begins to hedge when he states that "few if any artists are entirely conscious of their enterprise, and therefore of the manner in which the changing directions in their art may transcend the frames of reference imposed by their moment in time."[44] However, his

underlying propensity for a consecutive order breaks through his initial caution. For Rubin, Cézanne's influence cannot be disengaged from the history of cubism, and conversely, the experience of cubism has completely altered the way in which we see Cézanne. Viewing Cézanne with a postcubist bias has prevented Rubin and others from observing that purely abstract art would have been alien to Cézanne, for it would have denied the fidelity to nature that was his lifelong inspiration. Any features in his art that might be described as cubistic are actually products of his communication with nature, despite stylistic transformations meant to express a personal response to visual experience.

In analyzing the problems inherent in the formalist or cubist approach to Cézanne's art, it can be proposed that, once it has been recognized that the invariable role of the medium influences the representation of visual reality, Cézanne's formal concerns, such as his innovations with space and perspective or his fascination with geometric volumes, become manifestations of a stylistic preference rather than a conscious will-to-distortion. Cézanne did not begin with a prefixed stylistic framework that he imposed on nature. Rather, he began with nature, looking at it with scrutiny and recognizing its inherent individuality. From this recognition, he exploited its particular characteristics to develop a style that he felt corresponded as closely as possible to his aesthetic perception of nature, however much in a nonnaturalistic manner. Cézanne was constantly grappling with the relationship between art and nature, but not in the strict imitative terms of scientific naturalism. Nature always supplied the grounds for his art, the function of which was to comment on the natural world within the limits of its own multiple possibilities rather than to describe "mere outward appearances."[45] When Cézanne states that one must be more or less master of one's model and, above all of his means of expression, he demonstrates his awareness of the way the artist's vision necessitates the transformation of a motif to convey a personal interpretation of visible nature.

It has been stated that the cubist theory takes its primary source of inspiration from the much-abused quotation concerning the cylinder, the cone, and the sphere, which is often cited as presaging cubism. This statement clearly denotes a method of constructing space to recover the solidity lost by the impressionists. It in no way compromises his original representational intentions. Though some of his late paintings and watercolors did become simplified and abstract when compared to earlier works, they never lost contact with the motif. Purely abstract or nonobjective art would have been alien to Cézanne, for it would have denied the fidelity to nature that was his life-long inspiration. Any features in Cézanne's art that one might describe as "cubistic" are products of his communication with nature despite any stylistic transformations he may exhibit to express a personal, visual experience.[46]

The fatal remark that all forms in nature can be reduced to the cylinder, the cone, and the sphere apparently had become an end in itself for the cubists, rather than simply the means to an end. Cézanne's allusion to the simple geometry of nature was taken literally and seriously by a generation of artists too susceptible to theories of evolutionary development and lacking in a careful observation of the works themselves. An examination of Cézanne's statements about L'Estaque, which inspired a group of paintings singled out as particularly proto-cubist, shows the way in which theorists and art historians not only ignore the visual evidence, but the written as well, as the following quotation illustrates:

> "As you say," Cézanne wrote from L'Estaque to Zola, "there are some very beautiful views here. The difficulty is to reproduce them. . . . I began to perceive nature rather late, though this does not prevent it being full of interest to me." A letter to Pissarro reveals the strong emotion aroused in Cézanne by the view of the beautiful bay of L'Estaque: "It is like a playing card. Red roofs on the blue sea. The sun is so terrifying that it seems as though the objects are silhouetted, not only in black and white, but in blue, red, brown, and violet. I may be mistaken, but it seems to me the very opposite of modeling."[47]

From this example, it may be said that Cézanne's flattening of pictorial space is based upon a motif in nature as flat to his eye as a playing card; and his use of line or drawing is a direct response to the silhouetted forms outlined by the intense light of the Mediterranean sun. As a result, Cézanne's divergence from the purely plastic orientation of cubism becomes apparent.

Whereas the cubists reduced Cézanne's aesthetic to an extreme stylization of reality, forcing his procedures into molds of abstraction stressing geometrical patternization, Cézanne's attention was primarily on nature. Other than the obvious fact that there are no pure "cylinders, cones, and spheres" in his paintings, what many see as cubistic elements are, in fact, motifs from reality itself. Unlike the cubists who superimposed a geometric framework on reality, Cézanne started with reality in an inverse relationship in which he perceived geometrical relationships between forms and developed a corresponding pictorial representation. "I believe in the logical development of everything we see and feel through the study of nature and turn my attention to technical questions later; for technical problems are for us only the means of making the public feel what we painters feel and of making ourselves understood."[48] Critics such as Erle Loran, Clement Greenberg, or William Rubin, who devalue Cézanne's relationship to nature in order to play up his incipient modernism, ignore the role of nature simply because the limitation of their conception of art history as an evolutionary process (in line with the

destination model) allows them to perceive in his work only an artful design of planes instead of a valid representation of nature. If cubism never developed, would Cézanne still be appreciated today as a modernist? Undoubtedly many such critics would find him less exciting and revolutionary.[49]

Despite Cézanne's reputation as the father of modern art and as an apostate of nineteenth-century values, persistently acknowledged by subsequent generations of painters and critics, it is imperative to maintain that his influence on such a movement as cubism does not necessarily have any bearing on his own intentions. The cubists' misinterpretation of the artist as a master for whom nature was sphere, cone, and cylinder has been effectively extirpated by critics such as Theodore Reff, who notes that such a reclassification of nature had more to do with the type of teaching in French schools at the time Cézanne was young than with any conscious will-to-form that anticipates or even creates cubism. Cézanne's oft-quoted and much-abused remark about the geometry of nature is merely an elementary rule-of-thumb for depicting actual objects. Furthermore, "these so-called *passages*, which were soon to be employed more systematically in analytic cubism, were probably not conceived as such, but resulted from Cézanne's habit of alternating between color and line in the slow, cumulative shaping of a form."[50] In any case, categories and labels are superficial at best and are convenient only for the purposes of evolutionary art history. Cézanne's art is not a simple continuation of previous movements, nor is it a revolutionary reversal that leads directly to cubism and abstract art. However innovative his pictorial structure may appear to those with a preconceived mental image of what a representation of reality ought to be, this structure must be seen as a valid alternative mode of translating his visual experience of nature in terms of the particular medium employed. His art, like a second nature, is able to capture the essence of Provence, albeit in a more modern pictorial language than the nineteenth century had previously known.

Notes

1. Alfred Werner, Introduction to *Cézanne: A Study of His Development*, by Roger Fry (New York: Noonday Press, 1966), p. i. With the exception of Georges Rivière and a number of others (including Dr. Gachet, Chocquet, Théodore Duret, Gustave Geffroy, Maurice Denis, Emile Barnard, Charles Camoin, Gaston Bernheim de Villers, Edmond Jaloux, Joachim Gasquet, Léo Larguier, Louis Aurenche), none of the more advanced critics of the day suspected before 1905 the importance that would be conceded to this disconcerting master by future generations.

2. John Rewald, *Cézanne: A Biography* (New York: Schocken Books, 1968), p. 107.

3. Mary L. Kamp, "Cézanne's Critics," *Baltimore Museum of Art News* (1957):10. This

article provides a good summary of the criticism of Cézanne's art at the end of the nineteenth century.

4. From 1914 on, with the English critics Roger Fry and Clive Bell, nearly all critical attention was paid to Cézanne's form rather than to his concept. This might be the origin of the divorce between representation and formal abstraction in his work. for example: "Here the 'crystallization' of the forms is complete [*La Route du Château Noir*]. The planes interjoin and interpenetrate to build a design where the complexity does not endanger the lucidity of the relations. Not only has Cézanne's notion of plasticity and of the plastic continuity here attained its plenitude, but the artist controls it with perfect freedom. . . . We find this last phase a tendency to break up the volumes, to arrive almost at a refusal to accept the unity of each project, to allow the planes to move freely in space. We get, in fact, a kind of abstract system of plastic rhythms" (Roger Fry, *Cézanne, A Study of His Development* [New York: Noonday Press, 1958], pp. 75–76).

5. Cézanne's formal preoccupations and innovations seemed to indicate a new direction in painting like that of Gauguin and Van Gogh. According to Gustave Geffroy, "Cézanne has become a kind of precursor to whom the symbolists have referred, and it is quite certain, to stick to the facts, that there is a direct relation, a clearly established continuity between the painting of Cézanne and that of Gauguin, Emile Bernard, etc. . . . From this point of view alone, Paul Cézanne deserves that his name be put into the place that is his" (Linda Nochlin, *Impressionism and Post-Impressionism 1874–1904: Sources and Documents* [Englewood Cliffs, N.J.: Prentice-Hall, Inc., 1966], p. 104). From *Le Journal*, March 25, 1894). A few critics even go so far as to relate Cézanne directly to synthetism: "La même conviction qu'il ne faut pas essayer de rendre la nature, mais une émotion équivalente à celle qu'on a ressentie en sa présence; même volonté de synthèse, synthèse qui devra être exprimée à la fois par la couleur et par le dessin" (Charles Chassé, *Le Mouvement idéiste dans l'art du XIXᵉ siècle* [Paris: Librairie Floury, 1947], p. 98). In addition, for Denis, Cézanne conforms perfectly to his emphasis on the work of art "as a flat plane covered with colors assembled in a certain order." Thus, for Denis, Cézanne should be aesthetically appreciated for his quality of design rather than for a viable rendering of nature. It was this idea of Cézanne as the spiritual father of symbolism that was carried on by later exponents of expressionism. The emphasis on subjective states and emotional equivalents no doubt had as much influence on the expressionist theory as the rejection of naturalism. The symbolist interpretation is actually closely associated with the expressionist theory in that its premises are founded on the same dualistic misconceptions that spawned the latter viewpoint. This theory is not so widely held today, although it does have its contemporary adherents. (See Meyer Schapiro, *Paul Cézanne* [Paris: Nouvelles Editions Françaises, 1956], and "The Apples of Cézanne: An Essay on the Meaning of Still Life," *Art News Annual* 34 [1968]:35–53, concerning Cézanne's predilection for various depictions of solitude, loneliness, hopelessness, and romantic passion which Schapiro feels is a symbolic expression of Cézanne's inner emotional world). Also: "The artist painted in order to give expression to his own inner attitudes . . . Beneath the surface of his representations a 'motive force' lay hidden which compelled him and stimulated him at the same time to make violent alterations to the normal forms of real things as they are usually apprehended" (Kurt Badt, *The Art of Cézanne* [London: Faber & Faber, 1965], p. 124). These distortions are proof, for Badt, that under the guise of an intense objectivity, Cézanne is really portraying only the inner state of his own ego in paintings such as the *Cardplayers, Baigneurs, Mardi Gras*, etc.

Although the label *expressionist* did not come until 1910 with Roger Fry, the germination of the idea is no doubt also rooted in the early assumptions that Cézanne was technically incompetent or that he had defective eyesight resulting in the deformation of objective vision and the departure from traditional means of pictorial expression. Yet only after 1910 did the idea arise that he was consciously striving toward something more

subjective, unique, and personal, i.e., expressionism. Fry's description of *Two Men Playing Cards* perhaps sums up his opinion of Cézanne's early work as a whole: "The ardent and restless romanticism of Cézanne's temper outweighs the visual data of any actual scene" (Fry, p. 9). In this statement, Fry is implying that Cézanne's work is "romantic" in the sense of subjective and eccentric. This contrasts with the view of Cézanne's early work as "romantic" in the literary sense of subject matter rendered with passion such as in the artist's preoccupation with sensuality as well as in the intense emotional expression these early works display. Although Cézanne, in this sense, is not basically different from Delacroix in emotional expression, the fact that he was technically less knowledgeable led such critics as Fry to assume that he was more "expressionistic" in terms of emotionalism or private fantasy for its own sake. "*The Lazarus, The Autopsy, The Banquet*, and a number of other compositions are there to prove how large a part of Cézanne's activities were absorbed by this preoccupation (self-expression) during his early period. In all these works he set out to realize his inner vision without reference to actual models" (ibid., p. 10).

Fry goes on to point out the close dependence of Cézanne upon the Venetians, the baroque, and Delacroix. "What he found in the baroque painters was the response to the agitated, romantic exaltation of mood" (ibid., p. 15. Examples: *L'Eternel Féminin* compared with Delacroix's *Death of Sardanapalus*). Fry, perhaps not unjustly, criticizes Cézanne in certain works for his apparent lack of success in paintings of this type because of his failure to employ the direct observation of nature in the service of his art. However, he feels that even when Cézanne does work from nature (*Portrait of the Artist, Toits Rouges, Head of a Bearded Man, Advocate in His Robes*) he continues to express himself in this dramatic and exaggerated romantic style. Of course, Fry does recognize the change in Cézanne's art after his contact with the impressionists, yet the idea of emotional expression for its own sake is carried on later, transformed into a kind of formalist-expressionist theory: "Cézanne has realized his early dream of a picture [*La Route du Château Noir*] not only controlled but inspired by the necessities of the spirit, a picture which owes nothing to the data of actual vision . . . It lies not by way of willed and *a priori* invention, but through the acceptance and final assimilation of appearance" (ibid., p. 77). After a period of formal expressionism (constructive-compositional preoccupations), Cézanne, in his late work, once again returns to what had never really been expelled from his art in Fry's opinion. "*Vallier* [portrait of his gardener] . . . is typical of a good many portraits of these years. . . . Once more, at this moment of recrudescent romantic emotion, Cézanne was haunted by his old dream of the *a priori* creation of a design that should directly embody the emotions of his inner life" (ibid., p. 81. Fry also refers here to the *Bathers*). The following quotations provide some later examples of this attitude:

> Already during Cézanne's lifetime, critics accustomed to the naturalistic detail and slick finish of drawing were shocked by the brutality of his distortions [*Bathers*]. . . . It was this intensity of expression that appealed to young artists in the early twentieth century [Theodore Reff, "Cézanne: The Enigma of the Nude," *Art News* 58 [1959]:28, 68].

> In his desire to discipline his art and give it a more formal structure, he became an inverted expressionist: the fervor of his brushstrokes, let alone the agonized impurity of his drawing, is indicative of his inability to renounce the passionate and highly emotional basis of his art [John Coplans, *Cézanne Watercolors* (Los Angeles: Ward Ritchie Press, 1967), p. 15].

6. Georges H. Hamilton, "Cézanne, Bergson and the Image of Time," *College Art Journal* 16 (1956):2–3.

7. Meyer Schapiro, *Paul Cézanne* (Paris: Nouvelles Editions Françaises, 1956), p. 14.

8. "The Bay of Marseilles, seen from l'Estaque . . . he painted it several times . . . between 1883 and 1885. In reality, the mountains seen from L'Estaque are many miles

farther away and hence can be seen but vaguely. To indicate their structure, Cézanne brought them forward. . . . He abstracted both foreground and background from their real positions, and he excluded from the space of the picture the place where he was standing and hence every subjective reference. . . . Cézanne thus organized an objective relationship between the village, the sea, and the mountain, an objective not with respect to nature, but with respect to the picture, to art" (Lionello Venturi, *Impressionists and Symbolists* [New York: Charles Scribner's Sons, 1947–50], p. 133).

9. "Plus encore que dans les vues de l'Estaque, la construction devient, dans les paysages de Gardanne, une création purement intellectuelle, sans reférence directe aux données de la nature. Certes le réel y est présent, mais transposé par l'imagination et les speculations de l'esprit" (Frank Elgar, *Cézanne* [Paris: Aiméry-Somogy, 1968], p. 105).

10. See note 4. In addition: "Color becomes increasingly dominant, outlines provide only the barest indication of masses. Color dissolves shapes and fuses one form with another, giving an abstract appearance to the surface—a concern more and more with the interweaving of color planes to define space and relate different areas of the picture to one another. The late paintings, with their freely floating color patches, were as close as Cézanne ever came to an abstract art" (Richard W. Murphy, *The World of Cézanne* [New York: Time-Life Books, 1968], p. 145).

"*Cabanon de Jourdan* . . . [deals] exclusively in a brilliant patchwork of color rhythms carried to a disembodied extreme of pictorial abstraction" (Maurice Raynal, *Cézanne* [Paris: Editions Cluny, 1936], p. 114).

11. "Sous la réalité apparente, il a découvert une réalité profonde: les formes naturelles, têtes, arbres, montagnes, vases, fleurs, deviennent pour lui formes géométriques. Il ne copie pas, il crée" (M. de Langle de Cary, *Cézanne* [Paris: Caritas, 1957], p. 59).

"Here, then, was a favourable condition for the necessity which Cézanne felt so strongly of discovering always in the appearance of nature an underlying principle of geometric harmony. . . . It is characteristic of Cézanne's method of interpreting form, thus to seize on a few clearly related, almost geometrical elements" (Fry, pp. 64, 75).

"Ce qu'il cherchait était une discipline, un ordre nouveau . . . Cette discipline, il la trouve dans les lois intrinsèques de la forme qu'il émancipe des formes impures de la nature en réduisant celle-ci à ses essences géometriques" (Pierre-Henri Gonthier, *Cézanne* [Paris: Pierre Tisné, 1962], p. 7).

"The radical realism of the impressionists and their color theories destroyed the possibility of producing space even with newly developed non-perspective conventions. Cézanne . . . took on the whole problem of reconstructing form in space . . . In freely describing his paths of movement over the objects in nature, he distorted them to achieve maximum believability for the spaces and volumes represented" (Gabriel Laderman, "The Importance of Cézanne," *Art News* 65 [1966]:40).

12. "It seems clear that the main current of modernism proceeds in a line from Cézanne through the fauves and the cubists to the several contemporary groups that are usually explained as 'form seeking'" (Sheldon Cheney, *Expressionism in Art* [New York: Tudor, 1934], p. 57).

"The geometrical play of spherical against angular forms in his latest work creates an abstract synthesis that forecasts cubism" (Morris Davidson, *An Approach to Modern Painting* [New York: Coward McCann, 1948], p. 77).

"The cubism of Picasso, Braque and Leger completed what Cézanne has begun. . . . Cézanne could offer the cubists all the resources of a new discovery: they needed to expend little effort of their own in either discovery or rediscovery" (Clement Greenberg, *Art and Culture* [Boston: Beacon Press, 1965], p. 57).

"The young modernists . . . saw in him the precursor of their own theories. Especially

for the generation that created cubism he became a kind of god" (Réné Huyghe, *Cézanne* [London: Oldbourne Press, 1961], pp. 7, 12).

"L'obsession de décomposer le visage humain d'en rendre les volumes par le seul jeu de plans, est constanté dans l'oeuvre de Cézanne. Elle apparaît dejà dans ce dessin de 1865 (autoportrait) ou le découpage du visage par facettes contient une amorce de cubisme" (P. de Boisdeffre, Pierre Cabanne, et al., *Cézanne* [Paris: Hachette, Collection Génies et Réalites, 1966], p. 171).

"Les rochers de *La Carrière de Bibemus* . . . se disloquent en plans entassés les uns derrière les autres selon une méthode qui semble annoncer les expériences cubistes" (N. Ponente and P. Cabanne, *Cézanne* [Paris: Hachette, 1968], pp. 5–6).

"*Nature Morte*, 1885–1900 . . . un aspect insolite du génie cézannien, et ce qui se manifeste dans la dernière période, concurrément à la resorption des solides dans la transparence d'un espace coloré, la démultiplication frénétique du cube, un véritable grouillement cristallin, qui annonce le cubisme analytique" (Gonthier, *Cézanne*, p. 27).

"Paul Cézanne is generally accepted as the first modern painter . . . In his assertion of the pictorial world as a paradigm rather than a simulacrum of nature. . . . Cézanne brought to its culmination the revolutionary efforts of the avant-garde of the nineteenth century and set forth the problems of the twentieth" (Nochlin, p. 83).

"En s'éscartant de la peinture réaliste, Cézanne a suscité la peinture abstraite. Par ses déformations réfléchies, il inspira les fauves. Sa géométrie des corps est le principe de ce qui fut appelé le cubisme" (Langle de Cary, p. 95).

13. In a letter to Emile Bernard of April 15, 1904: "May I repeat what I told you here: treat nature by the cylinder, the sphere, the cone, everything in proper perspective so that each side of an object or a plane is directed toward a central point" (Nochlin, pp. 91–92).

14. Je suis . . . le primitif d'un art nouveau . . . mais s'ils essaient en mon nom de créer une école, dis-leurs qu'ils n'ont jamais compris, aimé, ce que j'ai fait" (Boisdeffre, p. 263).

15. *Aspects of French Painting from Cézanne to Picasso, January 15 to March 2, 1941* (Los Angeles: Los Angeles County Museum of Art, 1941).

16. Raynal, p. 67.

17. Edward A. Jewell, *Paul Cézanne* (New York: Hyperion, 1944), p. 9.

18. Frank Elgar, *Cézanne* (Paris: Aiméry-Somogy, 1968), p. 269.

19. Pierre Leprohon, *Paul Cézanne* (Lyon: Editions et Imprimeries du Sud-Est, 1961), p. 97.

20. Geneviève Monnier, "The Late Watercolors," in *Cézanne: The Late Work*, ed. William Rubin (New York: Museum of Modern Art, 1977), p. 116. Similarly:"The recourse to planimetry, the only possibility of absolute control over a composition in which spatial unification is sought by reducing the components to a structure tending toward abstraction . . . this is the path the cubists were to adopt" (Liliane Brion-Guerry, "The Elusive Goal," Ibid., pp. 77–78).

21. "L'éperon de la montagne [Mont Sainte-Victoire] se dresse au loin exhaussé sur un espace qu'unifie le tumultueux jaillissement de la couleur, auquel le ciel même participe. La densité des choses est dissoute, transferée au pur jeu chromatique des tâches et des facettes. Par-delà fauvisme et cubisme" (Gilbert Gatellier, *Cézanne* [Paris: Bordas, 1968],p. 53).

"This painting [*Sainte-Victoire at Early Morning*], which is a late work of Cézanne's, reveals a great preoccupation with complex colorplane structures. Very few paintings by Cézanne appear to be more abstract, and it is generally understood that cubism developed from this type of picture" (Erle Loran, *Cézanne's Composition* [Berkeley: University of California Press, 1959], p. 102).

The paintings of the village of Gardanne are also cited as the forerunners of cubism: "Together they visited the sunbaked village of Gardanne whose polyhedral construction

gave rise to some of Cézanne's boldest simplifications. The way in which the chief elements of the composition are stressed brings to their shapes an almost schematic relief. They proclaim the origin of cubism" (Huyghe, p. 51).

"À partir de 1885, l'exécution de ses paysages de l'Estaque, du Jas de Bouffan, de Gardanne, sera gouvernée par une méthode rigoureusement géométrique, que les cubistes adopteront un quart de siècle plus tard et qu'ils sauront hardiment exploiter. . . . On a voulu voir dans les vues de Gardanne les prémices du cubisme" (Elgar, p. 100).

22. Arnold Hauser, *The Philosophy of Art History* (New York: Alfred A. Knopf, 1959), p. 223. Hauser comments on Riegl as follows: "Thus nature also takes on a historical character; not only does the means of representing it change, but the tasks it presents to the artist also change. It is therefore senseless to speak of naturalistic and unnaturalistic styles; for there can be no question of getting closer to or farther away from nature, but only of adopting one or another conception of nature" (ibid.).

23. Greenberg, p. 54.

24. Ibid., p. 277.

25. Loran, p. 77.

26. Greenberg, p. 56.

27. Loran, p. 8.

28. Lionello Venturi, *Cézanne: son art, son oeuvre* (Paris: Paul Rosenberg, 1936), p. 42.

29. Rewald, *Cézanne*, p. 201.

30. Ibid., p. 107.

31. Badt, p. 33

32. Ibid., p. 212.

33. Ibid., p. 213.

34. William Rubin, "Cézannisme and the Beginnings of Cubism," in *Cézanne, The Late Work*, pp. 151–202.

35. Ibid., p. 165.

36. Ibid.

37. Leo Steinberg, "Resisting Cézanne," *Art in America* 66 (1978):115–133; idem., "The Polemical Part," *Art in America* 67 (1979):115–27.

38. Steinberg, "The Polemical Part," p. 125. Rubin's rebuttal, "Pablo and Georges and Leo and Bill," appears in the same issue, pp. 128–47.

39. James Ackerman, "Style," *Art and Archaeology* (Englewood Cliffs, N.J.: Prentice-Hall, Inc., 1963), p. 173. He continues: "The pattern of style change, then, is not determined by any destiny or by a common goal, but by a succession of complex decisions as numerous as the works by which we have defined the style. We can detect a pattern or distinguish a common problem because each decision in turn, by its choice of elements that are to be retained or rejected, and by its innovations, gives to the whole a determinable configuration. The configuration may *appear* purposeful or predestined because each successive work retains something of those that precede it and because its innovations, though not anticipated in earlier works, are coherently related to them. But what actually motivates the process is a constant incidence of probings into the unknown, not a sequence of steps toward the perfect solution" (ibid., p. 175).

40. Hauser, p. 235.

41. Ibid., p. 161.

42. "What appeared [*Quarry at Bibemus*] to be a highly abstract synthesis of planes and geometric, linear movements, unrelated to anything I had ever seen in nature, became quite definitely the analysis and organization of a very specific place as is shown by the photograph of motif" (Loran, p. 115).

"Photographies démontreront de nouveau que les oeuvres de Cézanne sont des portraits de la nature d'un fidelité toute exceptionnelle" (John Rewald, "Cézanne au Château Noir," *L'Amour de l'Art* [1935]: 18).

"Ces compagnes de Provences . . . les maisons y sont tassées comme des pierres, les feuilles ne les changent pas, les angles des toits et des murs arrêtent dans la lumière des figures géométriques qui remènent naturellement l'esprit à des simplifications dont il retrouve la prétexte dans la nudité sèche et dure des rochers qui barrent l'horizon, du ciel généralement sans nuages, des troncs dépouillés de feuilles qui s'élancent droits et nets" (Elie Faure, *Histoire de l'Art*, vol. 4 [Paris: G. Crès, 1921–26], p. 420).

"To one who has visited the country in which Cézanne painted, the landscapes recall the living scene more vividly than any photograph. They contain the very essence of the place. One almost smells the pine trees and feels the heat of the Provençal sun" (Theodore Rousseau and Daniel C. Rich, *Cézanne Paintings, Watercolors and Drawings. A Loan Exhibition, The Art Institute of Chicago* [Chicago: Hillison & Etten Co., 1952], p. 7).

"After studying the upper section of the photograph of the motif [*Gardanne*] one might well conclude that the actual buildings were as forcefully and geometrically cubistic in reality as Cézanne has made them in his painting" (Loran, p. 122 [quoting Alfred H. Barr]).

"Sainte-Victoire . . . il l'a représentée une infinité de fois dans des peintures, dans des aquarelles et dans des dessins depuis ses premiers temps romantiques jusqu'à ses derniers moments . . . C'est un motif décoratif qui participe du motif naturel . . . L'interprétation de la réalité dans sa verité, dans son essence, sans la moindre velleité imaginaire reste, après 1872, base de las vision de Cézanne. Si les branchés des pins accompagnent la ligne de la montagne, ils ne représentent autre chose qu'une accentuation poétique de la vérité naturelle" (Venturi, *Cézanne: son art, son oeuvre*, p. 55).

43. E. H. Gombrich, *Art and Illusion* (New York: Phaidon, 1968), p. 65. "The features and relationships the pencil picks out will differ from those the brush can indicate. Sitting in front of his motif, pencil in hand, the artist will, therefore, look for those aspects which can be rendered in lines . . . while brush in hand, he sees in terms of masses" (ibid.).

44. Rubin, p. 189. Brion-Guerry is more insistent along these lines: "It is not Cézanne who was to take up this essential mutation of the pictorial values of Western painting. Moreover, he would not have agreed with it. But it is undeniable that he made it possible" (Brion-Guerry, p. 82).

45. "But you know all pictures painted inside, in the studio, will never be as good as the things done outside. . . . I see some superb things and I shall have to make up my mind only to do things out-of-doors. . . . But I must work—all things, particularly in art, are theory developed and applied in contact with nature" (H. B. Chipp, *Theories of Modern Art* [Berkeley: University of California Press, 1968], p. 16, from a letter to Emile Zola, Aix, October 19, 1886).

"The Louvre is the book in which we learn to read. We must not, however, be satisfied with retaining the beautiful formulas of our illustrious predecessors. Let us go forth and study beautiful nature, let us try to free our minds from them, let us strive to express ourselves according to our personal temperaments" (ibid., p. 20, from a letter to Emile Bernard, Aix, July 25, 1904).

"I am progressing very slowly, for nature reveals herself to me in very complex forms; and the progress needed is incessant. One must see one's model correctly and experience it in the right way; and furthermore, express oneself forcibly and with distinction" (F. B. Blanshard, *Retreat from Likeness in the Theory of Painting* [New York: Columbia University Press, 1949], pp. 92–93).

If the strong experience of nature . . . is the necessary basis for all conception of art on which rests the grandeur and beauty of all future work, the knowledge of the means of expressing our emotion is no less essential, and is only to be acquired through very long experience" (ibid., pp. 93–94).

46. "The same cubistic forms which surprise in some of landscapes he found, as these photographs show, in these scenes. Cézanne's only direct contribution to cubism lies merely in his choice of subjects" (John Rewald, "The Camera Verifies Cézanne's Water-Colours," *Art News* 43 [1944]:13).

"Cylinders, spheres, and cones are not to be seen in Cézanne's paintings: thus his statement expressed an ideal aspiration towards an organization of forms transcending nature—nothing more" (Lionello Venturi, *Impressionists and Symbolists*, p. 128).

"Although Cézanne's art is infinitely more systematic than that of the impressionists, the fact remains that he spoke too often of 'sensations' for us to believe that his painting was inspired by geometry instead of nature itself" (Bernard Myers, *Modern Art in the Making* [New York: Whittlesey House, 1950], p. 208).

"Cézanne ramenait à la sphère, au cône et au cylindre tous les aspects de la nature. Mais . . . jamais il n'allait dans ses toiles jusqu'à l'abstraction linéaire . . . s'il apercevait au monde sensuel seul qu'elles se révélaient à lui" (Elie Faure, *Les Constructeurs* [Paris: Editions d'Histoire et d'Art, 1950], p. 187).

"Cézanne found in the older masters that which seemed to him to be lacking in the impressionists: the ability to express the geometric essence of nature in their orchestra-tion of forms in pictorial space. . . . It must not be supposed, however, that Cézanne was content merely to follow in the footsteps of the great artists of the past. . . . Many of Cézanne's letters stress the importance of his forming his ideas, slowly and laboriously from the perception of nature" (C. Gray, "Cézanne's Use of Perspective," *College Art Journal* [1959]:54–55).

"The precept about the cylinder, the sphere, and the cone is not a rule for the representation of objects, as it was later tortured by the cubists to signify. It specified the manner, the presupposition under which the artist was to approach nature" (Charles Gauss, *The Aesthetic Theories of French Artists* [Baltimore: The Johns Hopkins Press, 1966], p. 48).

"Cézanne's much-quoted advice to Bernard to look at nature in terms of simple shapes . . . has nothing to do with cubism but rather with the type of art teaching in French schools which was current at the time Cézanne was young and which he wished to pass on to his young admirer" (Gombrich, p. 306).

47. John Rewald, *Cézanne, A Biography,* pp. 135–36.

48. Chipp, p. 22 (letter to Emile Bernard, Aix, September 21, 1906).

49. "L'Erreur critique la plus grave ce n'est pas tant d'avoir catalogué Cézanne comme symboliste, neo-impressionniste, mystique, neo-classique ou cubiste: c'est d'avoir proclamé qu'il a été le précurseur de toutes les tendances qu'a connu la peinture après lui, un très grand précurseur, mais uniquement un précurseur" (Venturi, *Cézanne: son art, son oeuvre*, pp. 14–15).

50. Theodore Reff, "Painting and Theory in the Final Decade," in *Cézanne: The Late Work*, p. 49.

6
A Whiteheadian Reinterpretation of Postimpressionism

When mechanical vision is regarded as the objective component of perception (of pure sense data) and is thus separated from the subjective or interpretive component, it implies the acceptance of a materialistic and mechanistic reality and denies the possibility of an objective reality suffused with feeling or character. As a result, the concept of distortion is required in order to explain the liberties taken with "factual" (objective) reality by such artists as Cézanne, Van Gogh, or Gauguin. In the late nineteenth century, many critics and artists alike designated any formal adjustments of "normal" vision or its transposition into the medium of paint on a two-dimensional plane, as distortions and deviations from what was then considered to be the most accurate mode of depiction of nature possible. (This critical perspective has persisted to the present day.) If an artist did not comply with this scientific mode of transposing, he apparently had other subjective aims in mind than the convincing representation of nature. It was also in the nineteenth century, however, that research into the constitution of matter and the exploration of the human mind resulted in the discovery that the so-called facts of reality were not absolute.[1] These investigations led the way for the development in the twentieth century of quite a different understanding of reality which is expressed, for example, in the work of Alfred North Whitehead. His theories of reality are striking in their relevance to and approximation of the attitudes and aims of postimpressionism.

New Concepts of Reality for the Interpretation of Modern Art

Whitehead—mathematician, philosopher of science, metaphysician—is one of the major philosophers of the twentieth century for a number of reasons. Chief among these is also the reason for his relevance to a proper understanding of postimpressionism, namely, his effort to formulate a

108

new philosophy of nature. The orthodox view of nature in the nineteenth century, culminating in positivism, had its origins in the seventeenth century, particularly in Isaac Newton and Réné Descartes. The name Whitehead gives to this view is *scientific materialism*. According to this view, "nature is composed of permanent things, namely bits of matter, moving about in space which otherwise is empty. . . . A bit of matter is thus conceived as a positive fact . . . [which] supports its various qualifications such as shape, locomotion, color, or smell, etc. The occurrences of nature consist in the changes of these qualifications, and more particularly in the changes of motion. The connection between such bits of matter consists purely of spatial relations."[2]

The seventeenth-century view implied that the material universe is "senseless, valueless, purposeless."[3] Therefore, if meaning, value, and purpose were to be affirmed at all, they had to be located outside of the universe of matter which, with the ascendancy of science, had become *objective* reality, the locus of reality itself. A sharp and irreconcilable dualism was the inevitable result, as Descartes quickly concluded. The objective world was characterized by matter and motion; all else— including the realm of values explored in the arts, literature, and reli- gion—was increasingly consigned to the *subjective* sphere of the indi- vidual mind, a sphere whose reality became more dubious as its contents became more expansive. Hence, objective descriptions of reality were held to be quantitative in character. Descriptions of qualities, values, and meanings were relegated to the status of "mere" impressions, subjec- tive in nature.

Whitehead's critique of scientific materialism draws, first, upon the very philosophical traditions that had given it expression.[4] For example, Whitehead cited Berkeley's demonstration that all reality is relational, that there is no absolute nature, no unrelated and independent matters of fact. Whitehead cited Hume's reluctant conclusion that the accepted view, stemming in basic details from Newton, could make no sense of induction, of causal relationships, and thus of the movement and con- nection of material bodies central to the Newtonian scheme. Whitehead also appealed to the developments of science itself during the nineteenth century. Evolutionary theory suggested the universe to be a dynamic organism, pulsing with creativity, flavored with chance and haunted with faint traces of purpose. Quantum theory later replaced inert bits of matter with quanta of vibratory energy as the ultimate constituents of reality, and relativity theory insisted upon the universal interdepen- dence of things as well as the relative character of space and time.

Strikingly, however, Whitehead gave no less weight to the protest of the romantic poets against the limitations of scientific materialism. If seventeenth-century science "proved" the physical universe to be matter

without quality moving mechanically in a void without value, the romantics, like Wordsworth in *The Prelude*, knew better:

> Ye Presences of Nature in the sky
> And on the earth! Ye Visions of the hills!
> And Souls of lonely places! Can I think
> A vulgar hope was yours when ye employed
> Such ministry, when ye through many a year
> Haunting me thus among my boyish sports
> On caves and trees, upon the woods and hills,
> Impressed upon all forms the characters
> Of danger or desire; and thus did make
> The surface of the universal earth,
> With triumph and delight, with hope and fear,
> Work like a sea? . . .[5]

Reflecting on this and similar "poetic rendering[s] of our concrete experience," Whitehead concludes, "we see at once that the element of value, of being valuable, or having value, or being an end in itself, of being something which is for its own sake, must not be omitted in any account" of reality that is fully adequate.[6] Or, as Whitehead puts the matter more succinctly elsewhere, "when you understand all about the atmosphere and all about the rotation of the earth, you may still miss the radiance of the sunset."[7] Any account of reality, then, which divests reality of meaning, purpose, and value is simply not being empirical; it is not giving an account of things that is adequate to human experience, whatever philosophical and scientific inadequacies it may also be found to have.

In Whitehead's own metaphysical theory, the ultimate constituents of reality are atomic, relational, processive events which he terms *actual entities*. At the physical level these events are syntheses or streams of energy; at the level of the mind they are syntheses of experience. Such momentary processes are the ultimate constituents of all things—"the energetic activity considered in physics is the emotional intensity entertained in life."[8] Therefore, the absolute distinction between mind and matter is dissolved. Mental and physical activity illustrate the same metaphysical principles, without either being reduced to the other. The traditional subject-object dichotomy is also overcome. Each event, whether predominantly physical or mental, is both a subject and an object because each is contributed to by its past and contributes to its future. So, too, is the fact-value dichotomy avoided. Each atomic event is what it is for itself, i.e., a fact, but what it is for itself and thus for others is an aesthetic adjustment of inherited data, i.e., a particular evaluation. Nature is alive in some measure, however minimal; value,

creativity, and purpose pervade the whole of things, mental *and* physical.

Whitehead's relevance to overcoming the subjectivist misinterpretation of postimpressionism is evident, first, in his doctrine that value is ingredient in nature. From this standpoint, one need not assume that an art that speaks of value therefore of necessity speaks subjectively. Value is objective. Whitehead helps to clarify postimpressionism, secondly, by showing that the value ingredient in objective natural processes is "prehended" however dimly by the observer, including, of course, the sensitive artistic observer. Value is objectively given—given in an affective, preconscious mode of experiencing. Whitehead's position, relative to this particular issue, is that the obvious and evident way in which we "take account of" the external world, i.e., through our sensory experience, is in fact the dependent, highly refined consequence of another more fundamental mode of our relatedness to things. Sense experience is the outcome of a rich yet chaotic and vague perception wherein the physical world enters into that organismic unity of chemical, visceral, and psychic processes called the human body. The sense of Whitehead's doctrine is conveyed in the following statements:

> For the organic theory, the most primitive perception is "feeling the body as functioning." This is a feeling of the world in the past; it is the inheritance of the world as a complex of feeling; namely, it is the feeling of derived feelings. The later, more sophisticated perception is "feeling the contemporary world."[9]

> The irresistible causal efficacy of nature presses itself upon us; in the vagueness of the low hum of insects in an August woodland, the inflow into ourselves of feelings from enveloping nature overwhelms us; in the dim consciousness of half-sleep, the presentations of sense fade away, and we are left with the vague feeling of influence from vague things around us.[10]

> The perception of conformation to realities in the environment is the primitive element in our external experience. We conform to our bodily organs and to the vague world which lies beyond them. Our primitive perception is that of "conformation" vaguely, and of the yet vaguer relata "oneself" and "another" in the undiscriminated background. . . . One part of our experience is handy and definite in our consciousness; also it is easy to reproduce at will. The other type of experience, however insistent, is vague, haunting, unmanageable. The former type, of all its decorative sense-experience, is barren. It displays a world concealed under an adventitious show, a show of our own bodily production. The latter type is heavy with the contact of the things gone by, which lay their grip on our immediate selves.[11]

If Whitehead's doctrine of our vague, felt apprehension of the value-

laden external world is accepted, the concept of what the postimpressionist artist may have been trying to accomplish is considerably broadened. Seemingly subjectivist (expressionistic) art may in fact be profoundly objectivist (representational). Far from expressing a purely individual sense of the private worth of things, the artist may be transforming through his or her medium a vague but lively perception of the objective value that is only faintly perceived by the rest of us.

In chapter 2, the development of the interpretation of postimpressionism as a form of subjectivism has been traced. It appears to have had more to do with events external to postimpressionism than it did with any necessary analysis of the art itself. A Whiteheadian vision of nature and art, however, shows how one can view the postimpressionist concern for value as being a genuine form of representational art. It concurs with other evidence previously provided for the view that this possible interpretation of postimpressionism is, in fact, the proper one.

The Artists' Statements

Numerous statements by Gauguin, Van Gogh, and Cézanne provide some of the best support for the claim that they are representational artists. Apart from the paintings, they are the first documents that testify to their original intentions. Though many of them have been misquoted and misinterpreted by critics, a compilation of brief excerpts will reveal persistent affirmations of their intention to communicate the fullness of nature as it is objectively given to them:

Gauguin:

The impressionists . . . heed only the eye and neglect the mysterious centers of thought, so falling into merely scientific reasoning. . . . [It is] a purely superficial art, full of affectations and purely material. There is no thought there. "But you have a technique?" they will demand. No, I have not. Or rather I do have one, but it is very furtive, very flexible, according to my disposition when I arise in the morning: a technique which I apply in my own manner to express my own thought without any concern for the truth of the common, exterior aspects of Nature.[12]

(Note pour expliquer mon art tahitien)
C'est bien la vie en plein air, amis cependent intimes, dans les fourrés, les ruisseaux ombrés, ces femmes chuchotant dans un immense palais décoré par la Nature elle-même, avec toutes les richesses que Tahiti renferme. . . .
"Mais tout cela n'existe pas!"
"Qui, cela existe, comme équivalent de cette grandeur, profondeur, de ce mystère de Tahiti, quand il faut l'exprimer dans une toile d'un mètre carré."[13]

"I love Brittany," he soon wrote to his friend Schuffenecker. "I find wildness and primitiveness there. When my wooden shoes ring on this granite, I hear the muffled, dull, and powerful tone which I try to achieve in painting."[14]

But the landscape with its violent, pure colors dazzled and blinded me. I was always uncertain; I was seeking, seeking. . . . In the meantime, it was so simple to paint things as I saw them. . . . Why did I hesitate to put all this glory of the sun on my canvas?[15]

I plunged eagerly and passionately into the wilderness, as if in the hope of thus penetrating into the very heart of this Nature, powerful and there to blend with her living elements.[16]

You have fewer means that nature, and you condemn yourself to renounce all those which it puts at your disposal. Will you ever have as much light as nature, as much heat as the sun? And you speak of exaggeration—how can you exaggerate since you remain below nature?[17]

Van Gogh:

What Pissarro says is true; we should exaggerate the effects which colours produce by their harmonies or dissonances. . . . The study of colour . . . I am always hoping to find something in that. To express the love of two lovers by a marriage of two complementary colours, their blending and clashing, the mysterious vibrations of combined tones. To express the thoughtfulness of a brow by the radiance of a star. The ardour of a human being by means of a ray of the setting sun. This is certainly not a realist *trompe-l'oeil*, but is it not something that really exists? I should like to paint men or women with an indefinable external something about them; the halo used to be the symbol of what I mean, and now we seek it in radiance itself, in the vibrancy of our colouring.[18]

I know no better definition of art than this . . . man added to nature; nature, reality, truth, but with a significance, a conception, a character, which the artist brings out and to which he gives expression . . . disentangles, liberates, illuminates.[19]

I should be desperate if my figures were correct. . . . I do not want them to be academically correct. . . . My greatest longing is to learn to make those changes in reality so that they may become lies if you like, but truer than the literal truth.[20]

At present I absolutely want to paint a starry sky. It often seems to me that the night is still more richly colored than the day, having hues of the most intense violets, blues and greens. If only you pay attention to it you will see that certain stars are citron-yellow, others have a pink glow or a green, blue and forget-me-not brilliance—putting little white dots on a blue-black surface is not enough.[21]

There is something infinite in painting . . . so delightful just for expressing one's feeling. There are hidden things of harmonies or contrasts in colors which cooperate by themselves and which cannot be used in another way. . . . I see in the whole of nature, for instance in the trees, expression, and so to speak, soul. A row of pollard willows sometimes has something of a procession of orphaned men about it. The young wheat can have something indescribably pure and tender . . . as for instance the expression of a sleeping child. The trodden-down grass at the side of the road has something tired and dusty about it, like the people of the slums.[22]

It's a mighty tricky bit of country this; everything is difficult to do if one wants to get at its inner character so that it is not merely something vaguely experienced, but the true soil of Provence. . . . It's a question of giving the sun and the blue sky their full force and brilliance, of retaining the fine aroma of wild thyme which pervades the baked and often melancholy earth.[23]

Cézanne:

But I must work—all things, particularly in art, are theory developed and applied in contact with nature.[24]

The Louvre is the book in which we learn to read. We must not, however, be satisfied with retaining the beautiful formulae of our illustrious predecessors. Let us go forth to study beautiful nature, let us try to free our minds from them, let us strive to express ourselves according to our personal temperaments.[25]

If the strong experience of nature . . . is the necessary basis for all conception of art on which rests the grandeur and beauty of all future work, the knowledge of the means of expressing our emotion is no less essential, and is only to be acquired through very long experience.[26]

Je respire la virginité du monde. Un sens aigu des nuances me travaille. Je me sens coloré par toutes les nuances de l'infini. . . . Je ne fais plus qu'un avec mon tableau. Nous sommes un chaos irisé. Je viens devant mon motif, je m'y perde. Je songe. Je vague. Le soleil me pénètre sourdement, comme un ami lointain qui réchauffe ma paresse, la féconde; nous germinons.[27]

Technique grows in contact with nature. . . . It consists in seeking to express what one feels, in organizing sensations into personal esthetics.[28]

The clear emphasis of these quotations is upon what is objectively given to the artist, even if what is given is said somehow to transcend surface modes of perception. That emphasis appeals to what "I find and hear," to the "glory" of "the landscape," to "the very heart of this Nature . . . with her living elements," to "a significance in nature which the artist only brings out, . . . disentangles, liberates," to a truth about

"reality . . . truer than the literal truth," to "soul" and "expression" in "the whole of nature," to the "inner character" of the country, to the necessity of a "strong experience of nature." There is a persistent rejection of an art that, in seeking to portray the natural world, heeds "only the eye," falls "into merely scientific reasoning," is concerned only with the "external aspects of Nature," is content to remain "below nature," and is satisfied with only "the literal truth."

In view of this testimony of the artists themselves, reinforced by firsthand experience of the actual paintings in question, one must ask how they could have been so widely misinterpreted. The answer lies in the assumption of art historians that any deviation from naturalism implies intentional distortion. They seem to have forgotten that before naturalism became the norm for truth in art, almost every period in art history involved some kind of stylistic transformation of reality, whether it be through the classical balance of the Renaissance, the dynamic energy of the baroque, the diminutive prettiness of the rococo, or the intense emotionality of romanticism. Even though the twentieth century has recognized, in conjunction with relativity theory, that reality is not an absolute objective entity out there, wholly independent of the human observer, art historians have failed to assimilate this understanding into their theories. They have continued to work with a simplistic and groundless dualism which holds that whatever is not literally representational is therefore subjective. As a consequence, art historians have failed to understand postimpressionism as a return to the balance of style and reality that has characterized most traditional art. Because of inadequate theories, they have been unable to see that the postimpressionists, instead of turning inward as did the cubists, expressionists, and surrealists, were one of the last major movements in art history to fuse value and feeling with external or objective reality.

The destruction of the stable nineteenth-century world view caused artists to retreat into subjectivity, whether it be to the realm of the intellect (cubism) or the emotions (expressionism). Neither group felt it was able to represent objective reality any longer. The camera had fulfilled that function, and even if the artist wanted to compete with its neutral vision, the result was a lifeless imitation of the surface appearance of nature. This is what the postimpressionists were resisting. However, whereas together they represent the Whiteheadian concept of reality as fused experience involving the subject in interaction with the object, the earth-shattering changes that were taking place at the brink of the twentieth century caused artists to distrust more and more any existence of a reality somewhere "out there" in experience. Partially, it was a retreat from chaos caused by incomprehension of a new world view that devalued the old scientific notions of a stable concrete reality, and partly it was an artistic revolt against the lifeless, anecdotal, and

often sentimental art of the nineteenth century. No doubt, it was also an expression of the developing ideas about relativity.

The postimpressionists exhibit the ability to see reality aesthetically or valuationally, freed from the restrictions of nineteenth-century naturalism. The values inherent in nature, the expressiveness of nature, are as real to these artists as are the physical objects that convey these qualities. Their ability to perceive character in reality is so strong that they were not able to work within the existing conventions of their period, impressionism and naturalism, as they felt these styles had suppressed the evaluative component in the experience of nature. This naturalistic suppression is inherently fallacious. All representational art involves a stylistic transformation of reality in terms of the medium employed and is, like perception generally, a process of organizing sensory data into some degree of meaningful formal patterning—a patterning reflective of aspects of that which is objectively given. Once an artist arrives at a certain patterning, called the artist's style, he or she begins to see reality through the screen of its schema. For every finite subject, whose apprehension of some sense datum is necessarily limited and perspectival, the communication of a given reality must necessarily be through symbolic and metaphoric equivalence. The artist is merely a special case of this general principle. Style is a product of the artistic imagination in its interaction with the world, and it is inevitable. Only by means of the symbolic form of art as a visual language can reality be communicated or even conceived.

In postimpressionism, the importance of stylistic transformation is critical because the artists believed reality itself to have aesthetic form. Whatever else it might be in formal terms, postimpressionist art is tied fundamentally to a vision of nature. It seems to unite on canvas what Whitehead sought to unite in philosophical theory. On the basis of the elements of the larger aesthetic theory outlined and argued above, I have essentially defended their own conception of their task as revealed in the verbal and visual documents. Cézanne's rhythmic articulation of the picture surface of *Mont Sainte-Victoire* is no less indicative of nature's living force than Van Gogh's *Starry Night* or Gauguin's *Day of the God* as paradigmatic examples of mature postimpressionist art. Whether dissected and synthesized into mellifluous color patches of ochre and veridian, whipped into frenzied vertiginous motion by liberated brushstrokes, or patterned and compressed into meandering flat fields of ebullient color, nature provides a sustained presence and a perceptual catalyst for solidly representational images rich in aesthetic appeal and overt expressive intensity. Whatever one thinks of their view of nature or of the correlative aesthetic theories presented in these essays, the postimpressionists did have a representational orientation to reality which lends to their endeavor an objectivity wholly overlooked by more orthodox art

histories. Like Whitehead, the postimpressionists sought to express in a unity the quantitative (the "electronic waves") and the qualitative (the "red glow of the sunset") because they believed that both of these dimensions were intertwined in the nature of things.

Notes

I wish to acknowledge the assistance of Delwin Brown, chairman of the Department of Religious Studies at Arizona State University, who was indispensable in the writing of this chapter.

1. Of particular importance are the theories of Adelbert Ames, Jr., whose research in physiological optics influenced Dewey, Einstein, Whitehead, and others. Because Ames published no book, his ideas may be found in Arthur Bentley, *Knowing and the Known*; Hadley Cantril, *The "Why" of Man's Experience*; Earl Kelley, *Education for What Is Real*.

2. Alfred North Whitehead, *Modes of Thought* (New York: The Free Press, 1968), p. 128.

3. Alfred North Whitehead, *Science and the Modern World* (New York: The Free Press, 1967), p. 17.

4. Whitehead's most accessible writings on this topic are probably *Modes of Thought*, chapters 7 and 8, and *Science and the Modern World*, especially chapters 1 through 9. A good summary is provided in Thomas N. Hart, S.J., "Whitehead's Critique of Scientific Materialism," *The New Scholasticism* 43, 2 (1969): 229–51. A more extensive treatment is given in Ivor Leclere, *The Nature of Physical Existence* (New York: Humanities Press, 1972), part 2.

5. White, *Science and the Modern World*, p. 84.

6. Ibid., p. 93.

7. Ibid. p. 174.

8. Whitehead, *Modes of Thought*, p. 168.

9. Alfred North Whitehead, *Process and Reality* (New York: Macmillan, 1929), p. 125.

10. Ibid., p. 267; cf. pp. 184 and 271.

11. Alfred North Whitehead, *Symbolism: Its Meaning and Effect* (New York: Capricorn, 1959), p. 43f.; cf. pp. 39–49, 53–59. See, too, *Modes of Thought*, pp. 71ff.

12. Hershel B. Chipp, *Theories of Modern Art* (Berkeley: University of California Press, 1968), p. 65 (from Gauguin, *Divers choses*).

13. Charles Morice, *Paul Gauguin* (Paris: H. Floury, 1920), p. 205.

14. John Rewald, *Post-Impressionism* (New York: Museum of Modern Art, 1956), p. 189.

15. Paul Gauguin, *Noa Noa* (Oxford: B. Cassirer, 1961), p. 30 (speaking of his art inspired by Tahitian landscapes).

16. Ibid., p. 49.

17. Paul Gauguin, *Carnet de croquis* (New York: Hammer Galleries, 1962), p. 63.

18. Lionello Venturi, *Impressionist and Symbolists* (New York: Charles Scribners' Sons, 1950), p. 186.

19. Maurice Sérullaz, *The Impressionist Painters* (New York: Universe Books, 1960), p. 140.

20. Van Gogh, *Complete Letters* (Greenwich, Conn. New York Graphic Society, 1958), 2:401.

21. Ibid., 3:443.

22. H. Graetz, *The Symbolic Language of Vincent Van Gogh* (New York: McGraw Hill, 1963), p. 17.

23. Rewald, p. 361.

24. Chipp, p. 16 (from a letter to Emile Zola, Aix, October 19, 1866).

25. Ibid., p. 201 (from a letter to Emile Bernard, Aix, July 25, 1904).

26. F. B. Blanshard, *Retreat from Likeness in the Theory of Painting* (New York: Columbia University Press, 1949), pp., 92–93.

27. Sara Lichtenstein, "Cézanne and Delacroix," *Art Bulletin* 46 (1964):65.

28. John Rewald, *Cézanne* (New York: Schocken Books, 1968), p. 170.

Bibliography

Gauguin

Alloway, Lawrence, ed. *Gauguin and the Decorative Style*. New York: Solomon R. Guggenheim Foundation, 1966.

Andersen, W. "Gauguin's Motifs from Le Pouldu—Preliminary Report." *Burlington Magazine* 112 (1970): 614–20.

Aurier, Albert. "Symbolisme en peinture." *Mercure de France* (1891): 155–65.

Basler, A. *La Peinture indépendente en France: de Monet à Bonnard*. Paris: G. Crès, 1929.

Bazin G. *L'Epoque impressioniste*. Paris: Pierre Tisné, 1947.

Bell, Clive. *Landmarks of Nineteenth Century Painting*. New York: Harcourt, Brace & Co., 1927.

Bernard, Emile. "Notes sur l'école dite de Pont-Aven." *Mercure de France* (1903): 675–82.

———. *Souvenirs inédits*. Paris: Nouvelliste du Morbihan, 1941.

Birnholz, A. C. "Double Images Reconsidered: A Fresh Look at Gauguin's Yellow Christ." *Art International* 21 (1977): 26–34.

Blanshard, F. B. *Retreat from Likeness in the Theory of Painting*. New York: Columbia University Press, 1949.

Canaday, John *Mainstreams of Modern Art*. New York: Holt, Rinehart & Winston, Inc., 1959.

Chassé, Charles. *Gauguin et le groupe de Pont-Aven*. Paris: H. Floury, 1921.

———. *Gauguin sans légendes*. Paris: Editions du Temps Présent, 1965.

———. *Gauguin et son temps*. Paris: Bibliothèque des Arts, 1955.

———. *Le Mouvement symboliste dans l'art du XIXe siècle*. Paris: Librairie Floury, 1947.

Cheney, Sheldon. *The Story of Modern Art*. New York: Viking Press, 1941.

Chipp, Herschel B. *Theories of Modern Art*. Berkeley: University of California Press, 1968.

Cogniat, Raymond. *Gauguin*. Paris: Aiméry-Somogy, 1963.

———. *Histoire de la peinture.* vol. 2. Paris: F. Nathan, 1955.

Danielsson, Maria Thersée. *Gauguin à Tahiti.* Paris: Sociéte des Océanistes, 1973.

Denis, Maurice. *Théories 1890–1910 du symbolisme et de Gauguin vers un nouvel ordre classique.* Paris: L. Rouart & J. Watelin, 1920.

Devoluy, J. "Time to Think of Gauguin." *Art News* 48 (1949): 14–17.

Donnell, Carol. "Representation Versus Expressionism in the Art of Gauguin." *Art International* 19 (1975): 56–60.

Dorival, Bernard. *Les Etapes de la peinture française contemporaine.* Paris: Gallimard, 1943–48.

Estienne, Charles. *Gauguin, biographical and critical studies.* Geneva: Skira, 1953.

Gauguin, Paul. *Cahier pour Aline.* Paris: Société des Amis de la Bibliothèque d'Art et d'Archéologie de l'Université de Paris, 1963.

———. *Carnet de croquis.* New York: Hammer Galleries, 1962. (Text by R. Cogniat and Foreward by J. Rewald.)

———. *Lettres de Paul Gauguin à Georges Daniel de Monfried.* Paris: G. Crès, 1918. (Foreward by V. Sagalen.)

———. *Paul Gauguin's Intimate Journals.* New York: Crown Publishers, 1936.

———. *Paul Gauguin: Letters to His Wife and Friends.* Edited by Maurice Malingue. London: Saturn Press, 1948.

———. *Noa Noa.* Oxford: B. Cassirer, 1961.

———. *Writings of a Savage.* Edited by Daniel Guerin. New York: Viking Press, 1978.

Gauguin and the Pont-Aven Group: Catalogue of an Exhibition at the Tate Gallery. London: Arts Council of Great Britain, 1966.

Gauss, Charles E. *The Aesthetic Theories of French Artists.* Baltimore: John Hopkins Press, 1966.

Goldwater, Robert. *Gauguin.* Paris: Nouvelles Editions Françaises, 1957.

———. *Primitivism in Modern Art.* New York: Vintage Books, 1967.

Gombrich, E. H. *The Story of Art.* Greenwich, Conn: Phaidon, 1966.

Haftmann, Werner. *Painting in the Twentieth Century.* New York: Praeger, 1965.

Hautecoeur, Louis. *Gauguin.* Geneva: Skira, 1942.

Herban, M. "Origin of Paul Gauguin's Vision after the Sermon." *Art Bulletin* 59 (1977): 415–20.

Hess, T. B. "Gauguin, The Hidden Tradition." *Art News* 65 (1966): 26–28.

"Historical Method and Post-Impressionist Art." *The Art Journal* 21 (1961–62): 97–100.

Hofmann, Werner. *Art in the Nineteenth Century.* London: Faber & Faber, 1961.

———. *The Earthly Paradise: Art in the Nineteenth Century.* New York: Braziller, 1961.

Huyghe, Réné. *Gauguin*. New York: Crown Publishers, 1959.

Jaworska, Wladyslawa. *Gauguin and the Pont Aven School*. New York: Graphic Society Ltd., 1972.

Kunstler, Charles. "L'Art de Gauguin." *Beaux Arts* (1934): 4.

Lane, James W. *Masters in Modern Art*. Boston: Chapman & Grimes, Mt. Vernon Press, 1968.

Leroy, A. *Histoire de la peinture française*. Paris: A. Michel, 1934.

Leymarie, Jean. *Paul Gauguin: water-colours, pastels and drawings in color*. London: Faber & Faber, 1961.

Lövgren, Sven. *The Genesis of Modernism*. Stockholm: Almquist & Wiksell, 1959.

Malingue, Maurice. *Gauguin*. Paris: Les Documents d'Art, 1943.

———. *Gauguin, le peintre et son oeuvre*. Paris: Presses de la Cité, 1948.

Mellerio, André. *Le Mouvement idéiste en peinture*. Paris: H. Floury, 1896.

Morice, Charles. "Paul Gauguin." *Mercure de France* (1903): 100–135.

———. *Paul Gauguin*. Paris: H. Floury, 1920.

———. "Quelques opinions sur Paul Gauguin." *Mercure de France* (1903): 279–82.

Myers, Bernard. *Modern Art in the Making*. New York: McGraw-Hill, 1959.

Newton, Eric. "Gauguin." *Apollo* 59 (1954): 92–93.

Nochlin, Linda. *Impressionism and Post-Impressionism 1874–1904: Sources and Documents*. Englewood Cliffs, N.J.: Prentice-Hall, Inc., 1966.

Perruchot, Henri. *Gauguin*. Paris: Hachette, 1963.

———. *Gauguin, sa vie ardente et misérable*. Paris: Le Sillage, 1948.

———. *La Révolte de 1870*. Paris: Macléval, 1951.

Raynal, Maurice. *Modern Painting*. Geneva: Skira, 1956.

Read, Herbert. "Gauguin: Return to Symbolism." *Art News Annual* 25 (1956): 122–58.

"Review of Robert Rey, *La Renaissance du sentiment classique dans la peinture française à la fin du XIX^e siècle*." Gazette des Beaux Arts 8 (1932): 59.

Rewald, John. *Gauguin*. Paris: Hyperion, 1938.

———. *History of Impressionism*. New York: Museum of Modern Art, 1956.

———. *Post-Impressionism*. New York: Museum of Modern Art, 1956.

Rey, Robert. *La Renaissance du sentiment classique dans la peinture française à la fin du XIX^e siècle*. Paris: Les Beaux-Arts, Edition d'Etudes et de Documents, 1931.

Rich, D. C. "Gauguin in Arles." *Chicago Art Institute Bulletin* 29 (1935): 37–39.

Rookmaaker, H. R. *Synthetist Art Theories*. Amsterdam: Swets & Zeitlinger, 1959.

Roskill, Mark. *Van Gogh, Gauguin and the Impressionist Circle*. Greenwich, Conn.: New York Graphic Society, 1970

Rotochamp, Jean de. *Paul Gauguin 1884–1903*. Paris: G. Crès, 1925.

San Lazzarro, G. *Painting in France 1895–1949.* New York: Philosophical Library, 1949.

Sérullaz, Maurice. *Peintres maudits.* Paris: Hachette, 1968.

Sloan, T. L. "Gauguin's *D'où venons-nous? Que sommes-nous? Ou allons-nous?* A Symbolist Philosophical Liet-motif." *Arts Magazine* 53 (1979): 104–9.

Steefel, Lawrence, D., Jr. "Review of *Synthetist Art Theories* by H. R. Rookmaaker." *Art Bulletin* 45 (1963): 168–69.

Sterling, Charles, and Salinger, Margaretta. *French Paintings,* vol. 3. New York: Metropolitan Museum of Art, 1967.

Stralem, Jean and Donald. "The Nabis and their Circle." *Minneapolis Institute of Arts Bulletin* 51 (1962): 121–52.

Sutton, Denys. "The Revolutionary Quartet." *Burlington Magazine* 77 (1963): 478–81.

Teilhet, J. H. "*Te Tamari No Atua:* An Interpretation of Paul Gauguin's Tahitian Symbolism." *Arts Magazine* 53 (1979): 110–11.

Venturi, Lionello. "The Early Style of Cézanne and the Post-Impressionists." *Parnassus* 9 (1937): 15–18.

———. *Impressionists and Symbolists.* New York: Charles Scribner's Sons, 1947–50.

Werth, Leon. *Quelques peintres.* Paris: G. Crès, 1923.

Wildenstein, Georges. *Gauguin.* Catalogue. Paris: Les Beaux-Arts, 1964.

———. *Gauguin: sa vie, son oeuvre.* Paris: Gazette des Beaux-Arts, 1958. (With contributions by Yvonne Thirion.)

Wilenski, R. H. *French Painting.* London: Medici Society, 1949.

Wright, W. H. *Modern Painting.* New York: Dodd, Mead, 1927.

Van Gogh

Andriesse, E., and de Gruyter, J. *Le Monde de Van Gogh.* Bruxelles: Les Editions Lumière, 1953.

Arnheim, Rudolf. *Toward a Psychology of Art: Collected Essays.* Berkeley: University of California Press, 1966.

Artaud, Antonin. *Le Suicidé de la société.* Paris: K éditeur, 1947.

Aurier, Aurier. "Les Isolés, Vincent Van Gogh." *Mercure de France* (1890): 24–29.

Barr, Alfred H., Jr. *Masters of Modern Art.* New York: Museum of Modern Art, 1954.

Basler, Adolphe. *La peinture indépendente en France.* Paris: G. Crès, 1929.

Beer, J., M.D. *Du Démon de Van Gogh.* Nice: A.D.I.A., 1945.

Bourniquel, Camille and Cabanne, Pierre, *Van Gogh.* Paris: Hachette (Collection Génies et Réalités, 1968.

Cheney, Sheldon. *The Story of Modern Art*. New York: Viking Press, 1958.

Clark, Sir Kenneth. *Landscape Painting*. New York: Scribner, 1950.

Cogniat, Raymond. *Histoire de la peinture*, vol. 2. Paris: F. Nathan, 1954–55.

———. *Van Gogh*. Paris: Aiméry-Somogy, 1958.

Coquiot, Gustave. *Vincent Van Gogh*. Paris: P. Ollendorff, 1923.

Davidson, Morris. *An Approach to Modern Painting*. New York: Coward-McCann, 1948.

de la Faille, J. B. *L'Oeuvre de Vincent Van Gogh, catalogue raisonné*. Paris: L'Edition G. Van Oest, 1928.

———. *L'Epoque française de Van Gogh*. Paris: Bernheim-Jeune, 1927.

Dow, Helen J. "Both Prometheus and Jupiter." *Journal of Aesthetics and Art Criticism* 22 (1964): 269–88.

Elgar, Frank. *Van Gogh*. Paris: Fernand Hazan, 1958.

Estienne, Charles. *Van Gogh, Critical Study*. Geneva: Skira, 1953.

Focillon, H. *La Peinture aux XIXᵉ et XXᵉ siècles du réalisme à nos jours*. Paris: H. Laurens, 1928.

Fowlie, Wallace. "The Religious Experience of Van Gogh." *College Art Journal* 9 (1950): 317–24.

Francastel, Pierre. *Nouveau dessin, nouvelle peinture*. Paris: Librairie de Médicis (l'Ecole de Paris), 1946.

Fry, Roger. *Manet and the Post-Impressionists. Grafton Galleries, November 8 to January 15, 1910–1911*. London: Ballantyne & Co., Ltd., 1911.

Fry, Roger. *Vision and Design*. New York: Brentano's, 1924.

Gombrich, E. H. *The Story of Art*. New York: Phaidon Publishers, 1950.

Gordon, Jan. *Modern French Painters*. New York: Dodd, Mead & Co., 1929.

Graetz, H. *The Symbolic Language of Vincent Van Gogh*. New York: McGraw-Hill, 1963.

Guastalla, Pierre. *Essai sur Van Gogh*. Paris: Michel de Romilly, 1952.

Hammacher, A. M. *Van Gogh*. Paris: O.D.E.G.E., 1967.

———. *Van Gogh: The Land Where He Was Born and Raised*. The Hague, 1953.

Heelan, P. A. "Toward a New Analysis of the Pictorial Space of Vincent Van Gogh." *Art Bulletin* 54 (1972): 478–92.

Huyghe, Réné. *Les Contemporains*. Paris: Pierre Tisné, 1939.

———. *Gauguin*. New York: Crown Publishers, 1959.

———. *Van Gogh*. Paris: Flammarion, 1958.

Jarrett, James L. *The Quest for Beauty*. Englewood Cliffs, N.J.: Prentice-Hall, 1957.

Johnson, R. "Van Gogh and the Vernacular: His Southern Accent." *Arts Magazine* 52 (1978): 131–35.

————. "Van Gogh and the Vernacular: The Poet's Garden." *Arts Magazine* 53 (1979): 98–104.

Kardas. "The Subjects of Van Gogh as they Appear Today." *The Studio* 108 (1934): 91–95.

Knuttel, Gerard. *Van Gogh*. Holland: Marabout Université, 1960.

Leymarie, Jean. *Van Gogh*. Paris: Pierre Tisné, 1951.

Lövgren, Sven. *The Genesis of Modernism*. Stockholm: Almquist & Wiksell, 1959.

Marois, Pierre. *Le Secret de Van Gogh*. Paris: Librairie Stock, 1957.

Martini, Alberto. *Van Gogh*. Milan: Fabbri, 1969.

Mather, Frank J. *Modern Painting, a Study of Tendencies*. New York: H. Holt & Co., 1927.

Meier-Graefe, Julius. *Modern Art*. New York: G. P. Putnam's Sons, 1908.

————. *Vincent Van Gogh*. Paris: A. Michel, 1964.

Minkowska, F., M.D. *Van Gogh, sa vie, sa maladie, son oeuvre*. Paris: Presses du Temps Présent, 1963.

Morice, Charles. *Paul Gauguin*. Paris: H. Floury, 1920.

Museum of Modern Art First Loan Exhibition. New York: Museum of Modern Art, 1929.

Myers, Bernard. *Modern Art in the Making*. New York: McGraw-Hill, 1959.

Nicholson, B. "An Insult to Reality." *Burlington Magazine* 90 (1948):93.

Nochlin, Linda. *Impressionism and Post-Impressionism, 1874–1904, Sources and Documents*. Edited by H. W. Janson. Englewood Cliffs, N.J.: Prentice-Hall, Inc., 1966.

Pach, Walter. *Vincent Van Gogh*. New York: Artbook Museum, 1936.

Perruchot, Henri. *Van Gogh et la Provence*. Conférence Prononcée au Centre Universitaire Méditerranéen. Nice (1954): 181–91. (Extrait des Annales du Centre Universitaire Méditerranéen 7 (1953–54).

Perspex, "Whom the Daemon Drives." *Apollo* 46 (1947): 129–30.

Picon, G. *Discours à la mémoire de Vincent Van Gogh*. Auvers-sur-Oise, 1961.

Pollack, G. *Vincent Van Gogh: Artist of His Time*. New York: Dutton, 1978.

Pollack, Peter. "Learning to see Van Gogh with a Camera Eye." *Art Digest* 24 (1950): 11.

Raynal, Maurice. *History of Modern Painting*, vols. 1, 2. Geneva: Skira, 1949.

————. *The Nineteenth Century, New Sources of Emotion from Goya to Gauguin*. Geneva: Skira, 1951.

Rewald, John. "The Artist and the Land." *Art News Annual* 19 (1950): 64–73.

————. *Post-Impressionism*. New York: Museum of Modern Art, 1956.

————. "Van Gogh en Provence." *L'Amour de l'Art* (1936): 289–98.

————. "Van Gogh versus Nature: Did Vincent or the Camera Lie?" *Art News* 41 (1942): 8–11.

Richardson, Edgar P. *The Way of Western Art, 1776–1914*. Cambridge, Mass: Harvard University Press, 1939.

Robin, Michel. *Van Gogh, ou la remontée vers la lumière*. Paris: Plon, 1964.

Rookmaaker, Hendrik R. *Synthetist Art Theories*. Amsterdam: Swets & Zeitlinger, 1959.

Roskill, Mark. *Van Gogh, Gauguin and the Impressionist Circle*. Greenwich, Conn.: New York Graphic Society, 1970.

Rutter, Frank. *Evolution in Modern Art*. London: G. G. Harrap and Co., Ltd., 1926.

"Saint Rémy Landscape by Vincent Van Gogh acquired by the Art Institute." *Minneapolis Institute of Arts Bulletin* 40 (1951): 114–20.

Schapiro, Meyer. *Vincent Van Gogh*. Paris: Nouvelles Éditions Françaises, 1950.

Sérullaz, Maurice. *The Impressionist Painters, French Painting*. New York: Universe Books, 1960.

———. *Peintres maudits*. Paris: Hachette, 1968.

Spender, Stephen. "The Painter as a Poet." *Art News Annual* 19 (1950): 79 ff.

Sterling, C., and Salinger, M. *French Painting*. vol. 3. New York: Metropolitan Museum of Art, 1967.

Tralbaut, M. E. *Van Gogh*. Paris: Hachette, 1960.

Van Gogh, Vincent. *Complete Letters*, 3 vols. Greenwich, Conn.: New York Graphic Society, 1958.

"Van Gogh et les peintres d'Auvers chez le docteur Gachet." *L'Amour de l'Art* (1952).

Van Gogh, Loan Exhibition. March 24–April 30, 1955. New York: Wildenstein and Company, 1955.

Van Gogh, Paintings and Drawings, A Special Loan Exhibition. New York: Metropolitan Museum of Art, 1949.

Van Gogh raconté par lui-même et par ses amis: ses contemporains, sa posterité. (ed. Pierre Courthion and P. Cailler) Vésenaz-Genève: P. Cailler, 1947.

Venturi, Lionello. *Impressionists and Symbolists*. New York: Charles Scribner's Sons, 1950.

Vernon, M., and Baughman, M. L. "Art, Madness, and Human Interaction." *Art Journal* 31 (1972): 416.

Vinca, Masini, Lara. *Van Gogh*. Paris: Arts et Métiers Graphiques, 1968.

Ward, J. L. "Re-examination of Van Gogh's Pictorial Space." *Art Bulletin* 58 (1976): 593–604.

Wright, Willard H. *Modern Painting*. New York: John Lane Co., 1915.

Wylie, A. S. "Investigation of the Vocabulary of Line in Vincent Van Gogh's Expression of Space." *Oud Holland* 85 (1970): 210–35.

Cézanne

Ades, J. I., and Richardson, J. A. "D. H. Lawrence on Cézanne: A Study in the Psychology of Critical Intuition." *Journal of Aesthetics and Art Criticism* 28 (1970): 441–53.

Aspects of French Painting from Cézanne to Picasso. Los Angeles County Museum of Art. January 15 to March, 1941.

"Auvers vu par les peintres." *L'Amour de l'Art* (1952); 13–16.

Badt, Kurt. *The Art of Cézanne.* London: Faber & Faber, 1965.

Bannard, Darby. "Late Cézanne: A Symposium." *Art in America* 66 (1978): 82–95.

Barnes, Albert C., and de Mazia, Violette. *The Art of Cézanne.* New York: Harcourt, Brace & Co., 1939.

Barr, Alfred H. *Cubism and Abstract Art.* New York: Museum of Modern Art, 1936.

Bate, M. "Phenomenologist as Art Critic: Merleau-Ponty and Cézanne." *British Journal of Aesthetics* 14 (1974): 344–50.

Bazin, Germain. "Cézanne et la Montagne Sainte-Victoire." *L'Amour de l'Art* (1938): 377–83.

Berkman, Aaron. "Cézanne and Optics." *Art News* 59 (1960): 64.

Bernai, Emile. *Conversations avec Cézanne.* Paris: Collection Macula, 1978.

Bernard, Emile. "L'Erreur de Cézanne." *Mercure de France* (1926): 514–28.

———. *Souvenirs sur Paul Cézanne et lettres.* Paris: Rénovation Esthétique, 1920.

Bernex, Jules. "Souvenirs sur Cézanne." *L'Art Sacré* (1956): 22–31.

Blanshard, F. B. *Retreat from Likeness in the Theory of Painting.* New York: Columbia University Press, 1949.

Boisdeffre, P. de; Cabanne, Pierre; Cogniat, R.; Guillemin, H.; Lanoux, A.; Paris, J.; Perruchot, H.; and Rheims, M. *Cézanne.* Paris: Hachette, Collection Génies et Réalités, 1966.

Bourgeois, Stephan. *The Adolph Lewishohn Collection of Modern French Paintings and Sculptures.* New York: E. Weyhe, 1928.

———. "The Search for the Absolute." *Parnassus* 7 (1935): 13–24.

Burroughs, Alan, "David and Cézanne." *The Arts* 16 (1929): 97–111.

Canaday, John. *Mainstreams of Modern Art.* New York: Holt, Rinehart & Winston, 1959.

Carpenter, J. M. "Cézanne and Tradition." *Art Bulletin* 33 (1951): 174–86.

Chappuis, Adrien. *Drawings of Paul Cézanne: A Catalogue Raisonné.* Greenwich, Conn.: New York Graphic Society, 1973.

Chassé, Charles. *Le Mouvement symboliste dans l'art du XIXe siècle.* Paris: Libraire Floury, 1947.

Cheney, Sheldon. *Expressionism in Art.* New York: Tudor, 1934.

"Chestnut Trees at the Jas de Bouffan." *Minneapolis Institute of Arts Bulletin* (1950): 2–7.

Chipp, Herschel B. *Theories of Modern Art*. Berkeley: University of California Press, 1968.

Churchill, Alfred V. "On Cézanne." *Parnassus* 4 (1932): 19–21.

Clark, Sir Kenneth. *Landscape Painting*. New York: Scribner, 1950.

Cogniat, Raymond. *Cézanne*. Paris: Pierre Tisné, 1939.

———. *Cézanne*. Paris: Flammarion, 1967.

———. *Histoire de la peinture*. vol. 2. Paris: Fernand Nathan, 1955.

Combe, Jacques. "L'Influence de Cézanne." *La Renaissance* (1936): 22–32.

Coplans, John. *Cézanne Watercolors*. Los Angeles: Ward Ritchie Press, 1967.

Coquiot, Gustave. *Cézanne*. Paris: P. Ollendorff, 1919.

———. *Les Indépendents*. Paris: P. Ollendorff, 1920.

———. *Peintres maudits*. Paris: André Delpeuch, 1924.

Craven, Thomas. *Modern Art: The Men, the Movements, the Meaning*. New York: Simon & Schuster, 1940.

Davidson, Morris. *An Approach to Modern Painting*. New York: Coward-McCann, 1948.

Denis, Maurice. "L'Aventure posthume de Cézanne." *Prométhée (L'Amour de l'Art)* (1939): 193–96.

———. "L'Influence de Cézanne." *L'Amour de l'Art* (1938): 279–84.

———. *Théories de 1890–1910 du symbolisme et de Gauguin vers un nouvel ordre classique*. Paris: L. Rouart, J. Watelin, 1920.

Donnell-Kotrozo, Carol. "Cézanne and the Continuing Cubist Controversy." *Art International* 24. (1980):

Dorival, Bernard. *Cézanne*. Paris: Fernand Hazan, 1952.

———. *Les Etapes de la peinture française contemporaine*. Paris: Gallimard, 1943–48.

d'Ors, Eugenio. *Cézanne*. Madrid: M. Aguilar, 1966.

———. *Paul Cézanne*. New York: E. Weyhe, 1936.

———. "Crise de Cézanne." *Gazette des Beaux Arts* 15 (1936): 361–72.

Elderfield, J. "Drawing in Cézanne." *Artforum* 9 (1971): 51–57.

Elgar, Frank. *Cézanne*. Paris: Aiméry-Somogy, 1968.

Exhibition of French Masterpieces of the Nineteenth Century, January 11–February 10, 1936. New York: Century Club, 1936.

Faure, Elie. *Cézanne*. Paris: G. Crès, 1923.

———. *Les Constructeurs*. Paris: Editions d'Histoire et d'Art, 1950.

———. *Histoire de l'Art*. vol. 4. Paris: G. Crès, 1921–26.

Fell, H. Granville. "Constable or Cézanne, An Examination." *Conoisseur* 94 (1934): 73–78.

————. "In Cézanne's Country." *Apollo* 18 (1933): 268–70.

Focillon, Henri. *La Peinture aus XIX^e et XX^e siècles du réalisme à nos jours.* Paris: H. Laurens, 1928.

Fontainas, André. *Histoire de la peinture française au XIX^e et au XX^e siècles (1801–1920).* Paris: Mercure de France, 1922.

Francastel, Pierre. *Nouveau dessin, nouvelle peinture.* Paris: Librairie de Médicis, 1946.

French Paintings from the Chester Dale Collection. Washington, D.C.: National Gallery of Art, Smithsonian Institution, 1948.

Friedenwald, Jonas. M.D. "Knowledge of Space Perception in the Portrayal of Depth in Painting." *College Art Journal* 15 (1955): 96–112.

Fry, Roger. *Cézanne: A Study of His Development.* New York: Noonday Press, 1958.

————. "The Double Nature of Painting." *Apollo* 89 (1969): 362–71.

————. *Manet and the Post-Impressionists at the Grafton Galleries, November 8 to January 15, 1910–1911.* London: Ballantyne & Co., 1911.

————. "Post-Impressionism." *Fortnightly Review* 89 (1911): 856–67.

Fussiner, Howard. "Organic Integration in Cézanne's Painting." *College Art Journal* 15 (1956): 302–12.

Gatellier, Gilbert. *Cézanne.* Paris: Bordas, 1968.

Gaunt, W. "Paul Cézanne, an essay in valuation." *London Studio* 116 (1938): 142–45.

Gauss, Charles E. *The Aesthetic Theories of French Artists.* Baltimore: The Johns Hopkins Press, 1966.

George, Wademar. "The Twilight of a God." *Apollo* 14 (1931): 75–82.

Goldwater, Robert. "Review of Eric Loran, *Cézanne's Composition.*" *Art Bulletin* 27 (1945):160–61.

Gombrich, E. H. *Art and Illusion.* New York: Phaidon, 1968.

————. *The Story of Art.* Greenwich, Conn.: Phaidon, 1966.

Gonthier, Pierrre-Henri. *Cézanne.* Paris: Pierre Tisné, 1962.

Gordon, D. E. "Expressionist Cézanne." *Artforum* 16 (1978): 34–39.

Gordon, Jan. *Modern French Painters.* London: J. Lane, 1923.

Gottlieb, C. "The Joy of Life: Matisse, Picasso, Cézanne." *College Art Journal* 18 (1959): 106–16.

Gowing, Lawrence. *Tate Gallery, an exhibition of paintings by Cézanne, September 29 to October 27, 1954.* London: Shenval Press, 1954.

Gray, Christopher. "Cézanne's use of Perspective." *College Art Journal* 19 (1959): 54–64.

Greenberg, Clement. *Art and Culture.* Boston: Beacon Press, 1965.

————. "Cézanne and the Unity of Modern Art." *Partisan Review* 18 (1951): 323–30.

Guerry, Liliane. *Cézanne et l'expression de l'espace*. Paris: Flammarion, 1950.

Hamilton, George H. "Cézanne, Bergson and the Image of Time." *College Art Journal* 16 (1956): 2–12.

Hofman, Werner. *The Earthly Paradise: Art in the Nineteenth Century*. New York: Braziller 1961.

Hunter, Sam. *Modern French Painting*. New York: Dell Publishing Co., 1967.

Huyghe, Réné. *Cézanne*. Paris: Editions d'Histoire et d'Art, 1936.

———. *Cézanne*. Translated by K. M. Leake. London: Oldbourne Press, 1961.

———. "Cézanne." *L'Amour de l'Art* (1936): 183.

———. *Les Contemporains*. Paris: Pierre Tisné, 1939.

———. *Gauguin*. New York: Crown Publishers, 1959.

Huysmans, J. K. *Certains*. Paris: P. V. Stock, 1904.

Jewell, Edward A. *Paul Cézanne*. New York: Hyperion, 1944.

Jourdain, Francis. *Cézanne*. Paris: Editions Braune & Cie, 1950.

Juin, Herbert. *Sur les pas de Paul Cézanne*. Aix-en-Provence: Librairie de l'Université, 1953.

Kemp, Mary Louise. "Cézanne's Critics.". *Baltimore Museum of Art News* (1957): 4–16.

Klingsor, Tristan L. *Cézanne*. Paris: F. Pieder & Cie., 1924.

Laderman, Gabriel. "The Importance of Cézanne." *Art News* 65 (1966): 39ff.

Langle de Cary, M. de. *Cézanne*. Paris: Caritas, 1957.

Laporte, Paul M. "Cézanne and Whitman." *Magazine of Art* 37 (1944): 223–27.

Larguier, Leo. *Cézanne ou la lutte avec l'ange de la peinture*. Paris: Julliard, 1947.

LeClerc, André. *Cézanne*. Paris: Hypérion, 1950.

Lehel, Francois. *Notre art dément*. Paris: Editions H. Jonquières, 1926.

Leprohon, Pierre. *Paul Cézanne*. Lyon: Editions et Imprimeries du Sud-Est, 1961.

Levine, S. Z. "Claude Monet and Paul Cézanne: Beyond Impressionism." *Arts Magazine* 53 (1978): 156–57.

Levy, Simon. "Souvenirs sur Paul Cézanne." *L'Amour de l'Art* (1920): 285–87.

Lhote, André. *L'Enseignement de Cézanne*. Paris: Miroirs de l'Art, 1967.

———. *Ecrits sur la peinture*. Brussels: Editions Lumière, 1946.

Lichtenstein, Sara. "Cézanne and Delacroix." *Art Bulletin* 46 (1964): 55–67.

Lindsay, J. *Cézanne: His Life and Art*. Greenwich Conn.: New York Graphic Society, 1969.

Loran, Erle. *Cézanne's Composition: Analysis of His Form, with Diagrams and Photographs of His Motifs*. Berkeley: University of California Press, 1959.

———. "Cézanne in 1952." *The Art Institute of Chicago Quarterly* 46 (1952): 2–13.

Mack, Gerstle. *Paul Cézanne*. San Francisco: San Francisco Museum of Art, 1937.

———. *La Vie de Paul Cézanne*. Paris: Gallimard, 1938.

Marriott, Charles. *Modern Movements in Painting*. London: Chapman and Hall, Ltd., 1920.

Mather, Frank J. *Modern Painting: A Study of Tendencies*. New York: H. Holt & Co., 1927.

Meier-Graefe, Julius. "Souvenirs sur Paul Cézanne." *L'Amour de l'Art* (1921): 25–30.

———. *Modern Art*. New York: Arno Press, 1968.

Mellerio, André. *Le Mouvement idéiste*. Paris: H. Floury, 1896.

Micheli, Mario de. *Cézanne*. Paris: Flammarion, 1967.

Mirbeau, Octave; Duret, Théodore; Werth, Leon; and Jourdain, Franz. *Cézanne*. Paris: Bernheim-Jeune, 1914.

Morice, Charles. *Quelques maîtres modernes*. Paris: Société des Trente, 1914.

Moulin, Raoul-Jean. *Cézanne's natures mortes*. Paris: Fernand Hazan, 1964.

Murphy, Richard W. *The World of Cézanne*. New York: Time-Life Books, 1968.

Museum of Modern Art First Loan Exhibition. New York: Museum of Modern Art, 1929.

Myers, Bernard S. *Modern Art in the Making*. New York: Whittlesey House, 1950.

Nochlin, Linda. *Impressionism and Post-Impressionism, 1874–1904: Sources and Documents*. Englewood Cliffs, N.J.: Prentice-Hall, Inc., 1966.

Novotny, Fritz. *Cézanne*. Paris: Phaidon, 1948.

Pach, Walter, *The Masters of Modern Art*. New York: Viking Press, 1929.

Perruchot, Henri. *Cézanne*. Paris: Hachette, 1966.

———. *La Vie de Cézanne*. Paris: Hachette, 1956.

Phillips, Duncan, "El Greco, Cézanne, Picasso." *Art and Understanding* 1 (1929): 96–105.

Ponente, N. and Cabanne, P. *Cézanne*. Paris: Hachette, 1968.

Poole, Phoebe. *Impressionism*. London: Thames & Hudson, 1967.

Ramuz, C. F. *Cézanne*. Lausanne: International Art Book, 1968.

Rilke, Rainer Maria. *Lettres sur Cézanne*. Paris: Editions Correa, 1944.

Raynal, Maurice. *Cézanne*. Paris: Editions de Cluny, 1936.

———. *Cézanne, Biographical and Critical Studies*. Geneva: Skira, 1954.

———. *History of Modern Painting (from Baudelaire to Bonnard)*. Geneva: Skira, 1949–50.

———. *Modern Painting*. Geneva: Skira 1953.

———. *The Nineteenth Century: New Sources of Emotion from Goya to Gauguin*. Geneva: Skira, 1951.

Read, Herbert, *Art Now*. London: Faber & Faber, Ltd., 1960.

———. *The Philosophy of Modern Art*. New York: World Publishing Co., 1965.

————. "The Social Significance of Abstract Art." *Quadrum* (1960): 5–14.

Reff, Theodore. "Cézanne and Poussin." *Journal of the Warburg & Courtauld Institutes* 23 (1960): 150–74.

————. "Cézanne's Card Players and Their Sources." *Arts Magazine* 55 (1980): 104–17.

————. "Cézanne's Constructive Stroke." *The Art Quarterly* 25 (1962): 214–26.

————. "Cézanne in the Twentieth Century." *Columbia University Forum* vol. 6. (1963): 31–35.

————. "Cézanne's Late Bather Paintings." *Arts Magazine* 52 (1977): 116–19.

————. "Cézanne On Solids and Spaces." *Artforum* 16 (1977): 34–37.

————. "Pictures within Cézanne's Pictures." *Arts Magazine* 53 (1979): 90–104.

————. "Cézanne: The Enigma of the Nude." *Art News* 58 (1959): 26–30.

Rewald, John. "As Cézanne Recreated Nature." *Art News* 43 (1944): 9–13.

————. "The Camera Verifies Cézanne's Watercolors." *Art News* 43 (1944): 16–18.

————. *Cézanne: A Biography.* New York: Schocken Books, 1968.

————. "Cézanne au Chateau Noir." *L'Amour de l'Art* (1935): 15–21.

————. "Cézanne et la nature, sites et paysages." *L'Amour de l'Art* (1936): 194–95.

————. *Cézanne et Zola.* Paris: A. Sedrowski, 1936.

————. *Cézanne, Geffroy et Gasquet.* Paris: Quatres Chemins, 1959.

————. *Cézanne paysages.* Paris: F. Hazan, 1958.

————. *Cézanne, sa vie, son oeuvre, son amitié pour Zola.* Paris: A. Michel, 1939.

————. *History of Impressionism.* New York: Museum of Modern Art, 1956.

————. *Paul Cézanne, carnet de dessins.* Paris: Quatre Chemins, 1951.

————. ed. *Paul Cézanne, letters.* London: B. Cassirer, 1941.

Rey, Robert. *La Renaissance de sentiment classique dans la peinture française à la fin du XIX^e siècle.* Paris: Les Beaux-Arts, Edition d'Etudes et de Documents, 1931.

Richardson, E. P. *The Way of Western Art, 1776–1944.* Cambridge, Mass.: Harvard University Press, 1939.

Rivière, Georges. *Le Maître Paul Cézanne.* Paris: H. Floury, 1923.

————. *Cézanne, le peintre solitaire.* Paris: H. Floury, 1936.

Roger-Marx, Claude. *Le Paysage française.* Paris: Editions d'Histoire et d'Art, 1952.

Rookmaaker, H. R. *Synthetist Art Theories.* Amsterdam: Swets & Zeitlinger, 1959.

Rousseau, Theodore, Jr., and Rich, Daniel C. *Cézanne Paintings, Watercolors and Drawings. A Loan Exhibition, The Art Institute of Chicago.* Chicago: Hillison & Etten Co., 1952.

Rubin, William, ed. *Cézanne: The Late Work.* New York: MOMA, 1977.

Rutter, Frank. *Evolution in Modern Art*. London: G. G. Harrap & Co., 1926.

Salmon, André. *Cézanne*. Paris: Librairie Stock, 1923.

San Lazzaro, G. *Painting in France 1895–1949*. New York: Philosophical Library, 1949.

Schapiro, Meyer. "The Apples of Cézanne: An Essay on the Meaning of Still-Life." *Art News Annual*. (1968): 35–53.

―――. *Paul Cézanne*. Paris: Nouvelles Éditions Françaises, 1956.

Sérullaz, Maurice. *L'Impressionnisme*. Paris: Presses Universitaires de France, 1961.

―――. *The Impressionist Painters*. New York: Universe Books, 1960.

Sterling, Charles. "Cézanne et les maîtres d'autrefois." *La Renaissance* (1936): 7–15.

Sterling, Charles, and Salinger, Margaretta M. *French Painting: A Catalogue of the Collection of the Metropolitan Museum of Art*. vol. 3. New York: Metropolitan Museum of Art, 1967.

Sterne, Maurice. "Cézanne Today." *American Scholar* 22 (1952–53): 40–59.

Stokes, Adrien. *Cézanne*. Novara, Italy: I.G.D.A., 1953.

Sypher, Wylie. *Rococo to Cubism in Art and Literature*. New York: Vintage Books, 1960.

Taillandier, Yvon. *Paul Cézanne*. Paris: Flammarion, 1961.

Taylor, Basil. *Cézanne*. Middlesex: Paul Hamlyn, 1968.

Terresse, Charles. *French Painting in the XX Century*. New York: Hyperion Press, 1939.

Vaudoyer, Jean-Louis. *Les Peintres provençaux de Nicolas Froment à Paul Cézanne*. Paris: La Jeune Parque, 1947.

Venturi, Lionello. *Cézanne*. New York: Rizzoli International, 1979.

―――. "Cézanne, Fighter for Freedom." *Art News* 41 (1942): 16–18.

―――. *Cézanne: son art, son oeuvre*. Paris: Paul Rosenberg, 1936.

―――. *Four Steps toward Modern Art: Giorgione, Caravaggio, Manet, Cézanne*. New York: Columbia University Press, 1956.

―――. *Impressionists and Symbolists*. New York: Charles Scribner's Sons, 1947–50.

―――. *Les Archives de l'impressionnisme*. Paris: Durand-Ruel, 1939.

―――. "Review of *Cézanne's Composition* by Erle Loran." *Art News* 42 (1944): 25.

Vergnet-Ruiz, J. "Cézanne et l'impressionnisme." *La Renaissance* (1936): 16–21.

Vollard, Ambroise. *Paul Cézanne: His Life and Art*. New York: Crown Publishers, 1937.

Werth, Leon. *Quelques peintres*. Paris: G. Crés, 1923.

Wilenski, R. H. *French Painting*. London: Medici Society, 1949.

————. *Modern French Painters*. New York: Harcourt, 1954.

————. *The Modern Movement in Art*. London: Faber & Faber, 1945.

Williams, Forrest. "Cézanne and French Phenomenology." *Journal of Aesthetics and Art Criticism* 12 (1954): 481–92.

Wright, W. H. *Modern Painting*. New York: Dodd, Mead, 1927.

Zervos, Christian. *Histoire de l'art contemporain*. Paris: Editions "Cahiers d'Art," 1938.

Index

Abstract expressionism, 29, 32; as embodiment of feeling, 29

Ackerman, James: on style, 95–96

Advocate in his Robes (Cézanne), 102n.5

Aesthetics: art history's indifference to, 14–15; theories of art and life in, 22; theories of representation and expression in, 26–34

Arles, France: Van Gogh's paintings in, 68, 82n.58, 83n.77

Arnheim, Rudolf, 3, 73; theories of expression in, 26, 30–31, 33, 69, 73

Artaud, Antonin: on Van Gogh's madness, 77

Art history, 115; evolutionary theory of, 13, 89, 95–96, 100; as a methodology, 14–18; style in, 115; theories of expression in, 28, 31; versus aesthetics, 14–18

Aurier, Albert: on symbolism, 24, 39–40, 45, 60, 75–76; on synthetism in Gauguin, 39, 45; on Van Gogh, 60, 75–76

Autopsy, The (Cézanne), 102n.5

Badt, Kurt: on Cézanne, 93

Banquet, The (Cézanne), 102n.5

Barr, Alfred, Jr.: on Van Gogh at Saint Rémy, 58

Bathers (Cézanne), 102n.5

Baudelaire, Charles: on positivism, 20; *Salon of 1859*, 20

Bedroom, The (Van Gogh), 82n.52

Bell, Clive: on impressionism, 21; theory of significant form, 87

Berceuse, La (Madame Roulin) (Van Gogh), 70, 82n.52

Bernard, Emile: Cézanne's letters to, 89–90, 91, 104n.13, 107n.46; at Le Pouldu, 43; religious subjects of, 64, 81n.43; on

synthetism, 23–24, 39, 46; Van Gogh's letters to, 67

Bibemus Quarry. *See Carrière de Bibemus*

Blossoming Pear Tree (Van Gogh), 62, 71

Braque, Georges, 94; cubist paintings of, 87, 89, 94; and Cézanne, 87, 89, 94

Breakfast Table, The (Still Life with Cups and Coffeepot) (Van Gogh), 80n.28

Cabanon de Jourdan (Cézanne), 103n.10

Card Players, The (Joueurs de Cartes) (Cézanne), 88

Carrière de Bibemus, La (Quarry at Bibemus) (Cézanne), 104n.12, 105n.42

Cézanne, Paul: early criticism of, 86–87; expression in, 31, 66; as expressionist, 25; as forerunner of cubism, 21, 26, 86–100; and nature, 98–100, 108; new interpretation of, 22; paintings of Gardanne, 88, 90, 104–5n.21, 106n.42; paintings of Jas de Bouffan, 105n.21; paintings of L'Estaque, 99, 105n.21; *passage* technique, 94; as postimpressionist, 13–15, 17; quoted, 89, 93, 98, 106n.45, 114; rebellion from impressionism, 21; as representational painter, 87–88, 91, 94, 97–100; Van Gogh on, 74; watercolors of, 88, 90. Paintings: *Advocate in his Robes*, 102n.5; *The Autopsy*, 102n.5; *The Banquet*, 102n.5; *Bathers*, 102n.5; *Cabanon de Jourdan*, 103n.10; *La Carrière de Bibemus (Quarry at Bibemus)*, 104n.12, 105n.42; *L'Eternel Féminin*, 102n.5; *Head of a Bearded Man*, 102n.5; *Landscape with Houses*, 94; *The Lazarus*, 102n.5; *Une Moderne Olympia*, 86; *Mont Sainte-Victoire*, 32, 90, 104n.21, 106n.42, 116; *Nature Morte (Still Life)*, 104n.12; *Portrait of the Artist*

Illustrations

Paul Gauguin

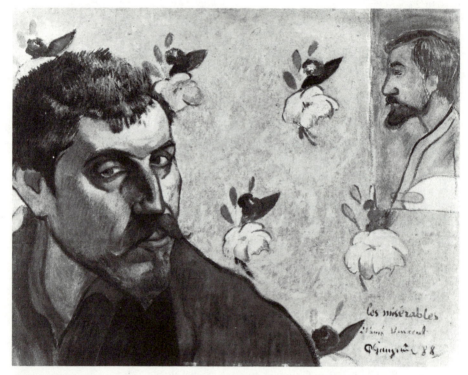

Self-Portrait, "Les Misérables," 1888, Stedelijk Museum, Amsterdam. 28⅛ × 35⅝"
(71.5 × 90.5 cm).

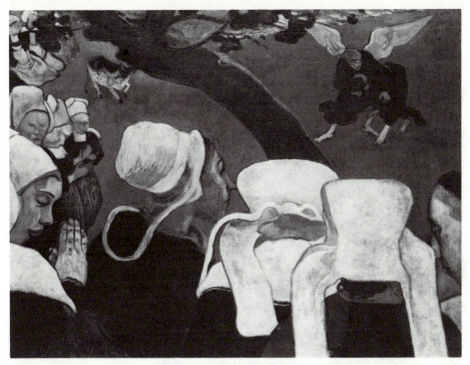

Jacob Wrestling with the Angel (Vision after the Sermon), 1888, oil on canvas, National Galleries of Scotland, Edinburgh. 28¾ × 36¼″ (73 × 92 cm).

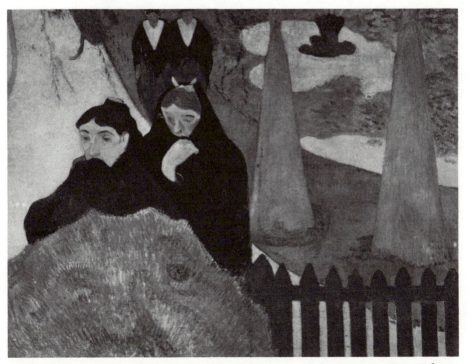

Old Women of Arles, 1888, The Art Institute of Chicago, Mr. & Mrs. Louis L. Coburn Memorial Collection. 28¾ × 36″ (73 × 91.4 cm).

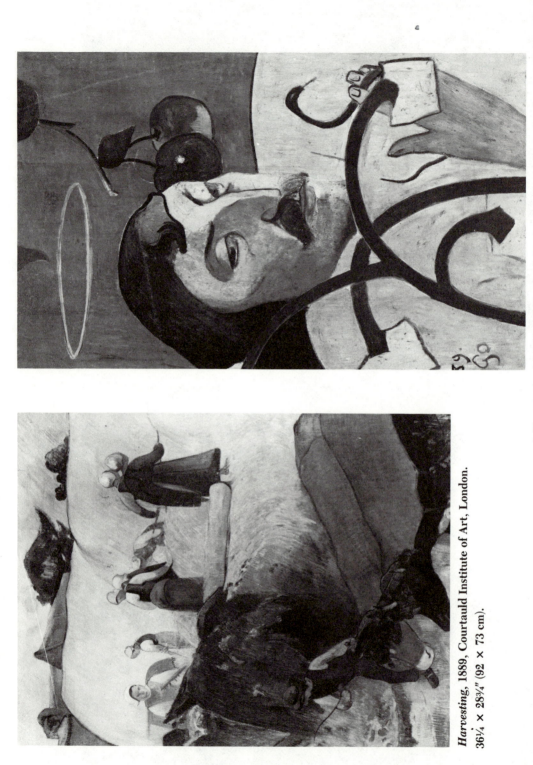

Harvesting, 1889, Courtauld Institute of Art, London. 36¼ × 28¾″ (92 × 73 cm).

Self-portrait with Halo, 1889, wood, National Gallery of Art, Washington, D.C., Chester Dale Collection. 31¼ × 20¼″ (79.2 × 51.3 cm).

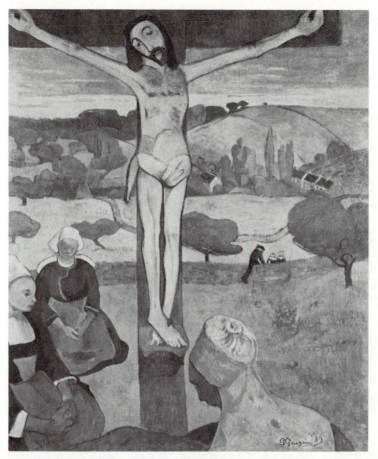

The Yellow Christ, 1889, Albright-Knox Gallery, Buffalo, New York. 36¼ × 28⅞″ (73 × 92 cm).

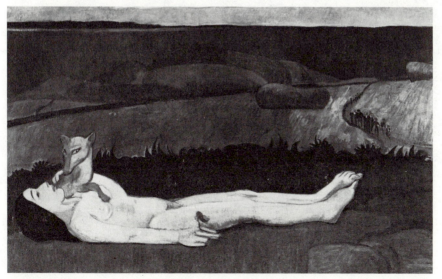

La Perte du Pucelage (Loss of Virginity), 1891, oil on canvas, The Chrysler Museum, Gift of Walter P. Chrysler, Jr. 51¼ × 35¼″ (130.2 × 89.5 cm).

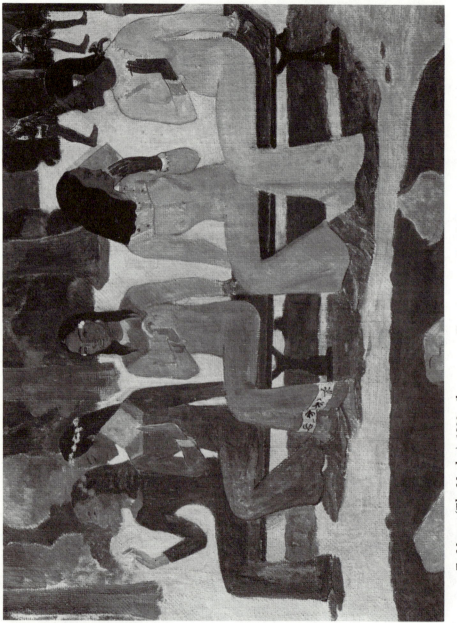

Ta Matete (*The Market*), 1892, oil on canvas, Kunstmuseum Basel. 28¾ × 36¼″ (73 × 92 cm).

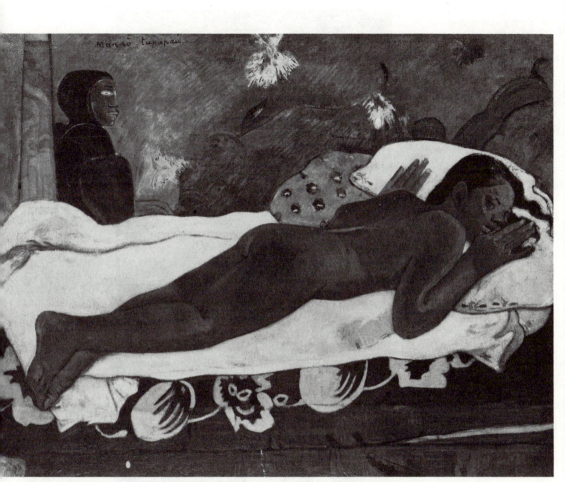

Spirit of the Dead Watching, 1892, Albright-Knox Gallery, Buffalo, New York, A. Conger Goodyear Collection. 28½ × 36⅜″ (72.4 × 92 cm).

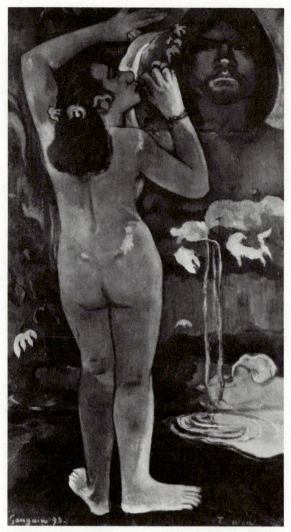

The Moon and the Earth, 1892, oil on burlap, The Museum of Modern Art, New York, Lillie P. Bliss Collection. 45 × 24½″ (114.3 × 62.2 cm).

Paysage de Bretagne, 1894, Louvre, Jeu de Paume. 28¾ × 26¼″ (73 × 92 cm).

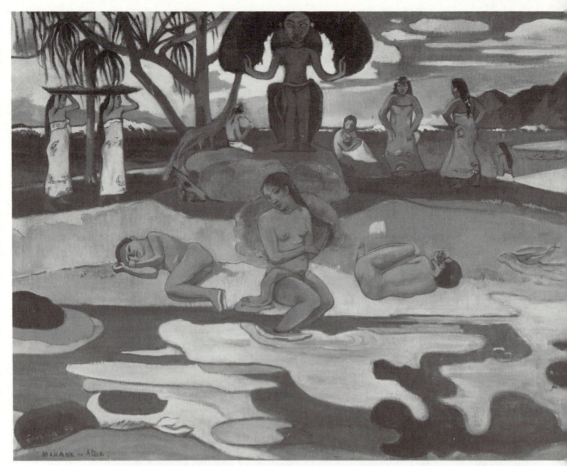

The Day of the God (Mahana No Atua), 1894, oil on canvas, The Art Institute of Chicago, Helen Birch-Bartlett Memorial Collection. 27⅜ × 35⅝" (72.3 x 91 cm).

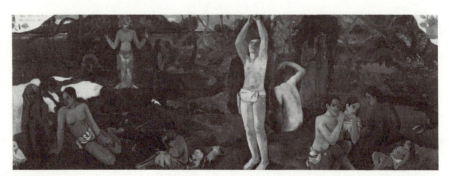

D'où venons-nous . . . Que sommes-nous . . . Où allons-nous? 1897, oil on canvas, Museum of Fine Arts, Boston, Massachusetts, Arthur Gordon Tompkins Residuary Fund. 54¾ × 147⅜ " (139 × 374.5 cm).

Vincent Van Gogh

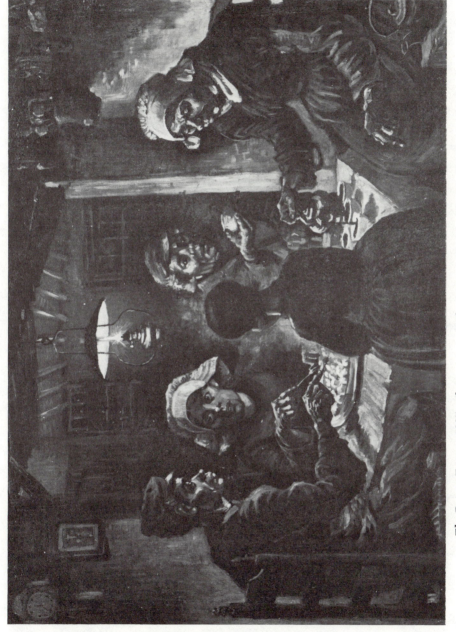

The Potato Eaters, 1885, oil on canvas, Rijksmuseum Vincent Van Gogh, Amsterdam. 32 × 44¾″ (81.3 × 113.7 cm).

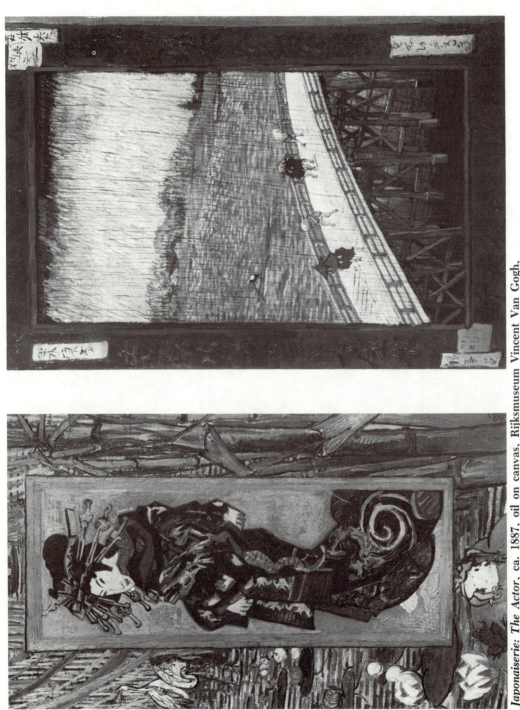

Japonaiserie: The Actor, ca. 1887, oil on canvas, Rijksmuseum Vincent Van Gogh, Amsterdam. 41.3 × 24″ (105 × 61 cm).

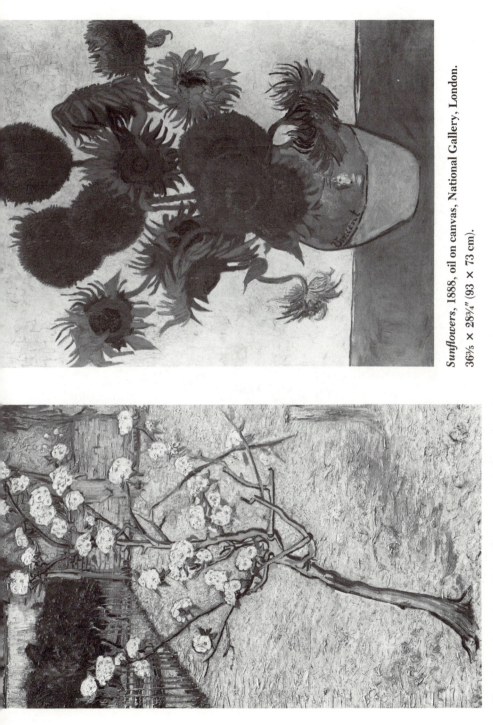

Sunflowers, 1888, oil on canvas, National Gallery, London. 36⅗ × 28¾" (93 × 73 cm).

Blossoming Pear Tree, 1888, oil on canvas, Rijksmuseum Vincent Van Gogh, Amsterdam. 28¾ × 18⅛" (73 × 46 cm).

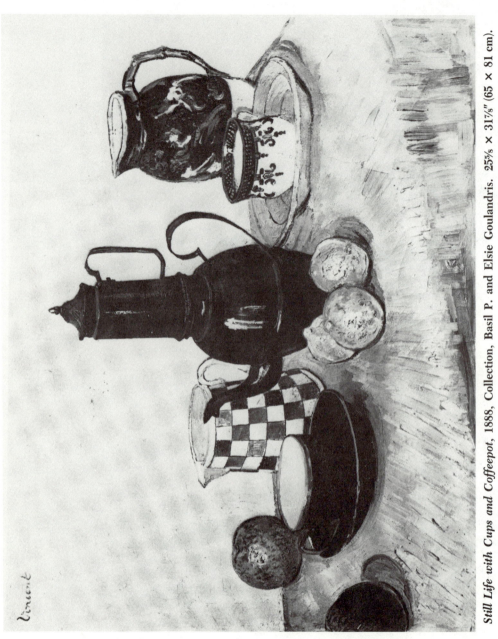

Still Life with Cups and Coffeepot, 1888, Collection, Basil P. and Elsie Goulandris. 25⅝ × 31⅞″ (65 × 81 cm).

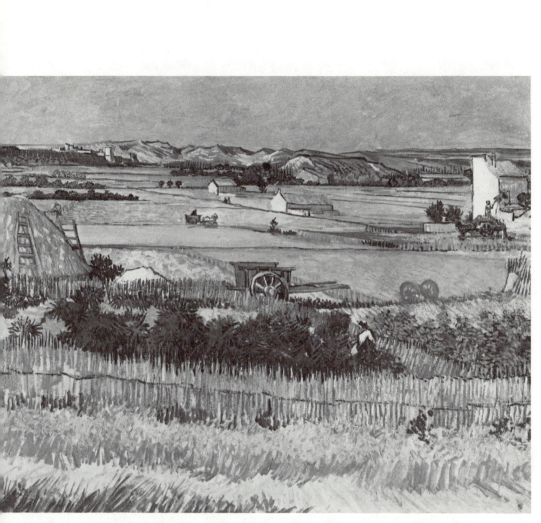

La Crau: Jardins de Maraîchers (The Harvest), 1888, oil on canvas, Rijksmuseum
Vincent Van Gogh, Amsterdam. 28½ × 36¼″ (72.5 × 92 cm).

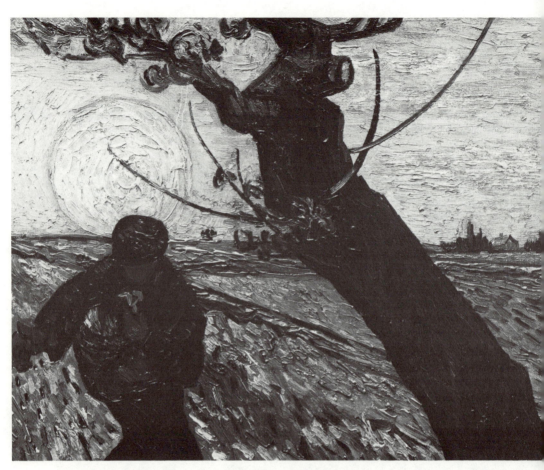

The Sower, 1888, oil on canvas, Rijksmuseum Vincent Van Gogh, Amsterdam. 12½ × 15⅝″ (32 × 40 cm).

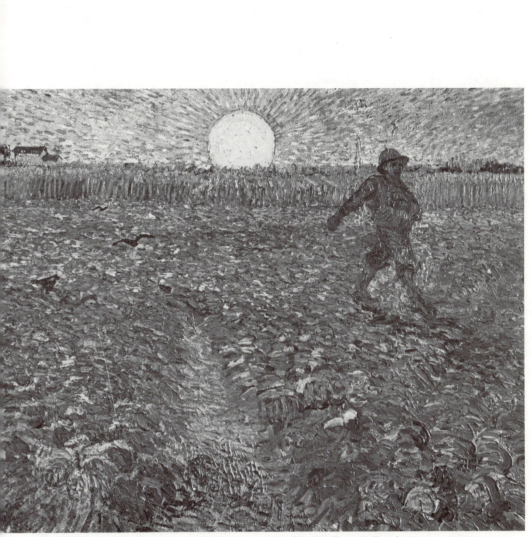

The Sower, 1889, oil on canvas, Rijksmuseum Kröller-Müller, Holland. 25¼ × 31¾"
(64 × 80.5 cm).

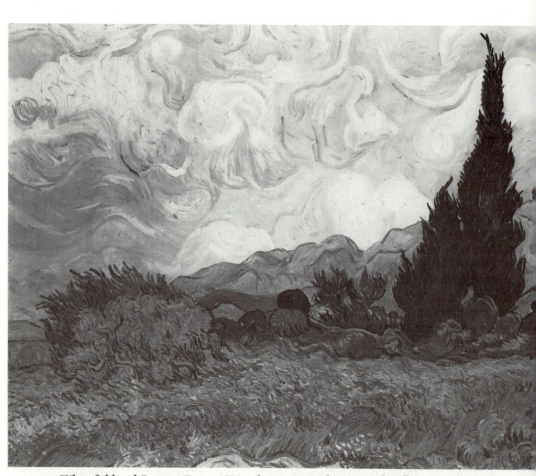

Wheatfield and Cypress Trees, 1889, oil on canvas, The National Gallery, London. 28⅜ × 35¾" (72.1 × 90.9 cm).

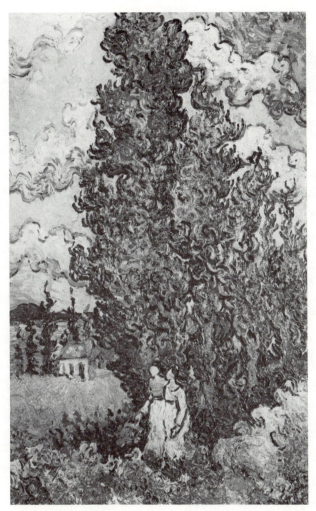

Cypresses, 1889, oil on canvas, Rijksmuseum Vincent Van Gogh, Amsterdam. 16½ × 10⅓″ (42 × 26 cm).

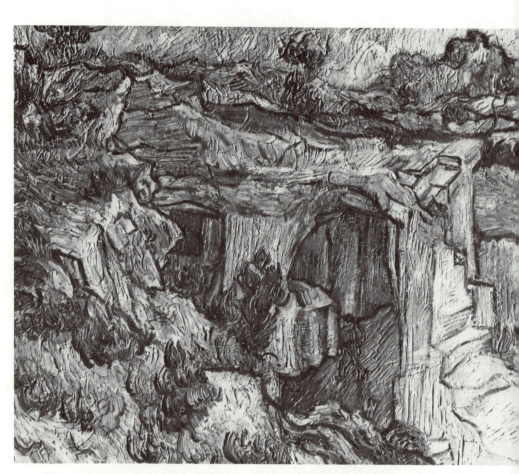

Entrance to a Quarry, 1889, Collection, Mrs. Morton M. Palmer, Jr. and Mr. George
A. Forman, New York. 20½ × 25¼″ (52 × 64 cm).

La Berceuse, 1889, oil on canvas, Museum of Fine Arts, Boston, Bequest of John T. Spaulding. 36¼ × 38¼″ (92 × 72 cm).

Cypresses, 1889–90, oil on canvas, The Metropolitan Museum of Art, Rogers Fund. 36¾ × 29⅛″ (95 × 73 cm).

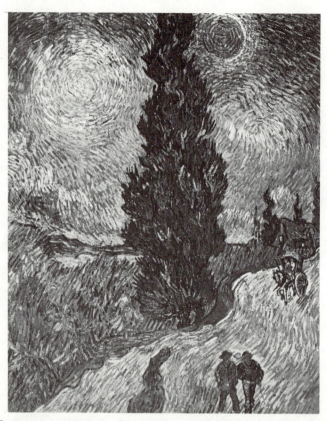

Road with Cypress, 1889–90, oil on canvas, Rijksmuseum Kröller-Müller, Holland. 36¼ × 28¾″ (92 × 73 cm).

Paul Cézanne

Une Moderne Olympia, 1872–73, Louvre, Jeu de Paume. 18½ × 22″ (46 × 55 cm).

Victor Chocquet Assis (Victor Chocquet Seated), ca. 1877, oil on canvas, Columbus Museum of Art, Museum Purchase: Howald Fund. 18 × 15″ (45.7 × 38.1 cm).

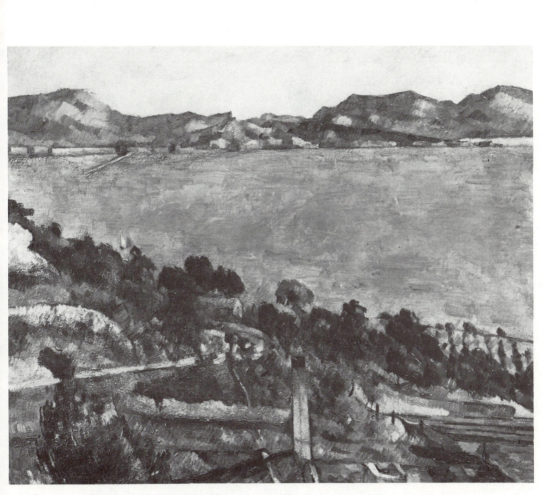

The Sea at L'Estaque, 1883–1885, oil on canvas, The Louvre, Jeu de Paume. 22⅖ × 28⅓″ (58 × 72 cm).

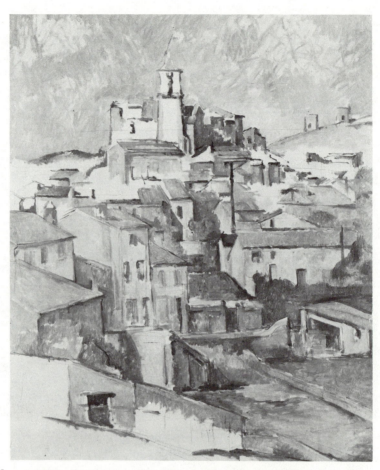

Gardanne, 1885, oil on canvas, The Metropolitan Museum of Art, Gift of Dr. and Mrs. Franz H. Hirschland. 31½ × 25¼″ (80 × 64 cm).

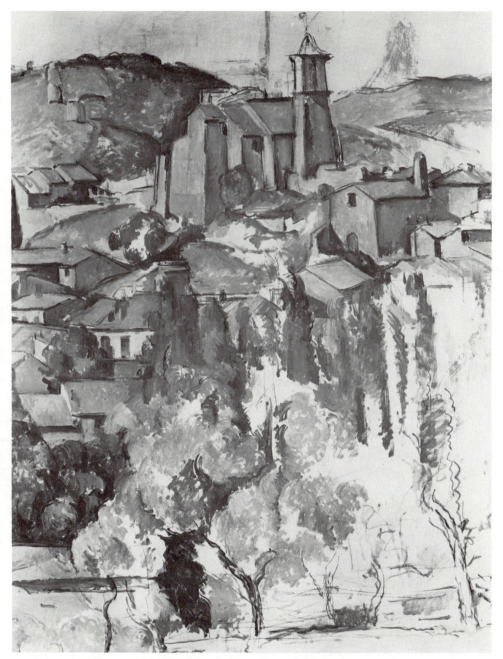

Village of Gardanne, 1885–86, oil on canvas, The Brooklyn Museum, Ella C. Woodward Fund and A. T. White Memorial Fund. 36¼ × 29⅜″ (92 × 74.6 cm).

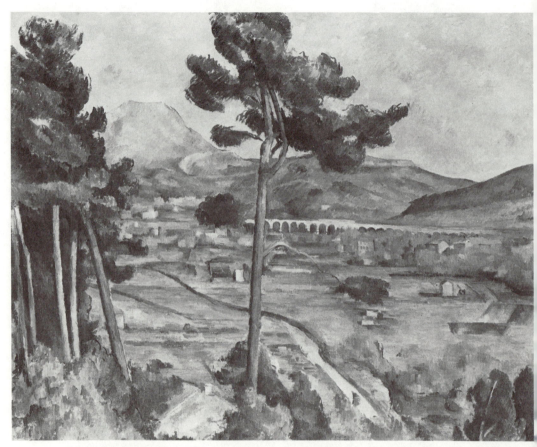

Mont Sainte-Victoire, 1885–87, oil on canvas, The Metropolitan Museum of Art, The
H. O. Havemeyer Collection, Bequest of Mrs. H. O. Havemeyer. 25¾ × 32⅛″ (65.4
× 81.6 cm).

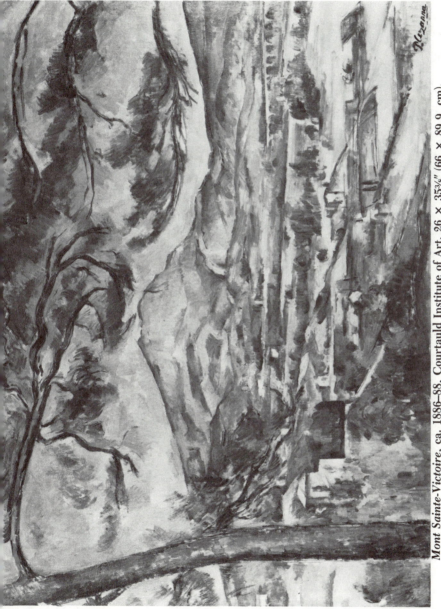

Mont Sainte-Victoire, ca. 1886–88, Courtauld Institute of Art. 26 × 35⅜″ (66 × 89.9 cm).

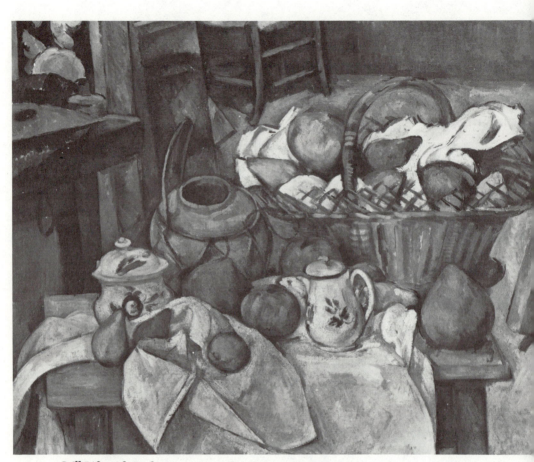

Still Life with Basket, ca. 1890, oil on canvas, The Louvre, Jeu de Paume. 25⅝ × 31⅞″ (65 × 81 cm).

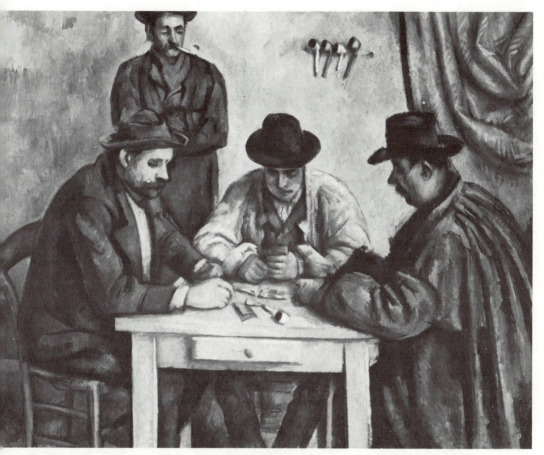

The Card Players, 1890–92, oil on canvas, The Metropolitan Museum of Art, Bequest
of Stephen C. Clark. 25½ × 32″ (64.8 × 81.3 cm).

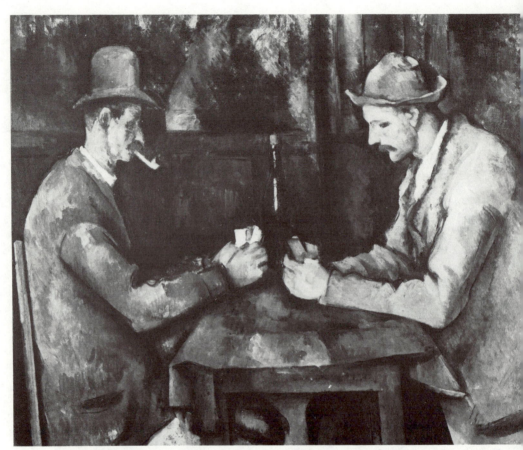

The Card Players, 1890–1892, oil on canvas, The Louvre, Jeu de Paume. 17¾ × 22½″ (45 × 57 cm).

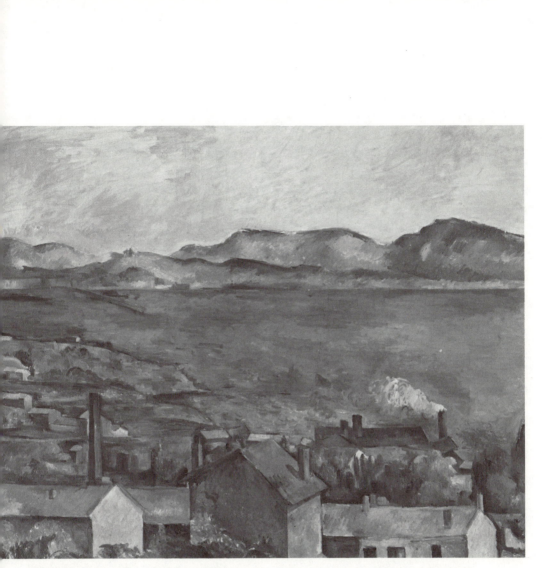

The Gulf of Marseilles, Seen from L'Estaque, ca. 1891, oil on canvas, The Art Institute of Chicago, Collection, Mr. and Mrs. Martin A. Ryerson. 31¾ × 39¼″ (80.6 × 99.7 cm).

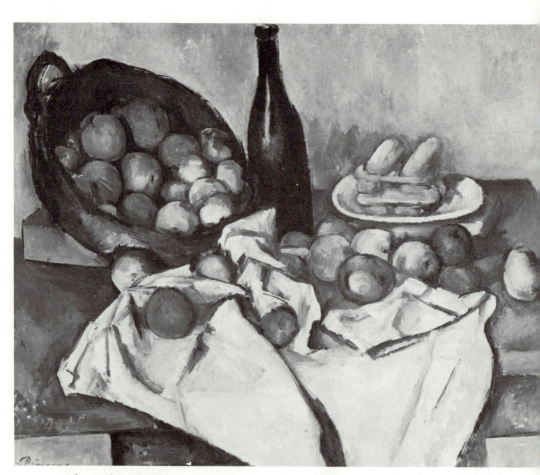

The Basket of Apples, ca. 1895, oil on canvas, The Art Institute of Chicago, Helen Birch Bartlett Memorial Collection. 24⅜ × 31″ (61.9 × 78.7 cm).

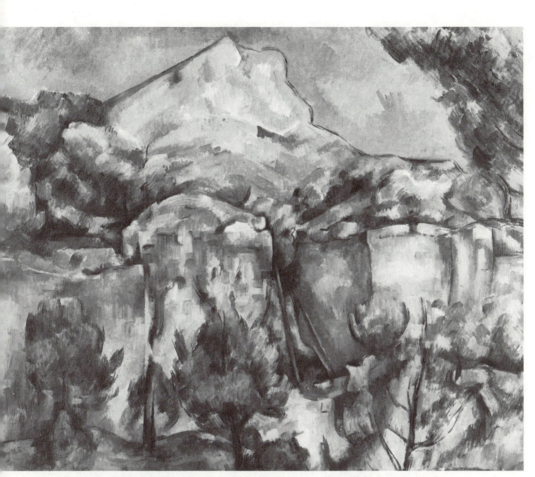

Mont Sainte-Victoire as Seen from Bibemus Quarry, ca. 1898–1900, The Baltimore Museum of Art, The Cone Collection formed by Dr. Claribel Cone and Miss Etta Cone of Baltimore, Md. 25½ × 32″ (64.8 × 81.3 cm).

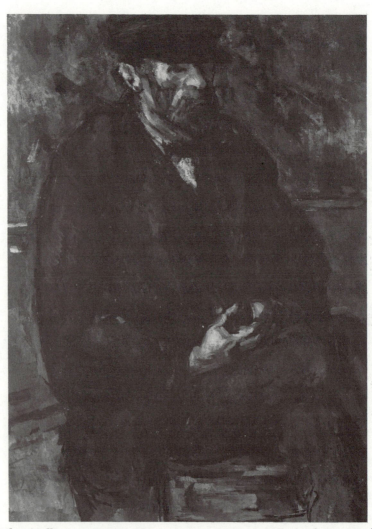

The Sailor (Vallier), ca. 1905, oil on canvas, National Gallery of Art, Washington, D.C., Gift of Eugene and Agnes Meyer. 42¼ × 29⅜″ (107.4 × 74.5 cm).

Emile Bernard

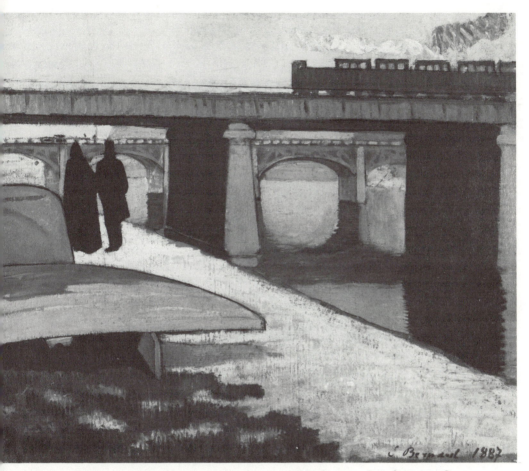

Bridge at Asnières, 1887, oil on canvas, Collection, The Museum of Modern Art, Grace Rainey Rogers Fund 18⅛ × 21⅜″ (46.04 × 54.29 cm).

Maurice Denis

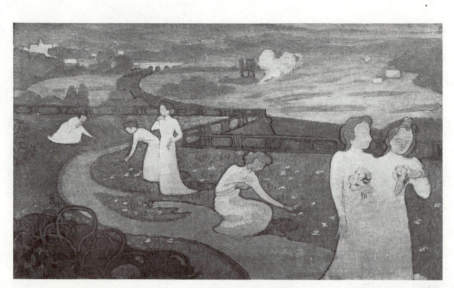

April, 1892, oil on canvas, Rijksmuseum Kröller-Müller. 14⅖ × 24″ (37.5 × 61 cm).

Paul Sérusier

Landscape: Bois d'Amour (The Talisman), 1888, oil on panel, Denis Family Collection, Alençon, France (photo Giraudon), S.P.A.D.E.M., Paris/VAGA, New York 1981. 10⅝ × 8⅝″ (27 × 22 cm).

Color Plates

Paul Gauguin

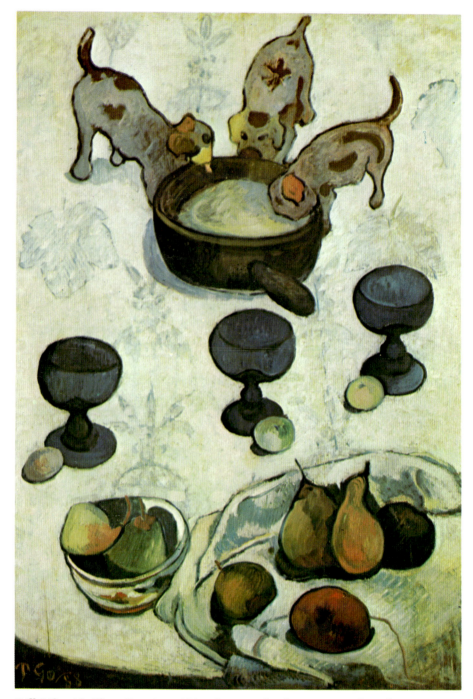

Still Life with Three Puppies, 1888, oil on wood, The Museum of Modern Art, New York, Mrs. Simon Guggenheim Fund. 36⅛ × 24⅝″ (91/8 × 62.6 cm).

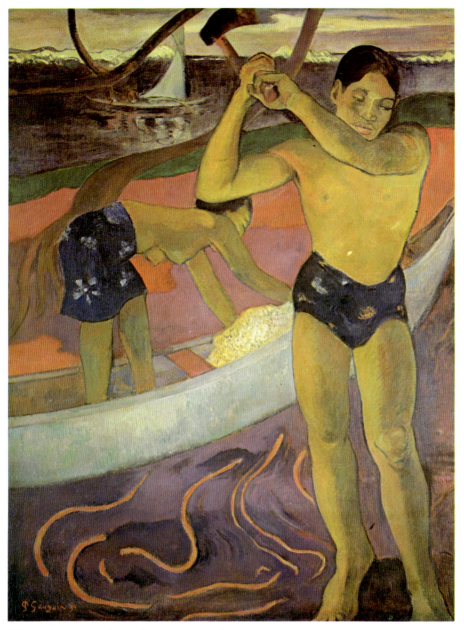

Man with an Axe, 1891, oil on canvas, Collection, private collection, New York. 36¼ × 27⅝″ (92 × 70 cm). Photo by Robert E. Mates.

Vincent Van Gogh

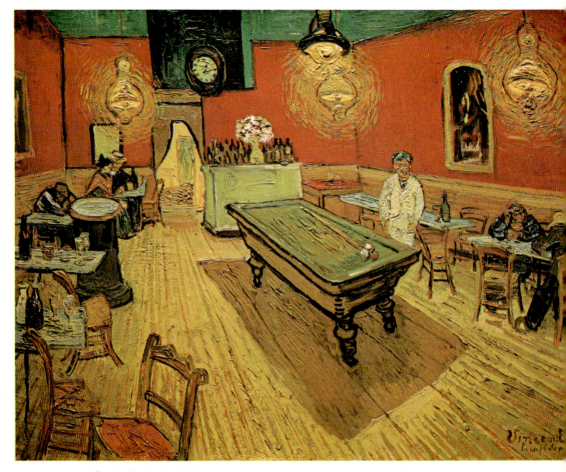

The Night Café, 1888, oil on canvas, Yale University Art Gallery, Bequest of Stephen Carlton Clark, B.A., 1903. 28½ × 36¼″ (70 × 89 cm).

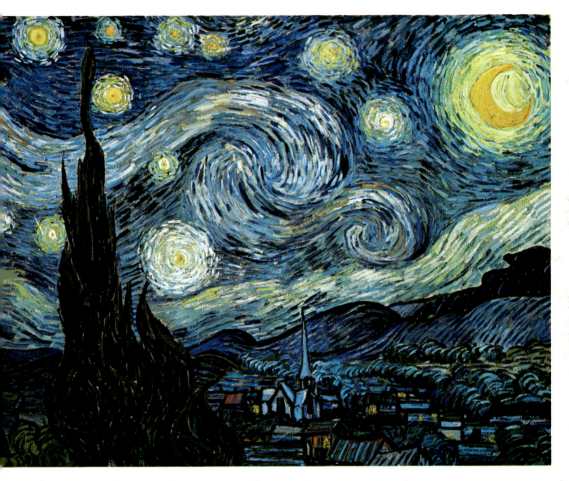

The Starry Night, 1889, oil on canvas, Collection, The Museum of Modern Art, New York, Acquired through the Lillie P. Bliss Bequest. 29 × 36¼″ (73.7 × 92 cm).

Paul Cézanne

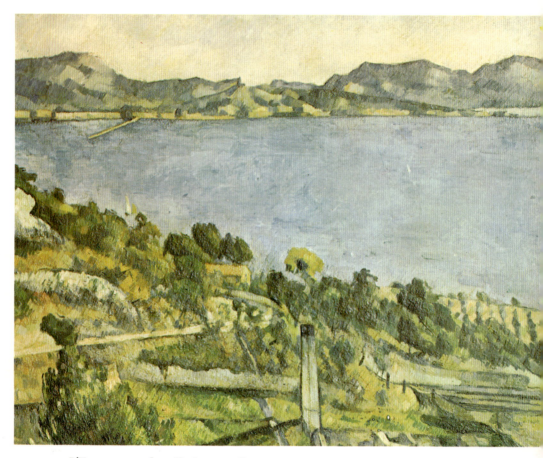

L'Estaque: vue du golfe de Marseilles, 1882–1885, oil on canvas, Louvre, Jeu de Paume. 23 ⅛ × 28¾″ (59.5 × 73 cm).

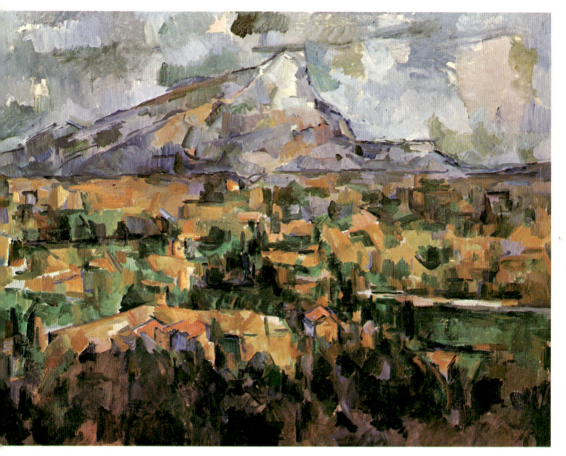

Mont Sainte-Victoire, 1904–1905, oil on canvas, Philadelphia Museum of Art, Purchased the George W. Elkins Collection. 28⅞ × 36¼″ (73.3 × 92 cm).